Hunter S. Thompson

AMMO
AMERICAN MODERN **BOOKS**

CONTENTS

Introduction by Johnny Depp 008
Air Force Days 012
Road Trip to the West Coast 018
New York 028
Rum Diary Days 040
Big Sur 050
Road Trip to Tijuana 064
Kentucky 072
South America 086
Plumas County Fair 098
Hell's Angels 104
Woody Creek 120
Freak Power Ticket 132
Fear and Loathing in Las Vegas 144
Fear and Loathing: On the Campaign Trail '72 160
The 1970s 170
Key West 182
The Curse of Lono 190
Night Manager 198
Buy The Ticket, Take the Ride. 204
List of Plates 226
French Translation 230
German Translation 232
Spanish Translation 234
Books by Hunter S. Thompson 237
Honor Roll 238
Colophon 239

INTRODUCTION

WHEN I THINK OF HUNTER, which is very often, the floodgates open and I am instantly, easily and willingly overcome by a great deluge of memories. Memories as diverse as the man himself soar through my mind. Images of some of our less publicized adventures:

A dawn shopping expedition for magnum handguns...

A 3:00 A.M. head shaving appointment, duly and gingerly performed by the Doctor...

Delicately nursing ghastly hang-overs—feeding each other *Fernet Branca* while taking turns hitting from an oxygen tank (neither worked)...

The sheer fascination of watching him salt and pepper his food (it could take up to an hour, but no less than twenty minutes)...

Our thankfully short lived and nearly fatal impromptu decision to take hillbilly brides—long distance...

The two of us, cackling like mad, chasing an escaped mynah bird (Edward—a gift from Hunter and Laila Nabulsi) through my house...

Being locked in a San Francisco hotel room with him for five days and nights (a vast accumulation of condiments, fruit plates, club sandwiches, shrimp cocktails, and yes... grapefruits, stacked precariously high in the corner of the suite towering up to the ceiling)...

Hours and hours of intensely lyrical tête-à-têtes—reading miraculous passages from his many inspired and legendary works...

There were snappy, split second, spot-on, hilarious observations that would buckle anyone's knees, endless moments of hysterical rage, hilarity and rantings that most times rendered me fetal, feeble and weeping on the floor with painful laughter.

Yes, he did have a knack, our good doctor. He had the uncanny ability to ruffle feathers while simultaneously charming anyone into anything, or out of anything that he might have had his sights on. All the while, and always, maintaining the story (because there was always a story). Keeping a keen eye to the happenings around him. Ever the observer, the gift of his genius never taken for granted. His nature was to observe and dissect any and all situations, so observe and dissect he did with an inexorable fervor. He lived it, breathed it, and celebrated it, all of it. And if you were lucky enough to prowl alongside him on any of his escapades, so did you, to the absolute hilt.

Every document, scrap of paper, newspaper clipping, cocktail napkin and photograph were sacred to Hunter. What lives in this book, are essential threads of his life's tapestry, pieces of the puzzle that had been diligently packed away, safely and surely for posterity. They form major insight into his life and work. Wandering these pages, it seems clear that Hunter was indeed more than well acquainted, and even in concert, with what destiny had in store for him.

Within minutes of hearing the devastating news of Hunter's decision to end his life, I was on the phone with Laila in a pathetic attempt to make some sense of what had happened, which of course was impossible. We wept and consoled one another as best we could under such horrible circumstances. And then suddenly, a realization took hold, as if the Doctor himself had nudged us out of our tragic haze. At the exact same moment we both blurted out, "WHAT ABOUT THE CANNON???" "Oh, God... The monument..." In that very second the focus slowly began to change. We were very well versed with what Hunter's expectations were, and they were not small. "Nothing Dinky!!!" seemed to be the prevalent instruction from our departed friend. The initial drawings and design commenced the following morning and construction of the beast followed within the coming weeks. His request had been for a 150 ft. monument/cannon to blast his remains into the sky over his beloved Owl Farm. Simple.
Not simple. I had been advised to abandon any hopes of this mission ever coming to fruition. Not only impossible, but completely insane, I was told. We forged ahead. During my research into how to make this impossibility possible, I discovered that the Statue of Liberty was 151 FEET TALL!!! Shit... "Dinky" and Hunter's monument seemed to be converging. Knowing that detail was everything to him and that this was a detail that needed to be addressed pronto, the decision was made to up the stakes and the design was changed for the monument to be scaled up to 153 ft. Two feet higher. Why? Because in death, as in life, Hunter would have to exceed the American Dream (and its comely representative) by more than just an inch or two. If you could drive a car on 40 lbs. of air pressure in each tire, Hunter would drive on 100 lbs., just to be sure.
Sure of what, only he ever knew. It was a Hunter thing. The Monument team and crew worked non-stop for months bringing Hunter's final wish to life, making the impossible possible. We all stayed focused and

driven even in the face of potential total failure, which loomed perilously close throughout the entire process. It wasn't until quite a bit later, once we were all wholly consumed with the project that I realized a grand part of Hunter's scheme was to distract those closest to him by handing over such an enormous task. Somehow, he knew that once his loved ones dove into the stringy muck of building the cannon, their mourning period would be distracted by such a mammoth undertaking. He was a subtle one that Dr. Thompson.

Reminiscing about the good doctor has always conjured up more than a few choice moments to chew on. Even now, nearly two years since he made his exit, I still get as keyed up when I think of him as I always did. And though I know he won't be calling and that bastard phone won't be ringing off the hook in the middle of the night I clearly hear his voice. I hear him "WHOOP!!!" every time "One Toke Over the Line" creeps up on the radio, I feel him puff up when "Sympathy for the Devil" kicks in. He calms and ponders the gravity of "Mr. Tambourine Man".

He appears when he is needed.

He arrives when absurdity peaks.

I imagine he always will.

Col. Depp
Los Angeles, September 5, 2006

'So we shall let the reader answer this question for himself: Who is the happier man, he who has braved the storm of life and lived, or he who has stayed securely on shore and merely existed?"

from "Security" by Hunter S. Thompson, age seventeen, 1955

AIR FORCE DAYS

Eglin Air Force Base, 1956–1957

NEWS RELEASE
AIR PROVING GROUND COMMAND
EGLIN AIR FORCE BASE, FLORIDA

OFFICE OF INFORMATION SERVICES
Telephone 26111 - 26222

"Proof by Test"

EGLIN AFB, FLORIDA-(Nov8)-S/Sgt. Manmountain Dense, a novice Air Policeman, was severely injured here today, when a wine bottle exploded inside the AP gatehouse at the west entrance to the base. Dense was incoherent for several hours after the disaster, but managed to make a statement which led investigators to believe the bottle was hurled from a speeding car which approached the gatehouse on the wrong side of the road, coming grom the general direction of the SEPERATION CENTER.

Further investigation revealed that, only minutes before the incident at the gatehouse, a reportedly "fanatical" airman had received his seperation papers and was rumored to have set out in the direction of the gatehouse at a high speed in a muffler-less car with no brakes. An immediate search was begun for Hunter S. Thompson, one-time sports editor of the base newspaper and well-known "morale problem". Thompson was known to have a sometimes over-powering affinity for wine and was described by a recent arrival in the base sanatorium as "just the type of bastard who would do a thing like that".

An apparently uncontrolable iconoclast, Thompson was discharged today after one of the most hectic and unusual Air Force careers in recent history. According to Captain Munnington Thurd, who was relieved of his duties as base classification officer yesterday and admitted to the neuropsychological section of the base hospital, Thompson was "totally unclassifiable" and "one of the most savage and unnatural airmen I've ever come up against."

"I'll never understand how he got this discharge", Thurd went on to say. "I almost had a stroke yesterday when I heard he was being given an honorable discharge. It's terrifying--simply terrifying."

And then Thurd sank into a delerium.

-30-

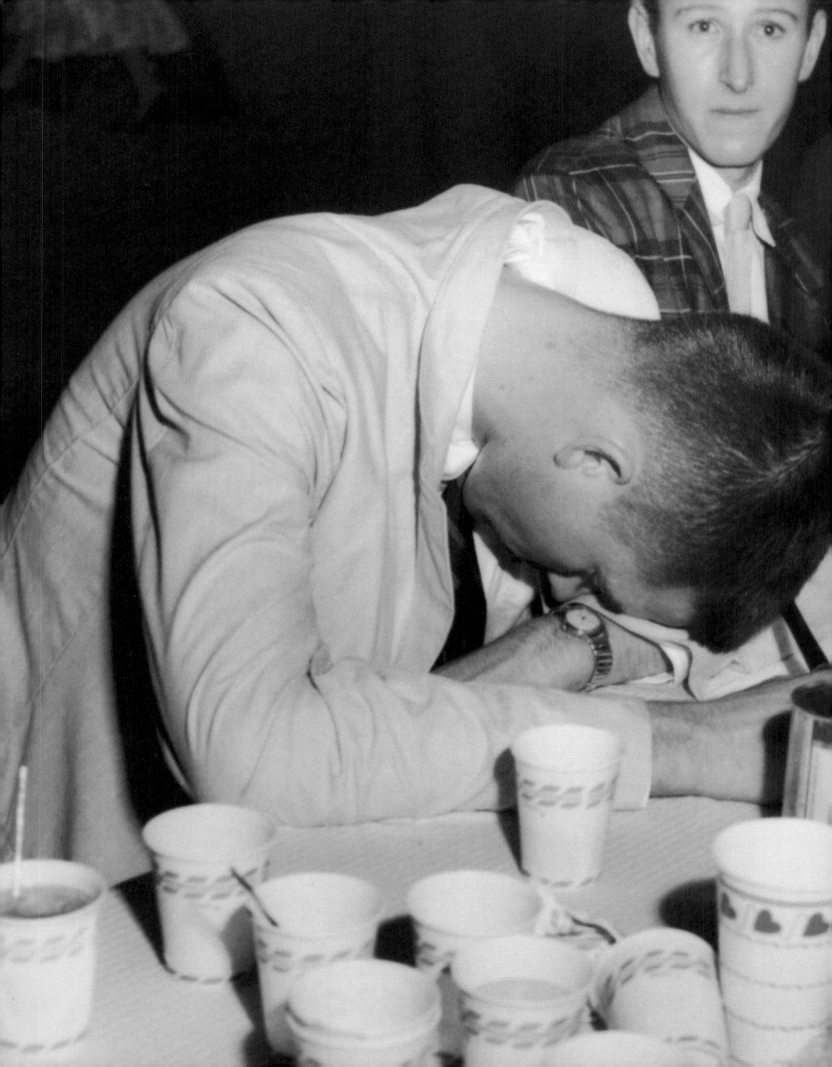

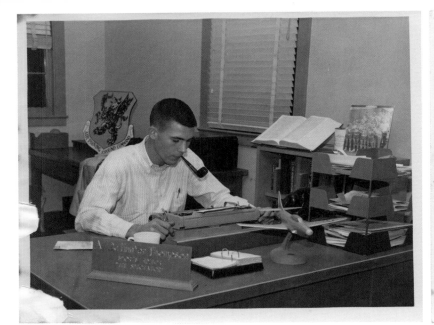

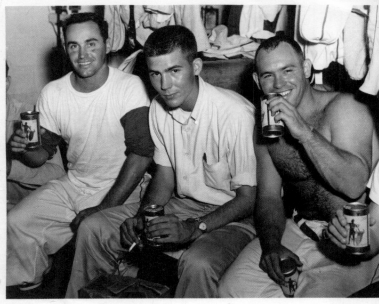

Confusion Reigns **By Thompson**

Sometimes we get the impression that Personnel Services is in the throes of a rather pitiful quandary. The tryouts for the base basketball team last Monday certainly did nothing to change our mind.

Naturally, since we'll have to cover the basketball games this winter, we are slightly curious as to just what sort of team Eglin will have. And, since the sports section of Personnel Services had informed us that the first tryouts for the squad would be held on Monday the 22nd, we thought we'd amble down to the gym and look the boys over.

Once inside, we did our best to find out who was in charge of the confusion which confronted us. It was almost instantly apparent that nobody in the gym had any idea of what was going on. The building was full of prospective cagers; all wandering about with puzzled expressions on their faces and asking each other how to sign up for the team. The whole scene was one of disorganized, unplanned chaos.

Now a rationally thinking man, when he issues a call for help, will undoubtedly stay and wait for some response. Personnel Services issued a call for candidates for the base team, and then failed to have anyone there to receive those who turned out. The only representative of the sports section on hand, was a burly airman with a vacant grin, who was interested in nothing but having the photographer take some pictures of the weight-lifting room. Beyond that, he was strictly hear no evil, see no evil, speak no evil.

A Sobering Thought

It seems to us, that Personnel Services should have more than a passing interest in this sort of thing. If Eglin fails to field a team this fall, a lot of people are going to be slightly curious as to why a base with a population of approximately 15,000, can't seem to muster a 5 man basketball team. Lack of interest obviously isn't the answer; because over forty candidates turned out for the first practice.................or perhaps we'd better qualify that last statement; and say that the answer isn't lack of interest on the part of the prospective players.

A word to the wise is sufficient.

United States Air Force

Air Training Command

Be it known that

A/3C Hunter S. Thompson, AF15546379

has satisfactorily completed the prescribed course of instruction of the Air Training Command specializing in

GROUND COMMUNICATIONS EQUIPMENT REPAIRMAN
(VHF-UHF)

In testimony whereof and by virtue of vested authority we do confer upon him this

CERTIFICATE OF PROFICIENCY

Given at Scott Air Force Base, Illinois

on this third day of July

in the year of our Lord one thousand nine hundred and fifty six

Attest:

KERBY P. SPENCER WENTWORTH GOSS
Captain, USAF Brig General, USAF
SECRETARY COMMANDANT

ATC FORM 33

"Be a beachcomber, a Parisian wino, an Italian pimp, or a Danish pervert; but stay away from the Armed Forces."

from "The Proud Highway", letter from Eglin Air Force Base, March 10, 1957

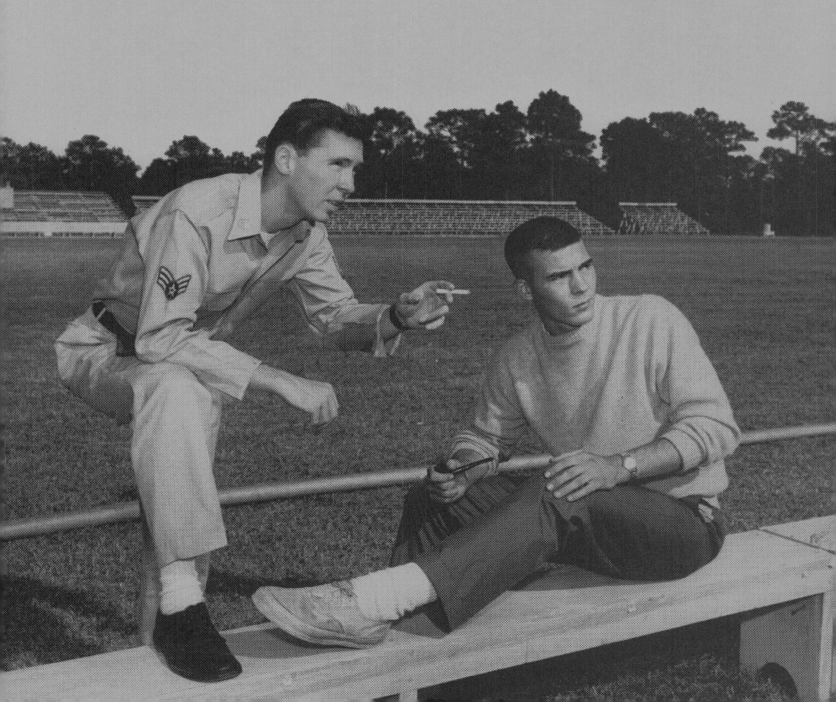

ROAD TRIP TO THE WEST COAST

Photographs circa 1960

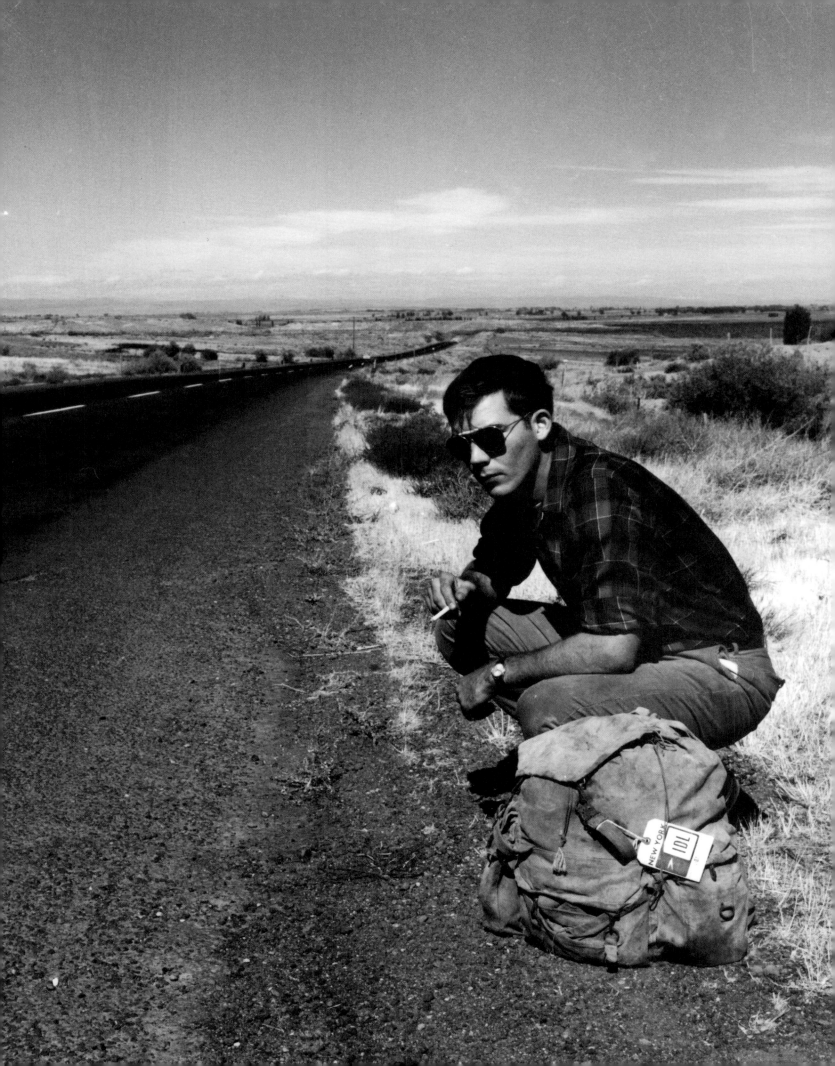

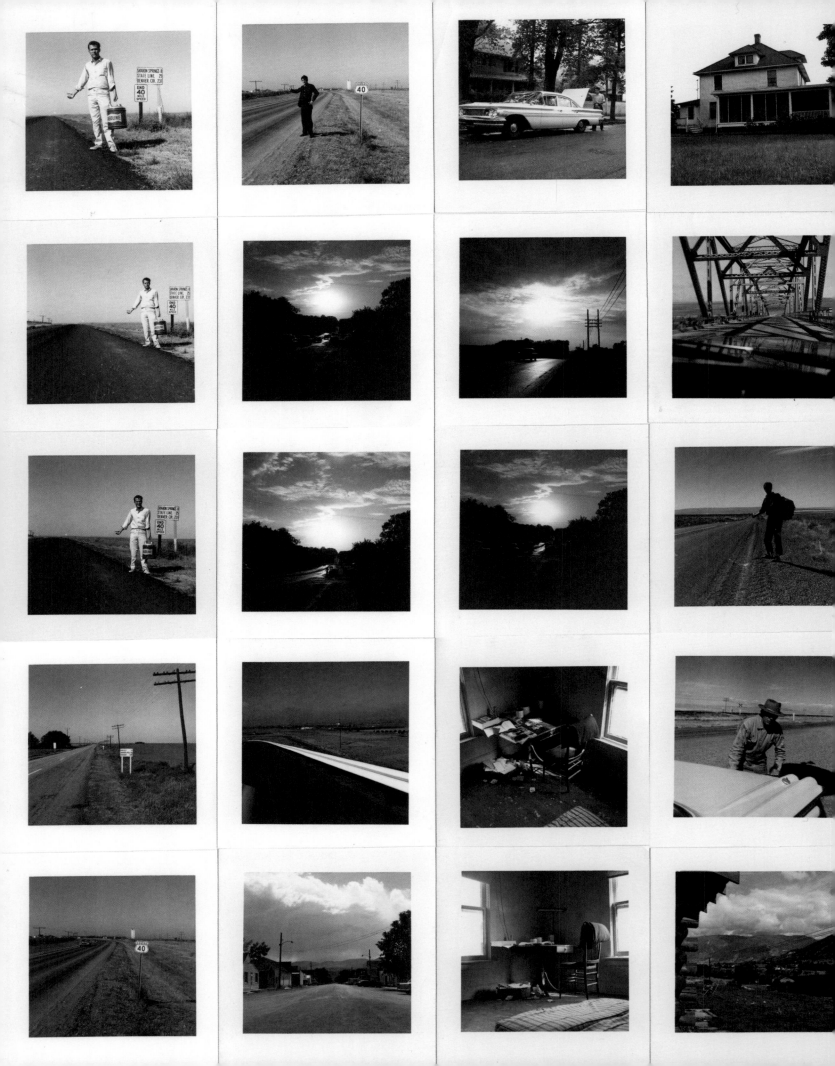

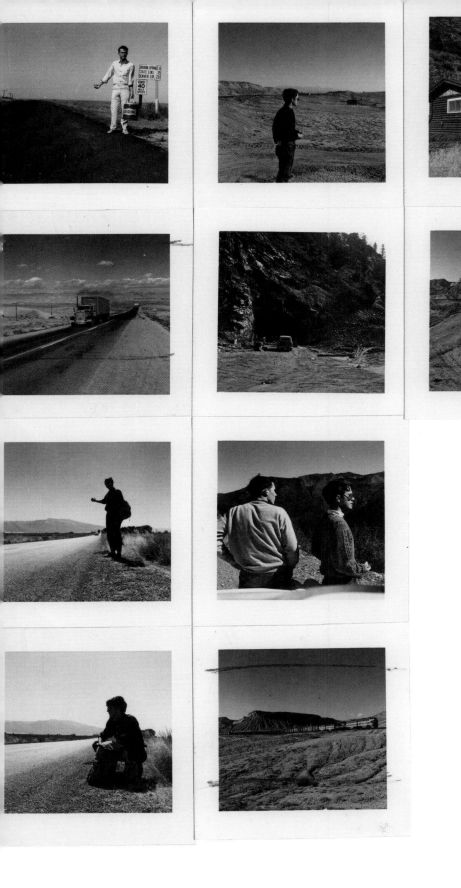

"At age 22 I set what I insist is an all-time record for distance hitchhiking in Bermuda shorts: 3,700 miles in three weeks."

from "The National Observer", "The Extinct Hitchhiker", July 22, 1963

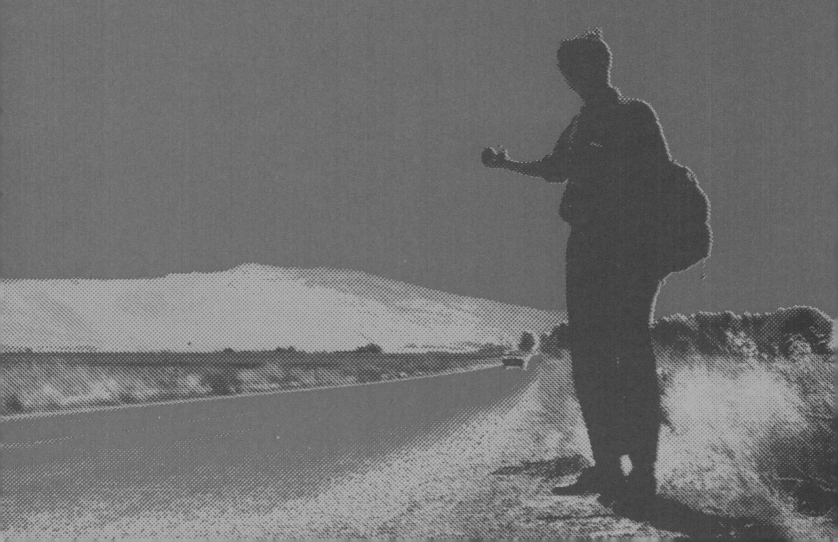

LOW OCTANE FOR THE LONG HAUL (By Hunter S. Thompson

Hitchhikers have fallen on bad times in recent years. The raised thumb, long a symbol of youthful adventure, suddenly took on a threatening aspect when both Hollywood* and the Readers' Digest** decided the public would be much better off if hitchhiking were a lost art.

It almost is, and things have come to such a sad pass that only uniformed servicemen and Jack Kerouac (seem to be able to) move about the country with any ease. The others are having trouble. Most people are (are) afraid of them, insurance regulations prevent truckers from picking them up, and a good many of those who still stop for (the) stranded thumb are often more dangerous than the hitchhikers themselves.

As in most other fields in these highly-technical times, a good hitchhiker needs a gimmick. They range from huge signs, proclaiming the traveler's hoped-for destination, to standing beside a crippled-looking car, wearing the tragic expression of a man who has just dropped his transmission all over the road. But these are old-hat, and when 19 year-old Steve Bragg set out from his home in Baltimore, Maryland, for Salt Lake City, Utah, he covered _____ miles in five days -- spending each night in a motel, with what might be called "the mostest gimmick of them all."

It was a simple gasoline can -- converted to a suitcase by cutting out the bottom and putting in on hinges. Instead of gasoline, it carried: one pair of shoes, one raincoat, one light jacket, three pairs of slacks, (pants, trousers) # four shirts, six pairs of socks, underwear, a towel, a washcloth, soap, shaving gear, one toothbrush and one hairbrush.

People who wouldn't pick up a hitchhiker on a bet will stop for a man out of gas without batting an eye. According to Bragg, it took

(more)

him "about thirty" rides, and only one of these objected to the fact that things were not what they appeared to be. The one, driving a new Cadillac, wouldn't let Bragg into the car until he said where he was going, then sped off in a huff at the mention of Salt Lake City. This happened in Ohio.

All the others took it with varying degrees of amusement. "As soon as I got in the car," Bragg explained, "they'd ask me where I'd run out of gas. When I showed them the can and said I was going to Salt Lake City, most of them seemed a little surprised. After a few seconds, though, they usually laughed and said it was a pretty clever idea."

It was clever enough to keep him moving just as fast as if he'd been driving, and he rarely waited more than fifteen minutes for a ride. Aside from getting where he was going, he convinced "about thirty" people that hitchhiking is not yet a lost art. Perhaps it's becoming a bit too refined for the dangerous types, but a bit of ingenuity can still take a man a long way. —30—

And, despite Hollywood and the Readers' Digest, there are still a lot of hitchhikers of the road with no motive but to get where they want to go. Steve Bragg was going to Salt Lake City to "see the West and get a job." He simply found a new means to an old end.

* I think the movie was called "The Hitchhiker." Vintage, at least pre-1957, and perhaps earlier.

** I don't know when the RD did this article, but it put hitchhikers in a pretty bad light and smeared a lot of the honest ones along with the rotten apples. I would guess it appeared between '55 and '57. Maybe not, but the RD would know.

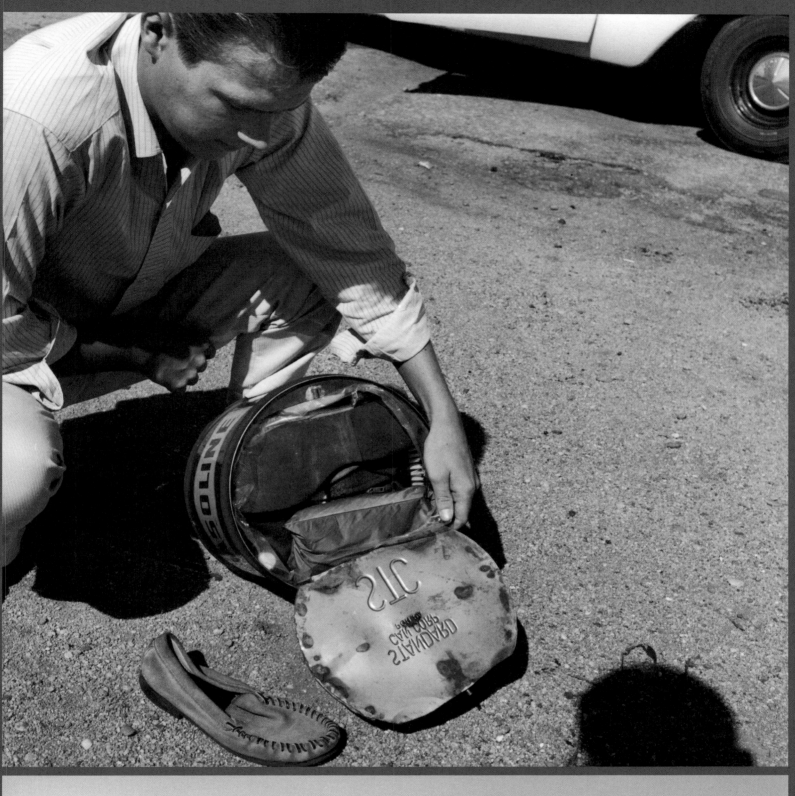
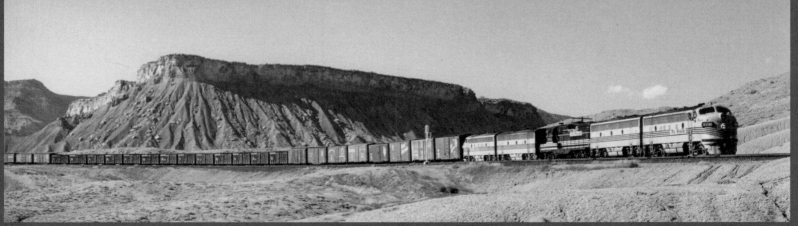

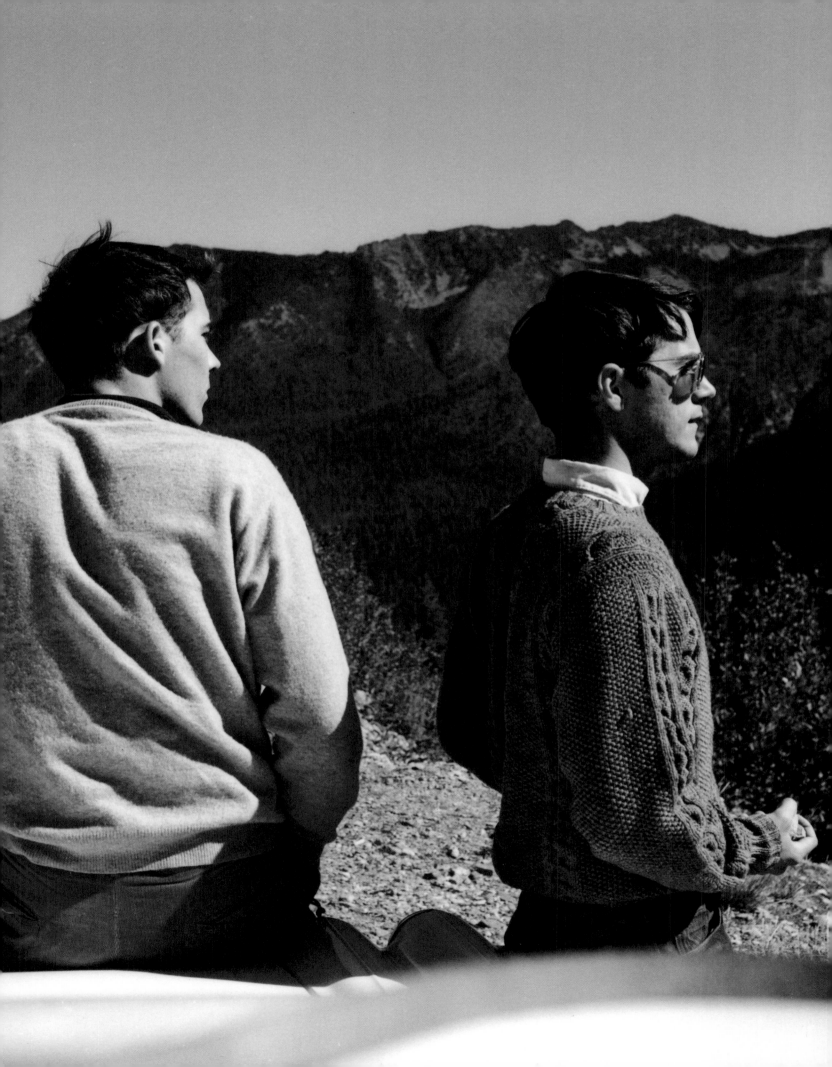

'Can any bus, plane, or train, match the feeling of standing out on a morning road with the sunlight in your face and the smell of new-cut grass all around and no worry in the world except how far the next ride will take you?"

from "The National Observer", "The Extinct Hitchhiker", July 22, 1963

NEW YORK

Photographs circa 1957–1962

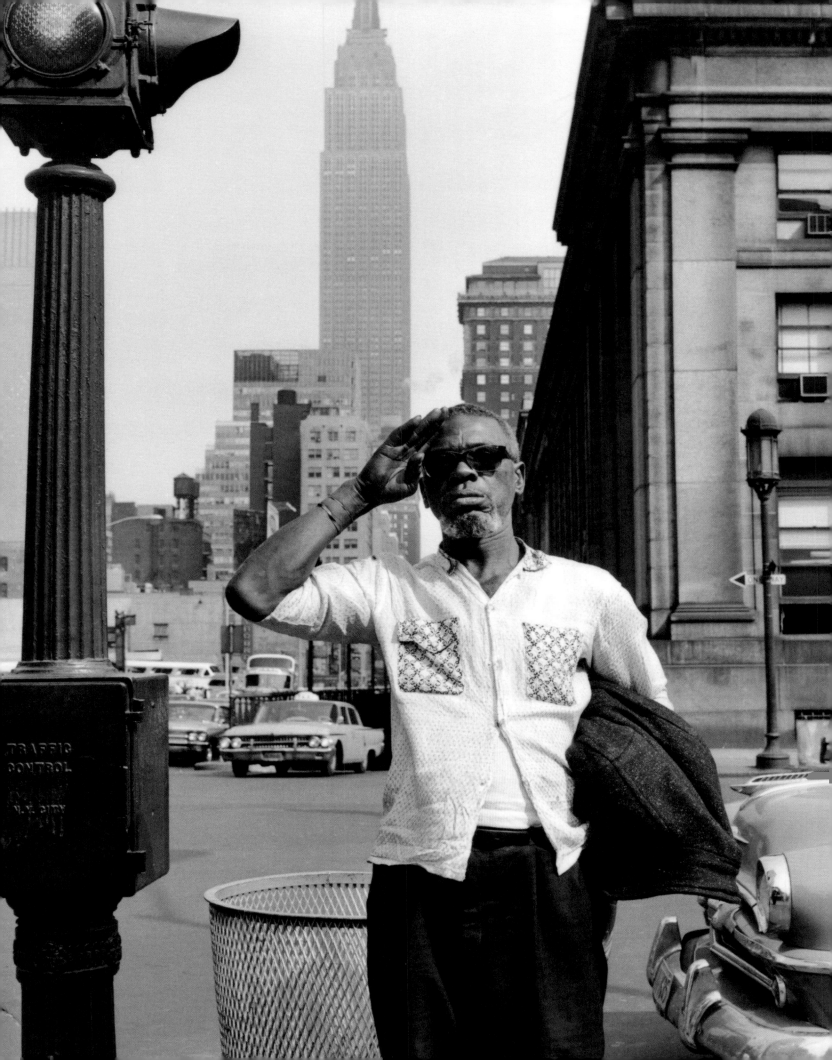

 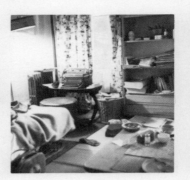 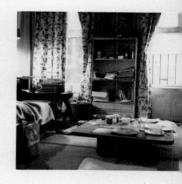

 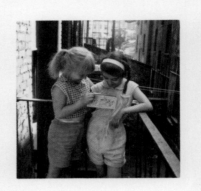

SEP · 60

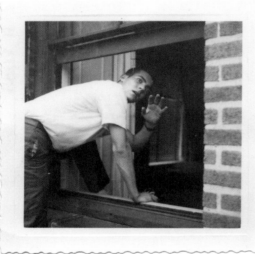 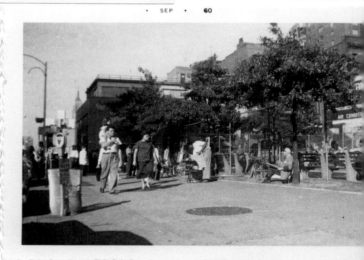

JUL · 58

SEP · 60

"My apartment, once the scene of lazy sex and quiet privacy, has erupted during the past two weeks into a virtual cave of howling drunken insanity. There are people sleeping everywhere—on my bed, on the couch, on the cot, and even on sleeping bags on the floor. Everything in the place is covered with stale beer, most of my records are ruined, every piece of linen, towel, or clothing in the place is filthy, the dishes haven't been washed in weeks, the neighbors have petitioned the landlord to have me evicted, my sex life has been absolutely smashed, I have no money, no food, no privacy, and certainly no peace of mind."

from "The Proud Highway", letter to Roger Richards from Cuddebackville, June 3, 1959

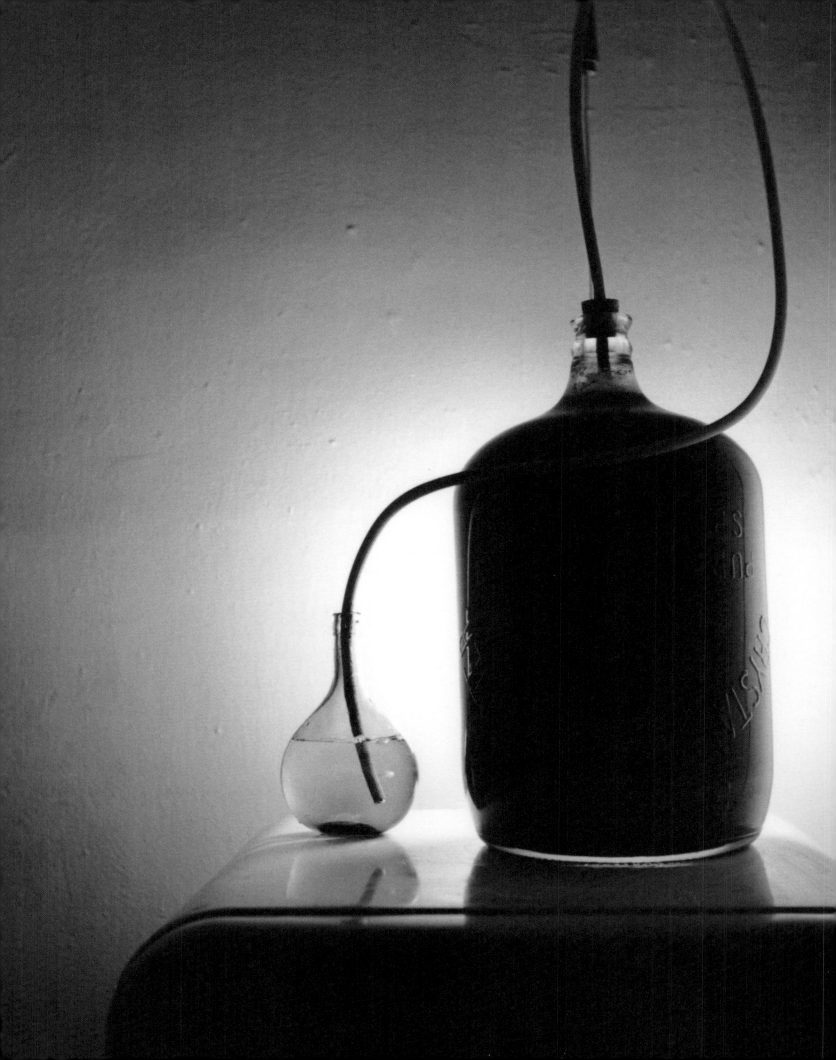

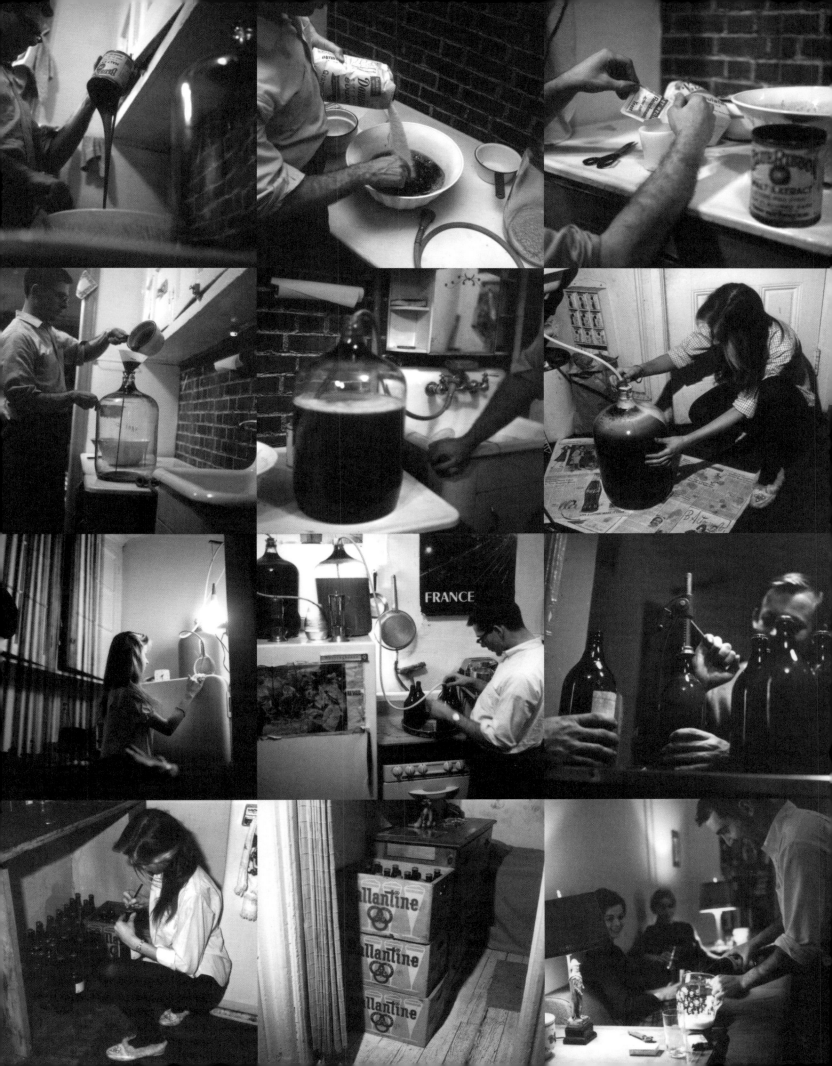

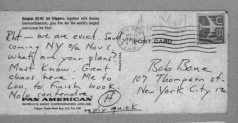

Rht — we are evict. Saudi
coming NY o/a Nov.
What/ are your plans?
Must Know. Great
chaos here. Me to
Lou. to finish book.
Nolo contendre. (H)
reply quick

Bob Bone
107 Thompson st.
New York City 12

JOB NO. _____ 4

NEG NO. _____

Thompson

PRESS

THIS WILL IDENTIFY

NAME HUNTER THOMPSON

AN ACTIVE MEMBER OF THE STAFF OF

JERSEY SHORE HERALD

Please Cooperate as Your Duty Permits

Ronald E. Confer

Chief of Police

034

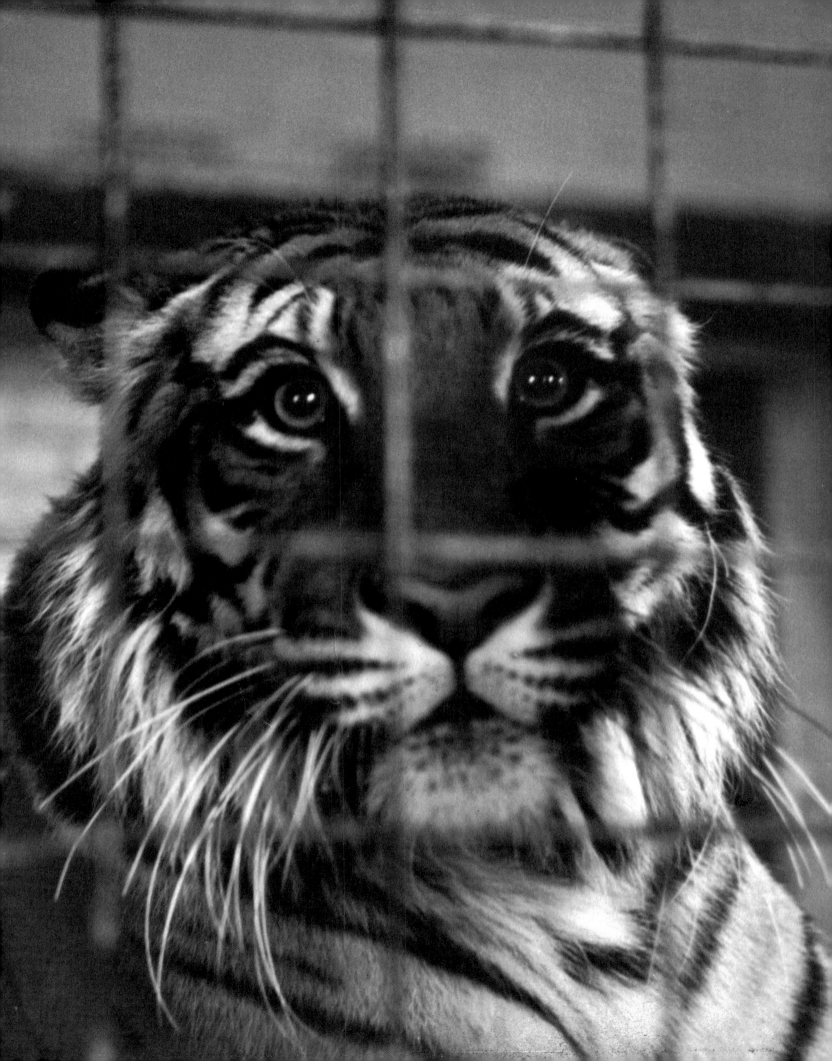

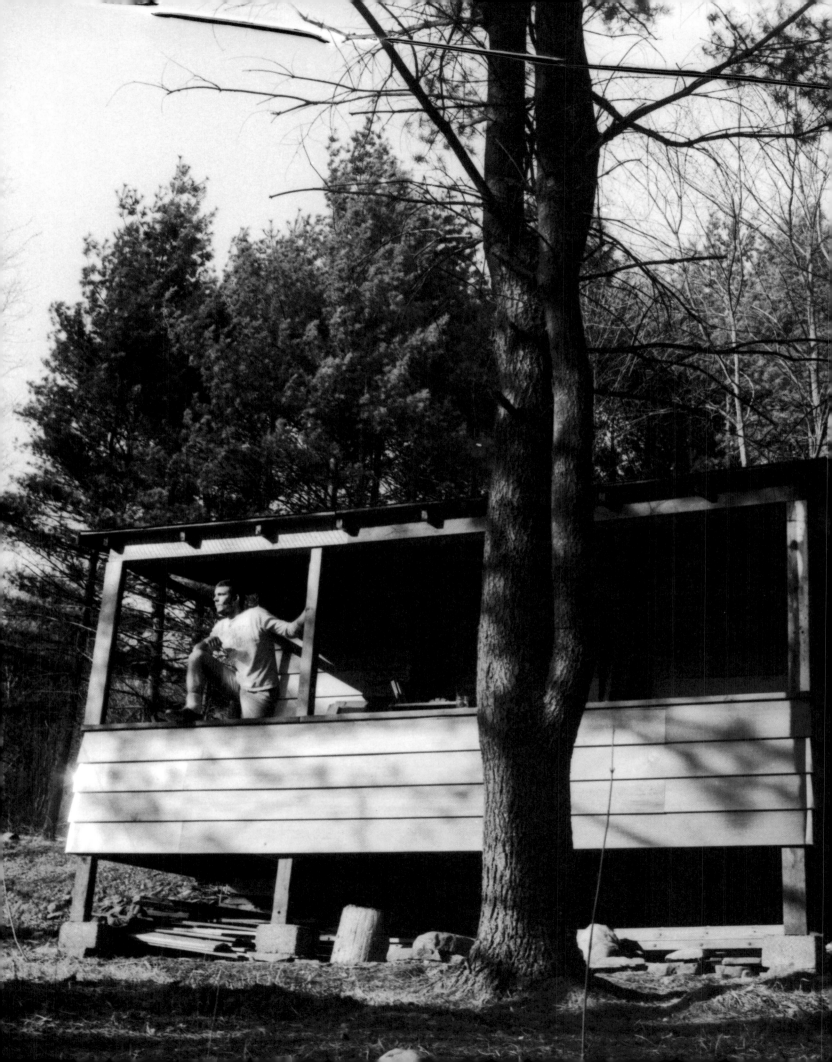

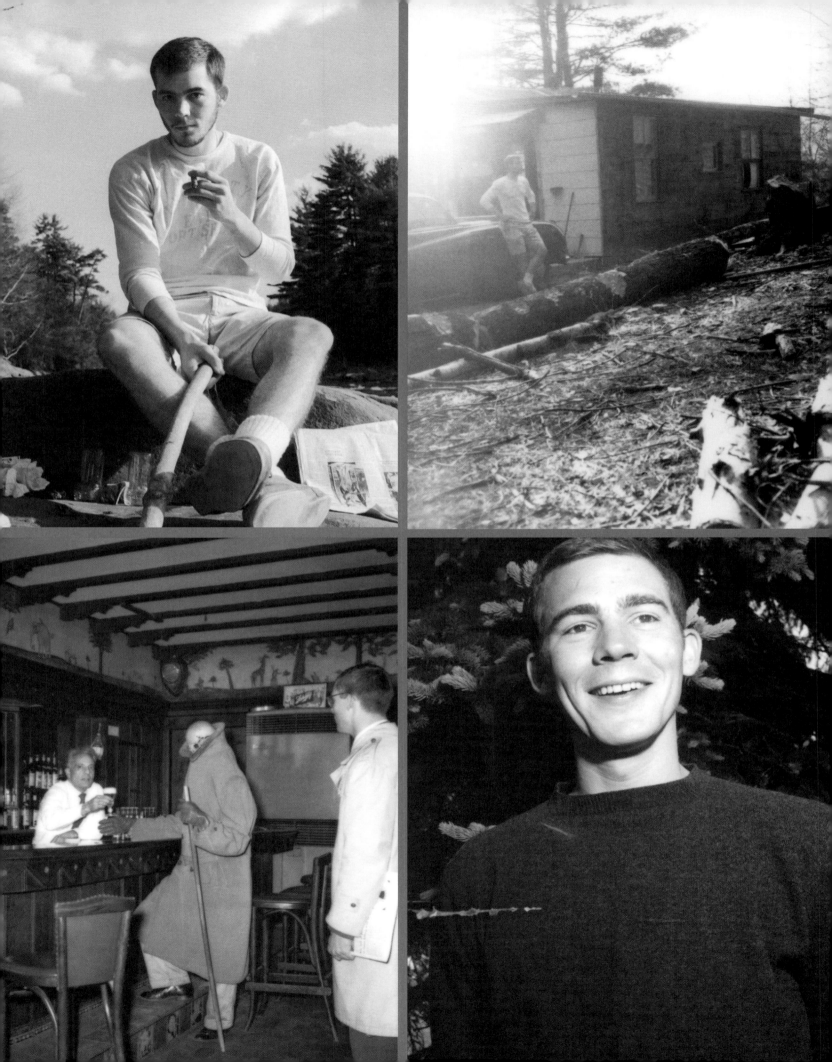

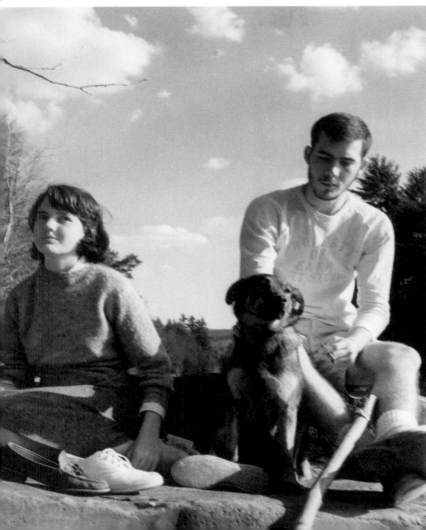

"As things stand now,
I am going to be a writer.
I'm not sure that I'm going
to be a good one or even
a self-supporting one, but
until the dark thumb of
fate presses me to the dust
and says, 'you are nothing',
I will be a writer."

from "The Proud Highway", letter to Roger Richards from Cuddebackville, June 3, 1959

RUM
DIARY
DAYS

Photographs circa 1960s

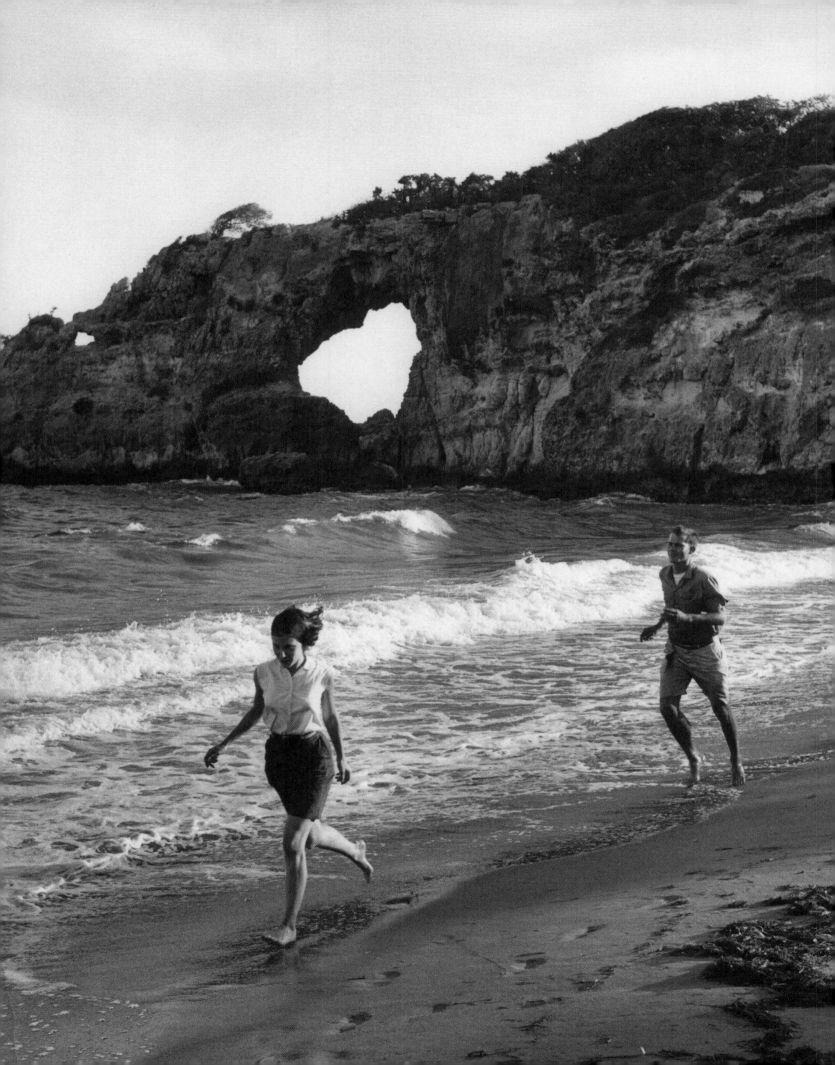

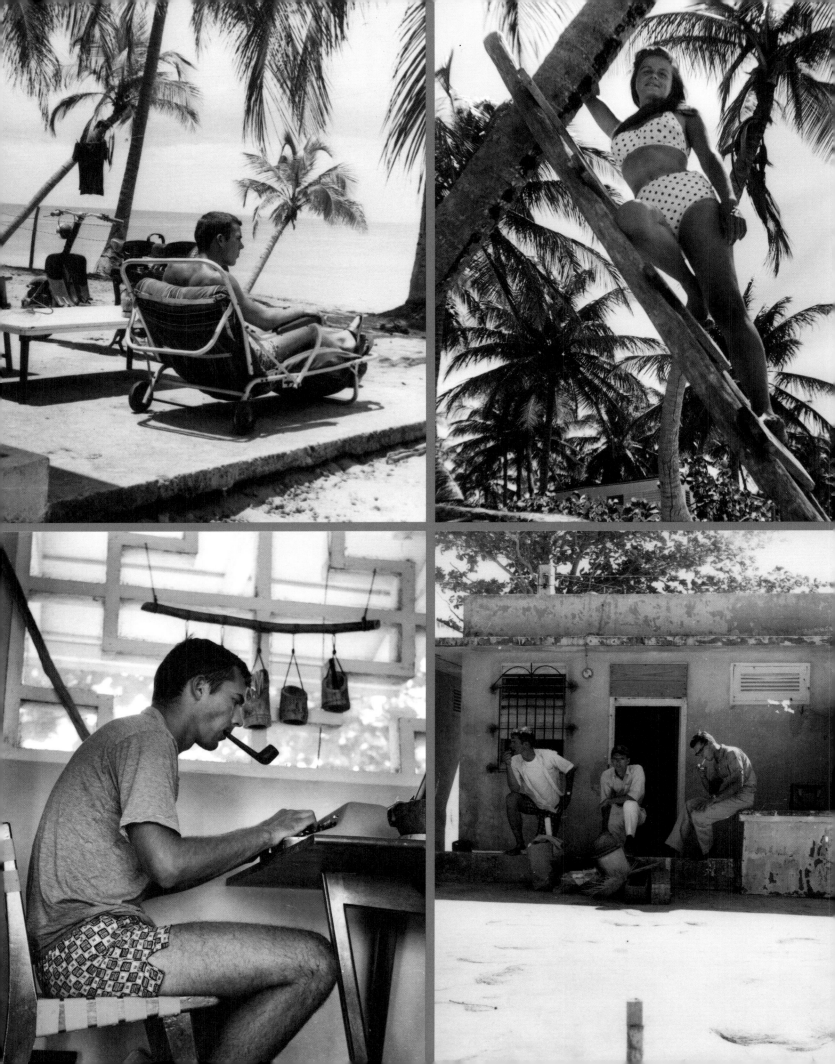

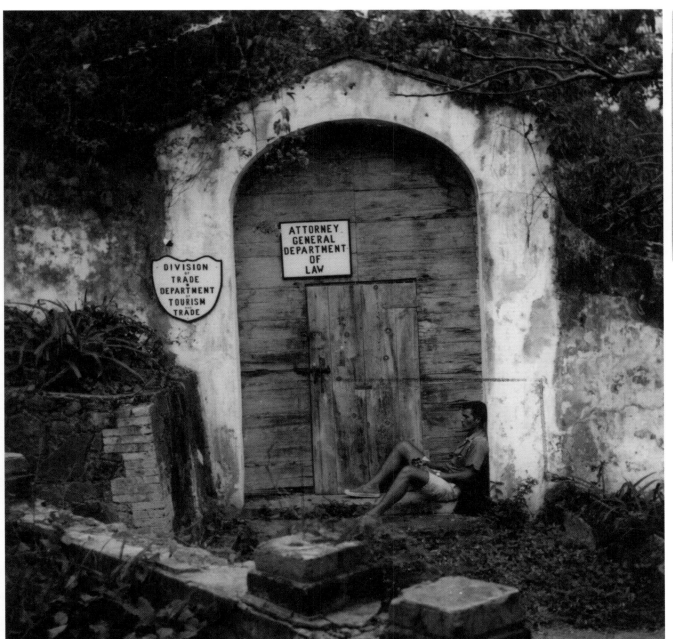

Vagrant + scooter on
Montebay patio —
worrying about $
San Juan 4/60

3620

"The Hovel"
— trio with last
load of baggage
before eviction.
(send this pic back
to me via next
letter — only one
I have of house
San Juan 3/4/60

"I live 5 miles from town, on the beach, 4-room house, motor scooter, no job, writing freelance stuff for Stateside newspapers, also fiction, so many bugs I can barely breathe, wife here and cooking, no money, vagrant artist from New York also living here, has sailboat, all in all life is not bad."

from "The Proud Highway" letter from Loiz Aldea, Puerto Rico May 25, 1960

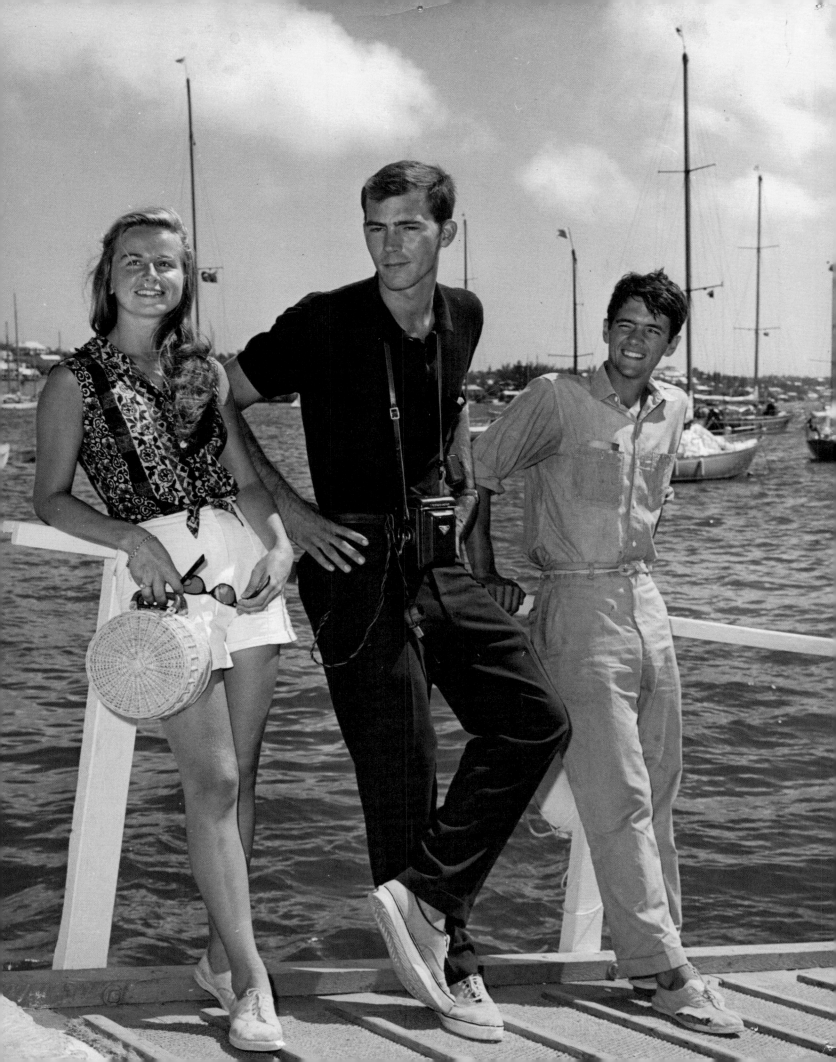

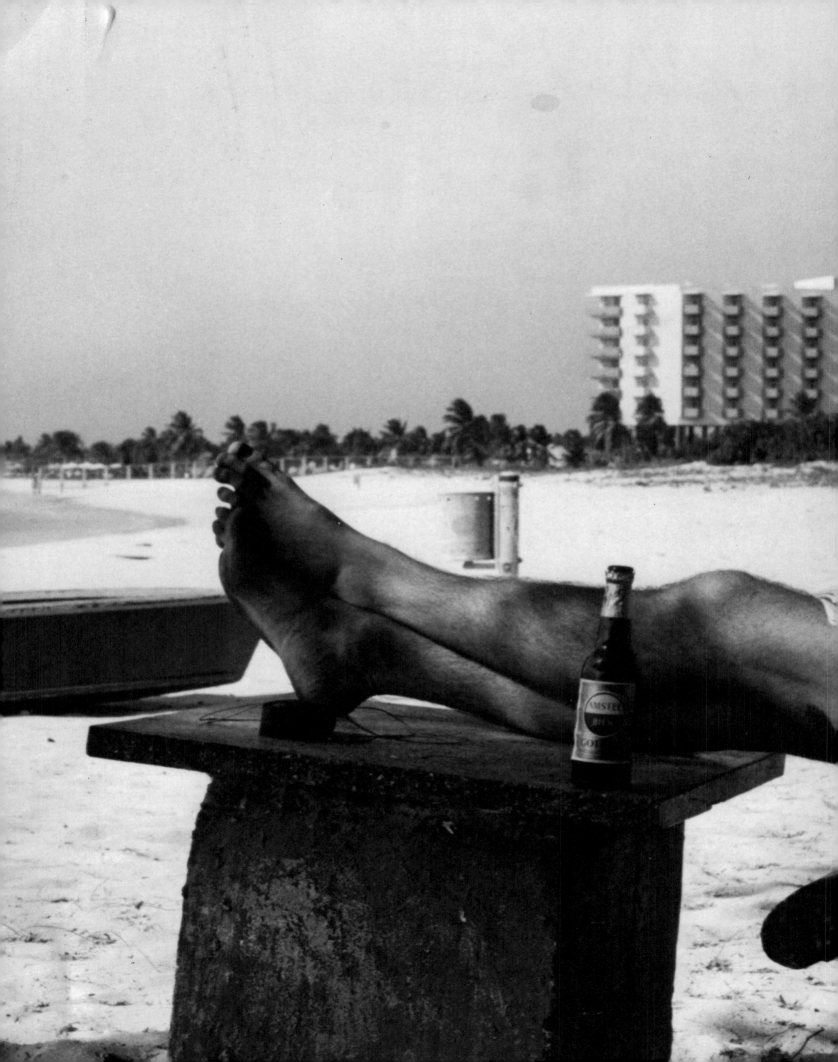

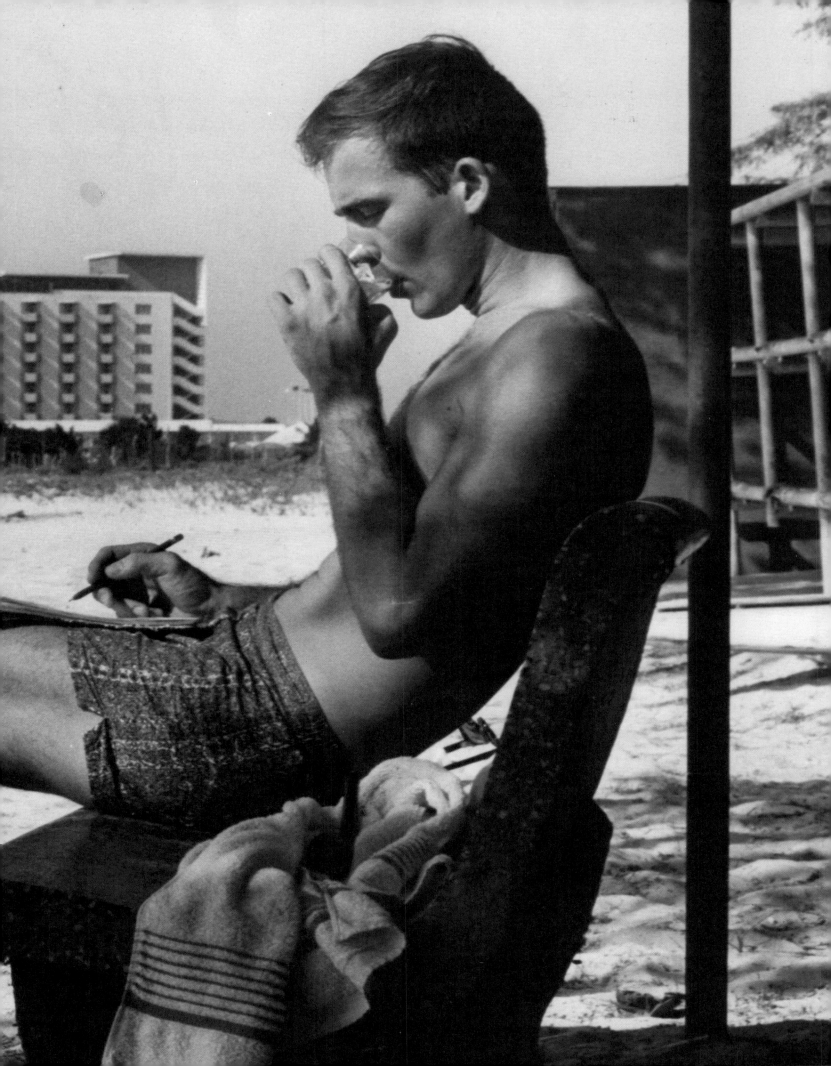

"My life is a wild merry-go-round and I'm beginning to feel like a big hungry jack-rabbit, hopping from one part of the world to another in a frenzy of greed and violence."

from "The Proud Highway" letter from Loiz Aldea, Puerto Rico May 25, 1960

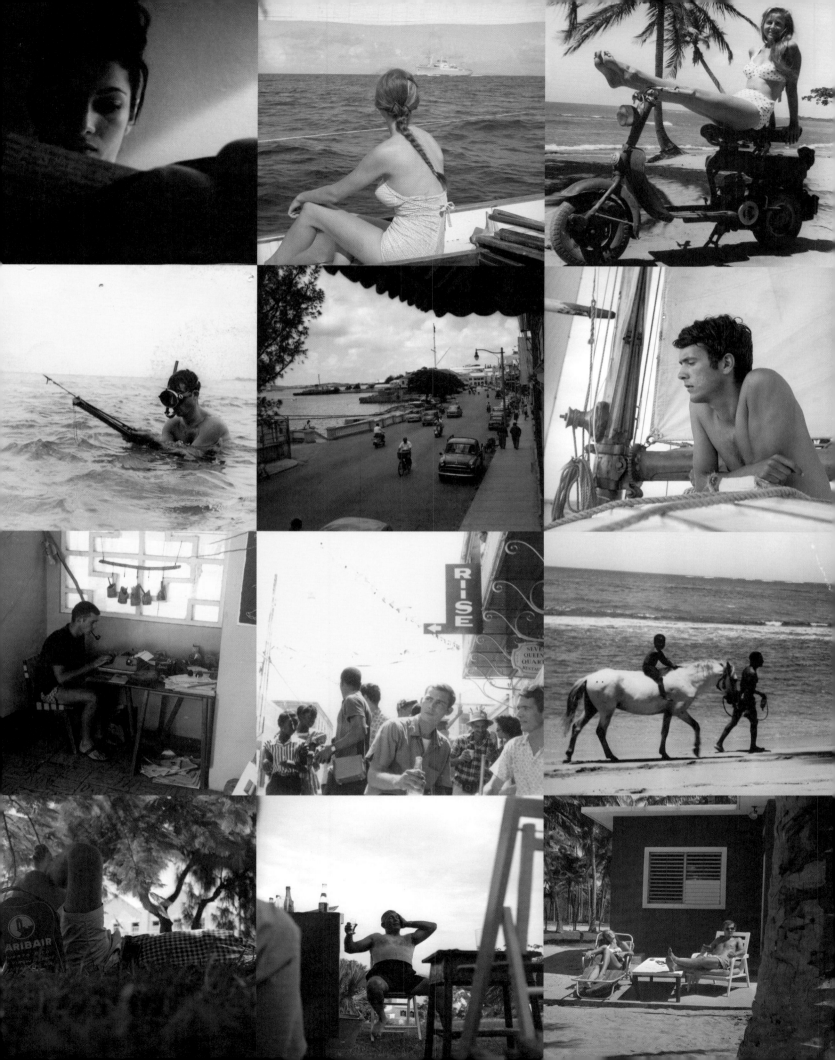

BIG SUR

Photographs circa 1960–1963

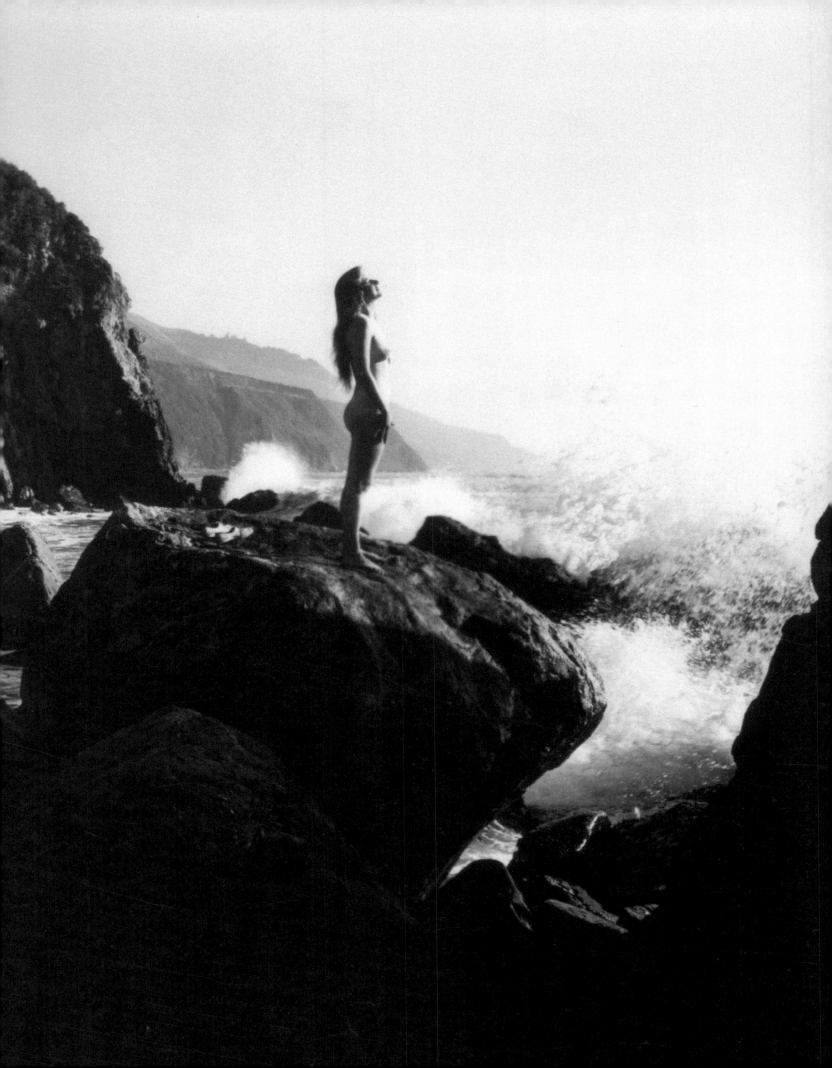

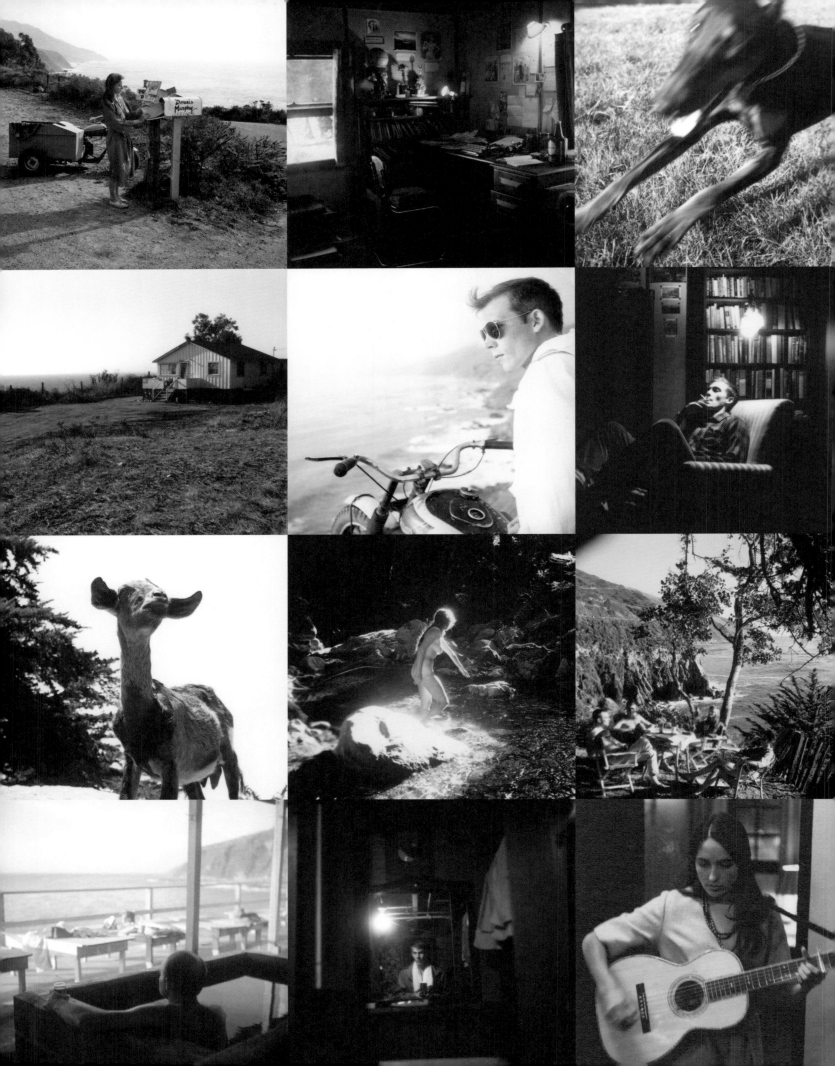

"This is the way life goes in Big Sur: waiting for the mail, watching the sea-lions in the surf or the freighters on the horizon, sitting in the tubs at Hot Springs, once in a while a bit of drink—and, most of the time, working at whatever it is that you came here to work on, whether it be painting, writing, gardening or the simple art of living your own life."

from "Rogue Magazine", "Big Sur: The Garden of Agony" 1961

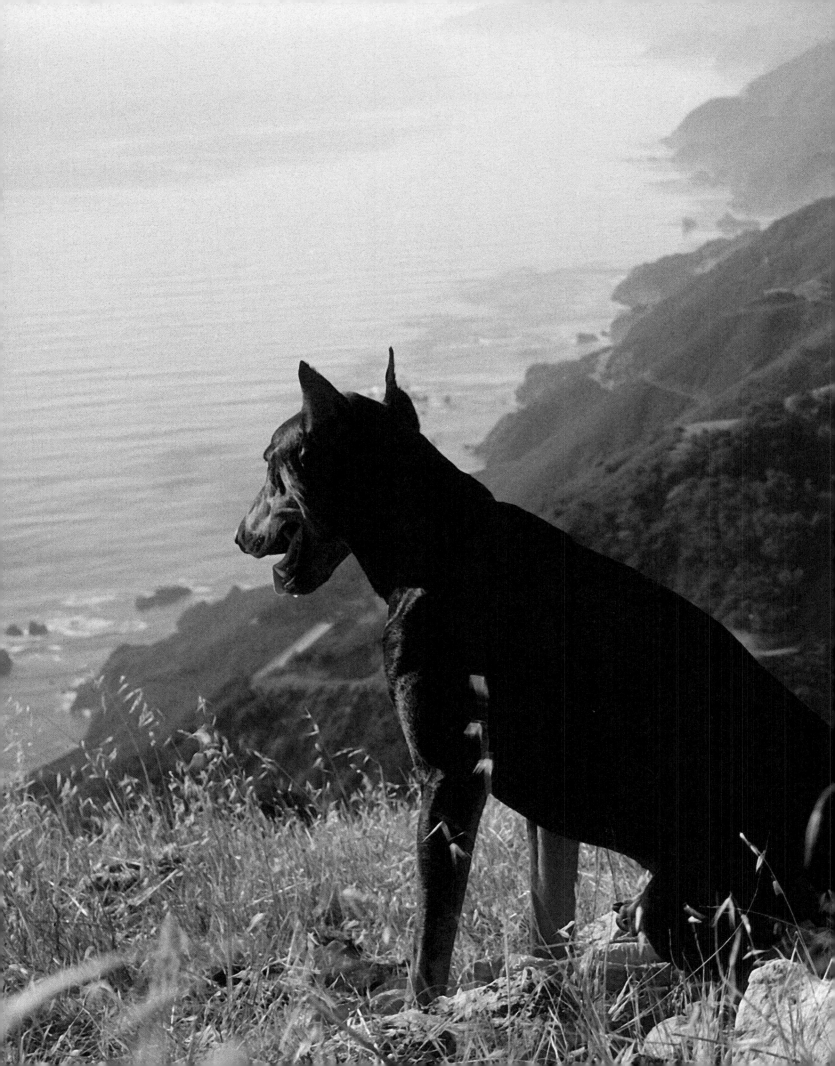

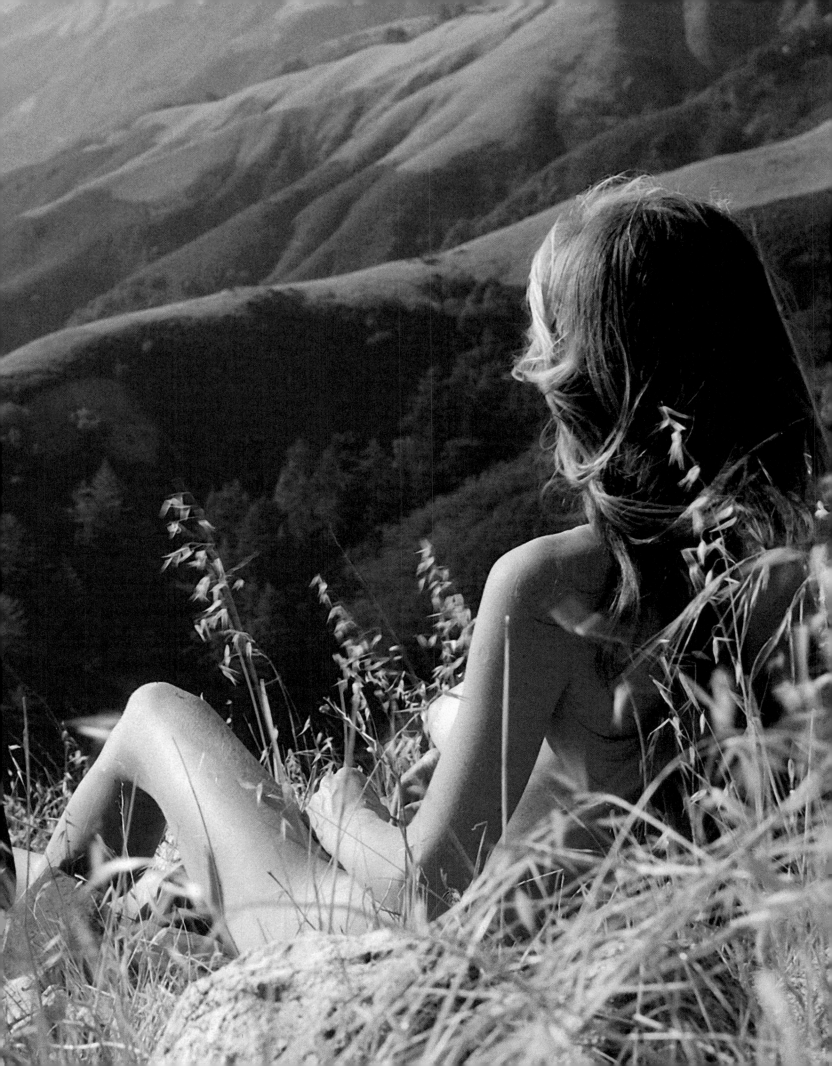

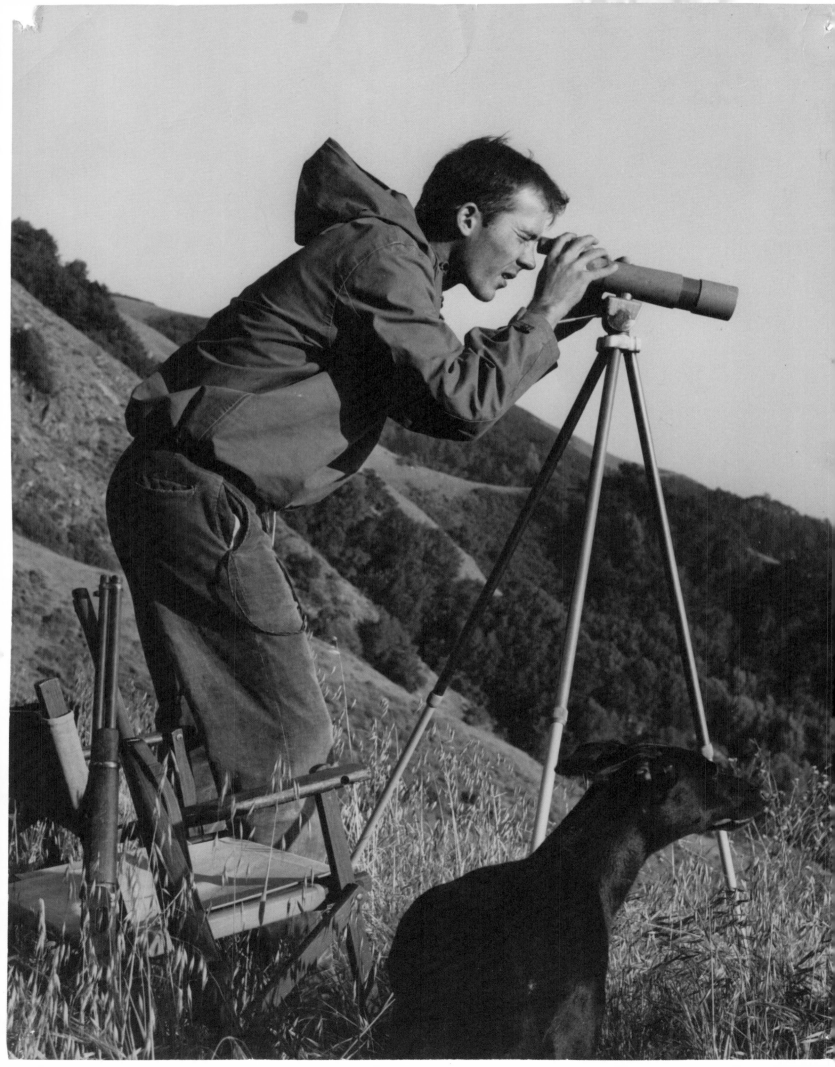

Joan Baez Butchering
~~Slaughtering~~
Hogs – Big Sur
1961

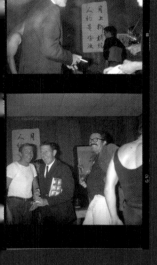

1) Bob Raushenburg (left) of "pop art" fame, and experimental
 composer John Cage (center) whooping it up at the Hot Springs
 Lodge. At right is a man who ~~inibmma~~ claimed to be doing a Big
 Sur piece for the SatEvePost, but he didn't hang around long.
 He was in a cabin next to mine, and suffered what appeared to
 be a minor fit of nerves after I loosed two 12 gauge blasts at
 a thieving coon about three in the morning. He left for L.A.
 the next morning, after lodging a bitter complaint with the
 management. At the time of the photo Cage had just finished his
 "presentation," a mountain of bullshit for sure. But it was
 taken seriously, by a large crowd of Big Sur residents who paid
 $2.50 a head to attend, and I guess that's why Cage and Bob R.
 are laughing.

2) Big Sur residents taking it easy on front porch of old Joan
 Baez homestead at Hot Springs. At left is Jo Hudson, yachtsman
 and big-game hunter; at right is John Clancy, now a SF lawyer.
 Sitting is Sandy, then private secretary and constant companion
 to Big Sur's most prominent thug.

3) More of same. Foreground is the thug -- in this case, the author.

4) An atmospheric shot in the "baths" at Hot Springs

5) Sandy and lawyer Clancy relax in front yard of prominent thug.
 This is a good, sort of typical Big Sur shot.

6) Author and wife enjoy after-breakfast newspaper in their
 Big Sur front yard. In the good old days.

 Note-- I can send some boar-hunting shots, and will if you
 insist, but would rather save them for upcoming Boar-hunting
 story.

 see enc, contact
 without negative

 ✱ home-made bed
 is behind camera — tough

058

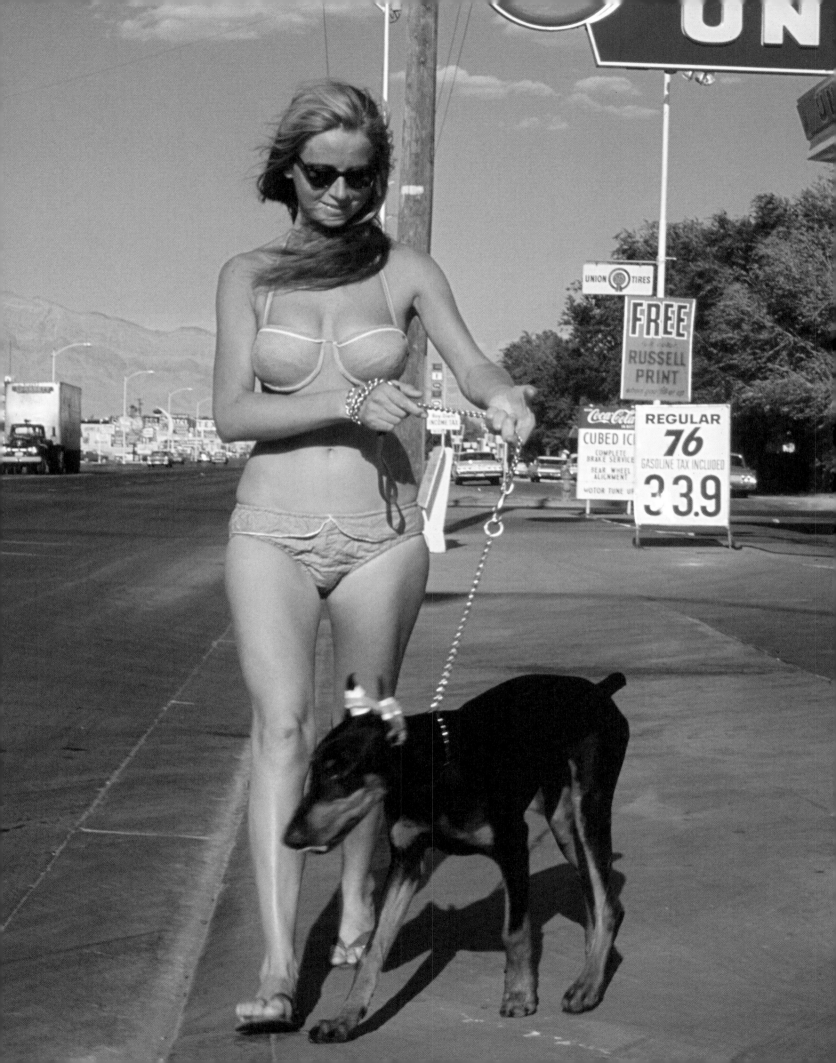

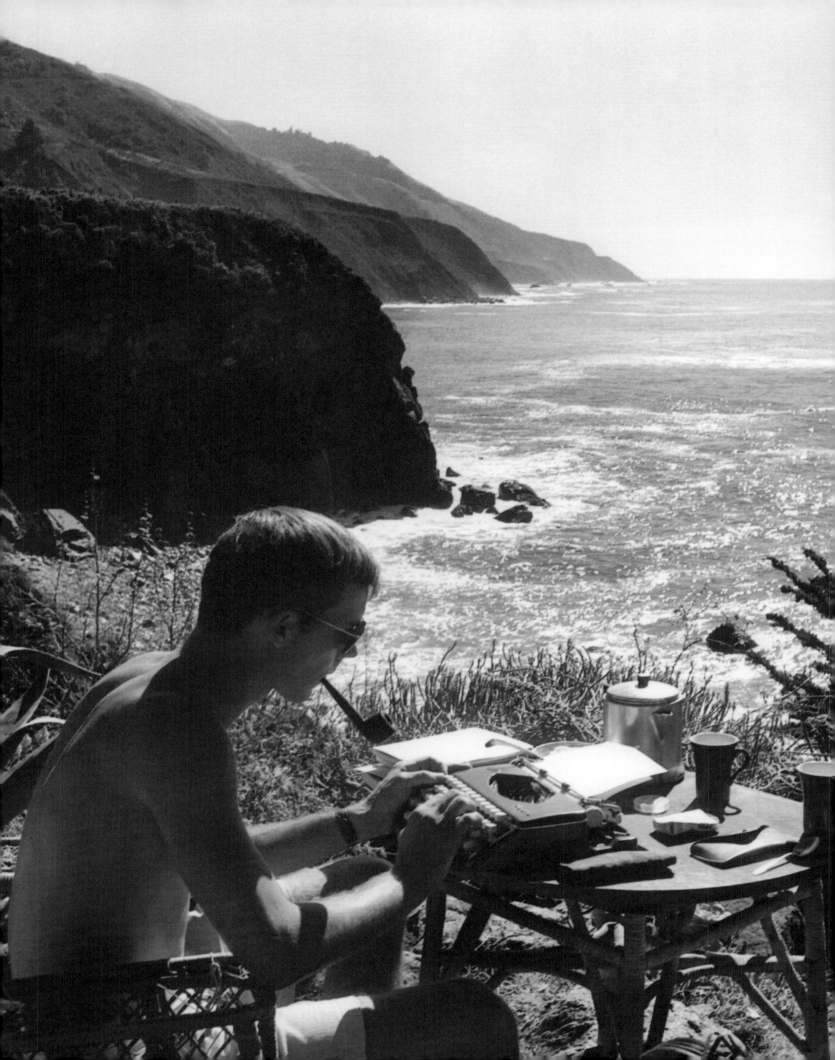

"I am surrounded by lunatics here, people screeching every time I pull a trigger, yelling about my blood-soaked shirt, packs of queers waiting to do me in, so many creditors that I've lost count, a huge Doberman on the bed, a pistol by the desk, time passing, getting balder, no money, a great thirst for all the world's whiskey, my clothes rotting in the fog, a motorcycle with no light, a landlady who's writing a novel on butcher-paper, wild boar in the hills and queers on the roads, vats of homemade beer in the closet, shooting cats to ease the pressure, the jabbering of Buddhists in the trees, whores in the canyons, Christ only knows if I can last it out."

from "The Proud Highway", letter from Big Sur, August 4, 1961

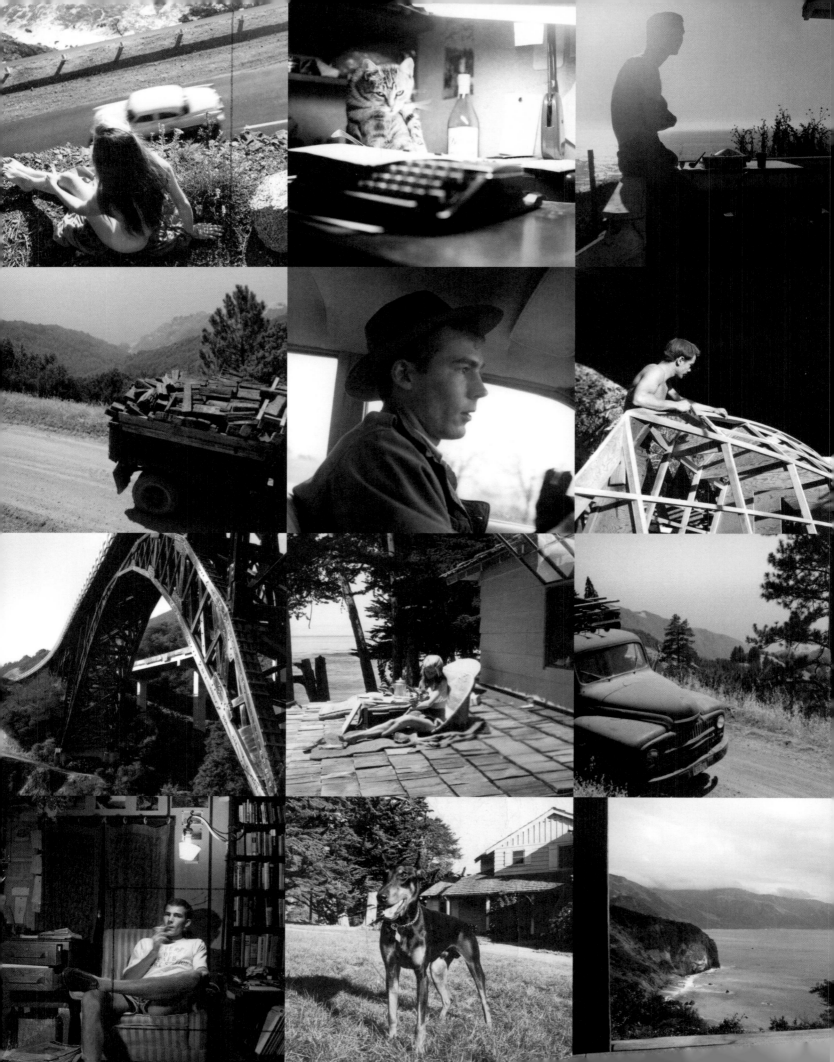

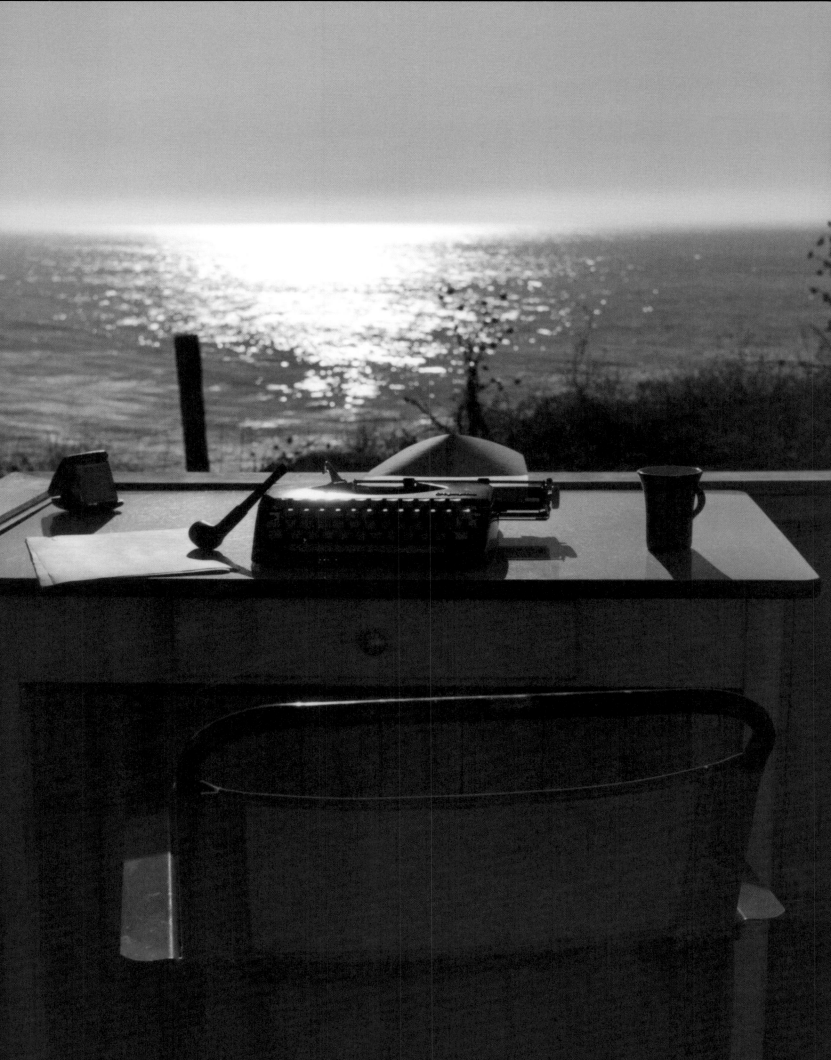

ROAD TRIP TO TIJUANA

Photographs circa 1960

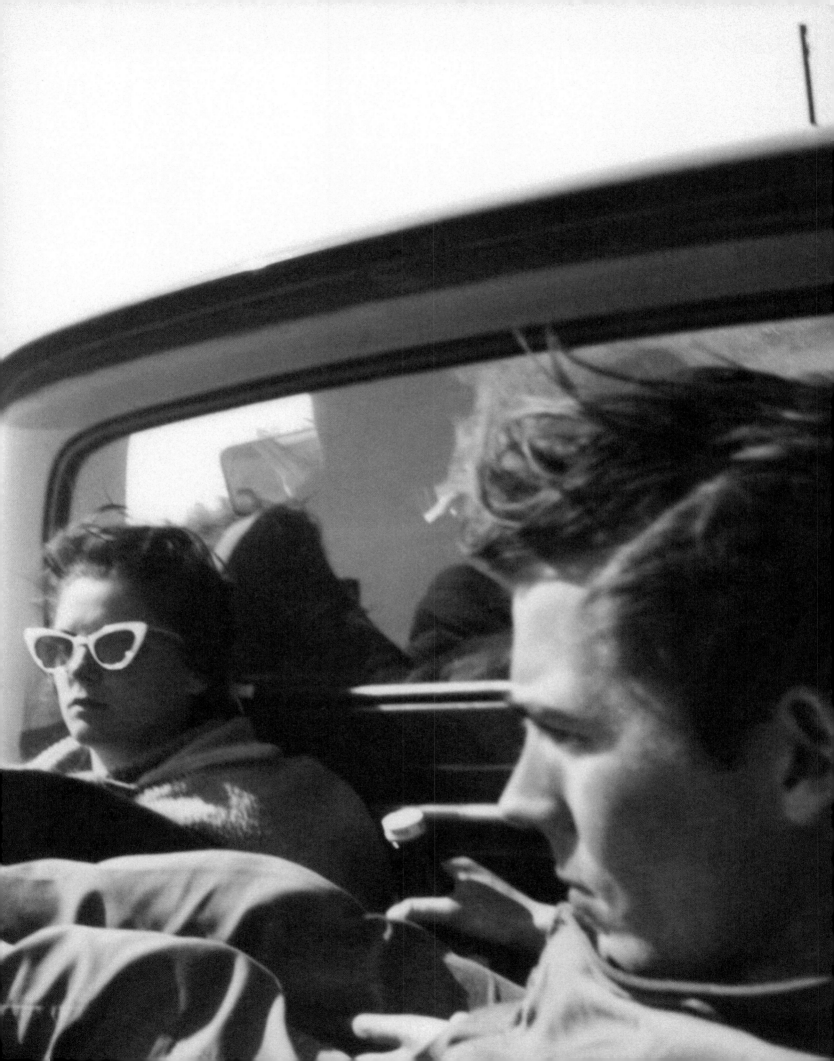

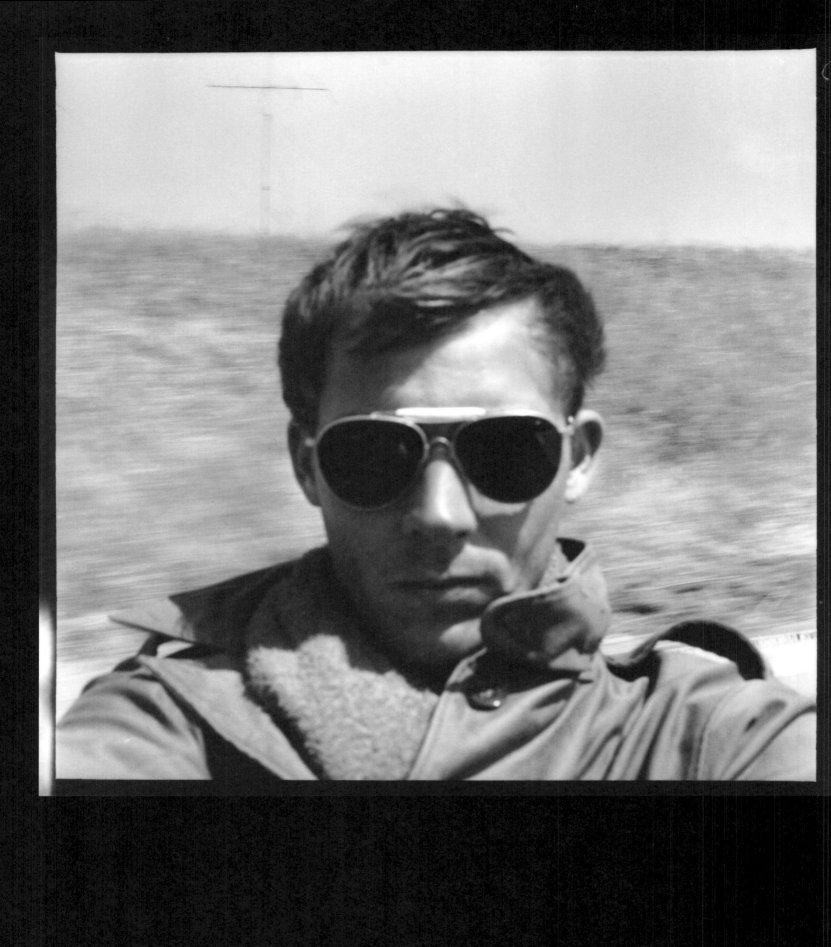

"Monday I'll ride my thumb south—Carmel, Monterey, Big Sur, and maybe all the way to Los Angeles. Whatever happens will be all right. I do not care and have no plans. All I want to do is get out on the coast and see the California everybody talks about. I'll go as far as the rides take me, sleep on the beach (sleeping bag), and beg, if necessary, for food."

from "The Proud Highway", letter to Sandy Conklin, Oct. 28, 1960

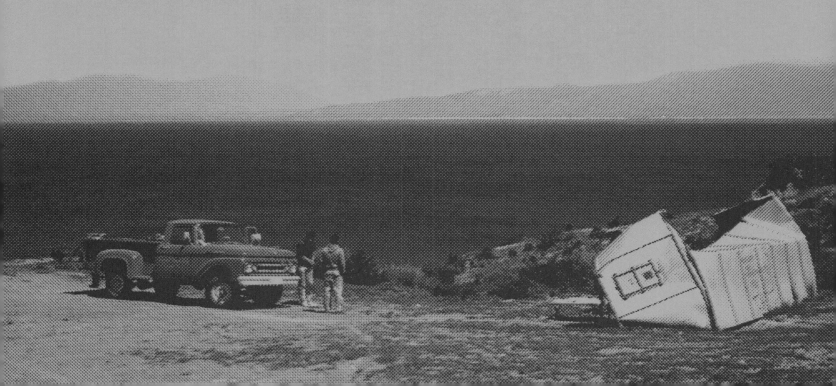

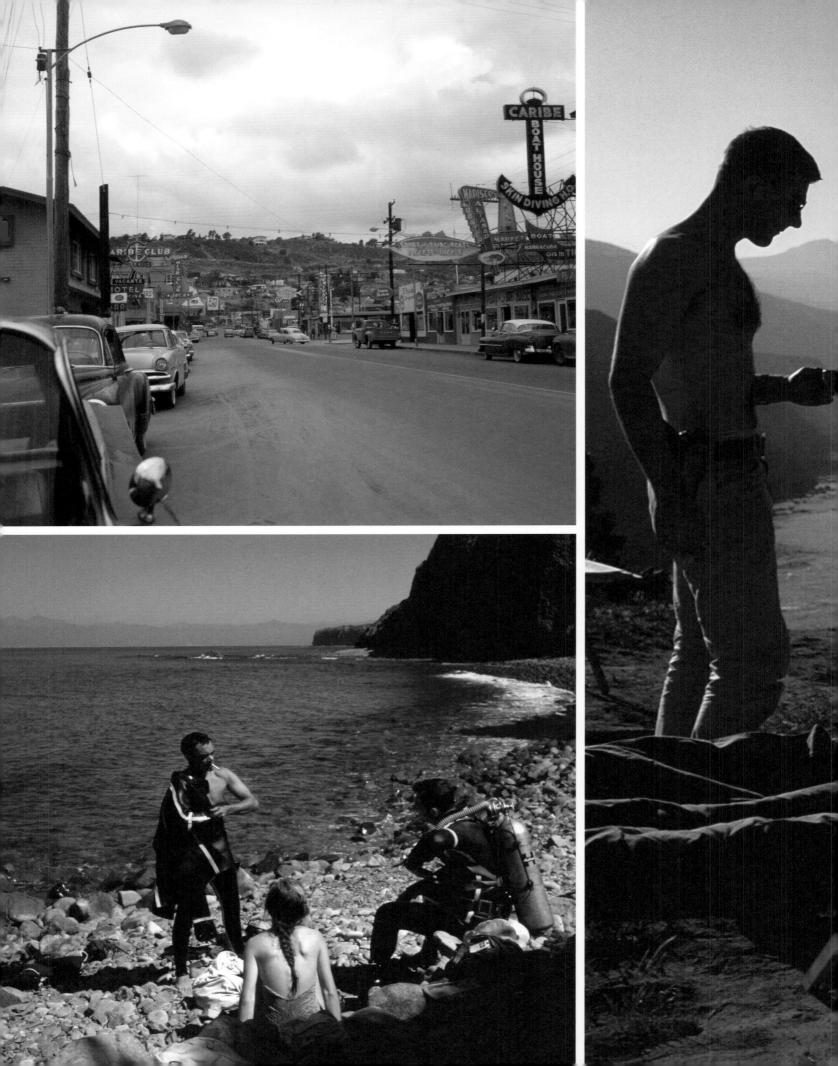

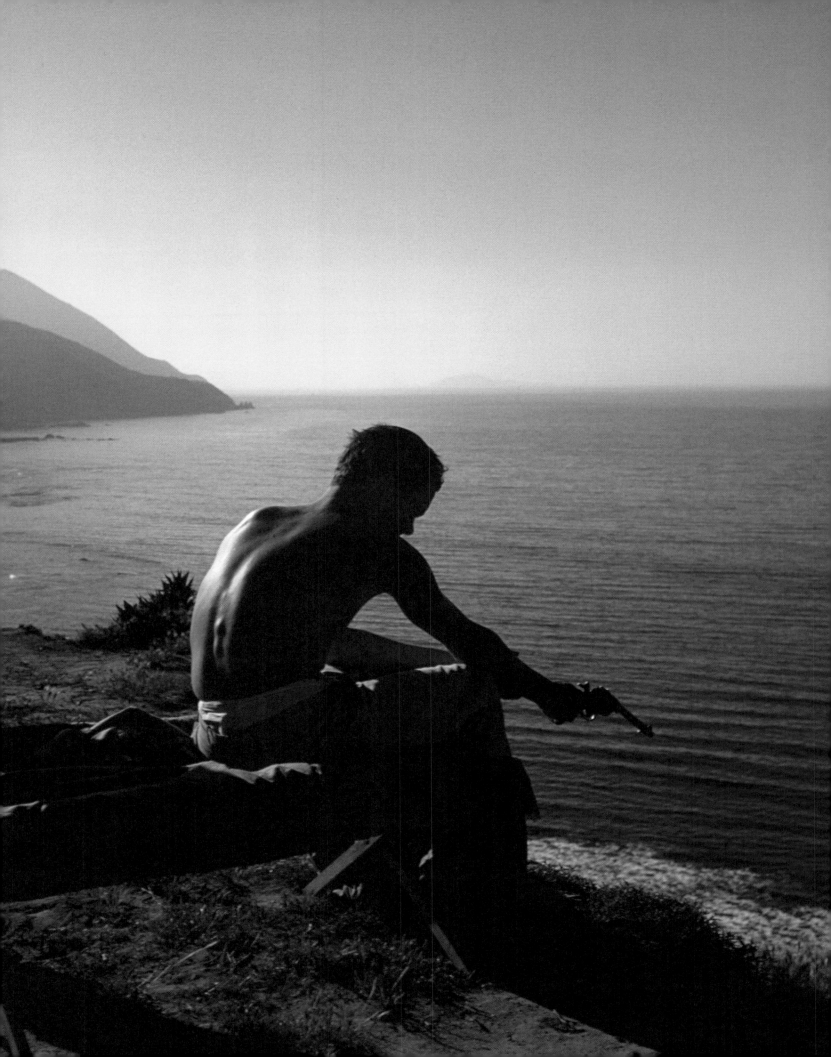

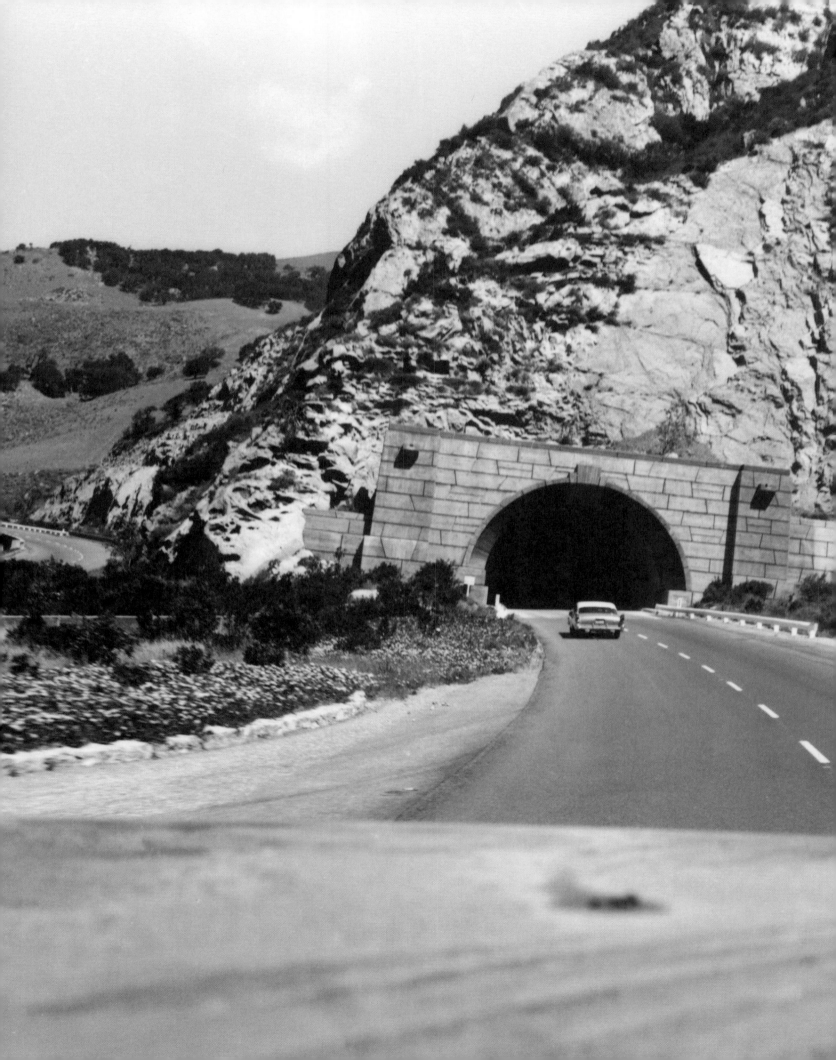

KENTUCKY

Photographs circa 1961–1963

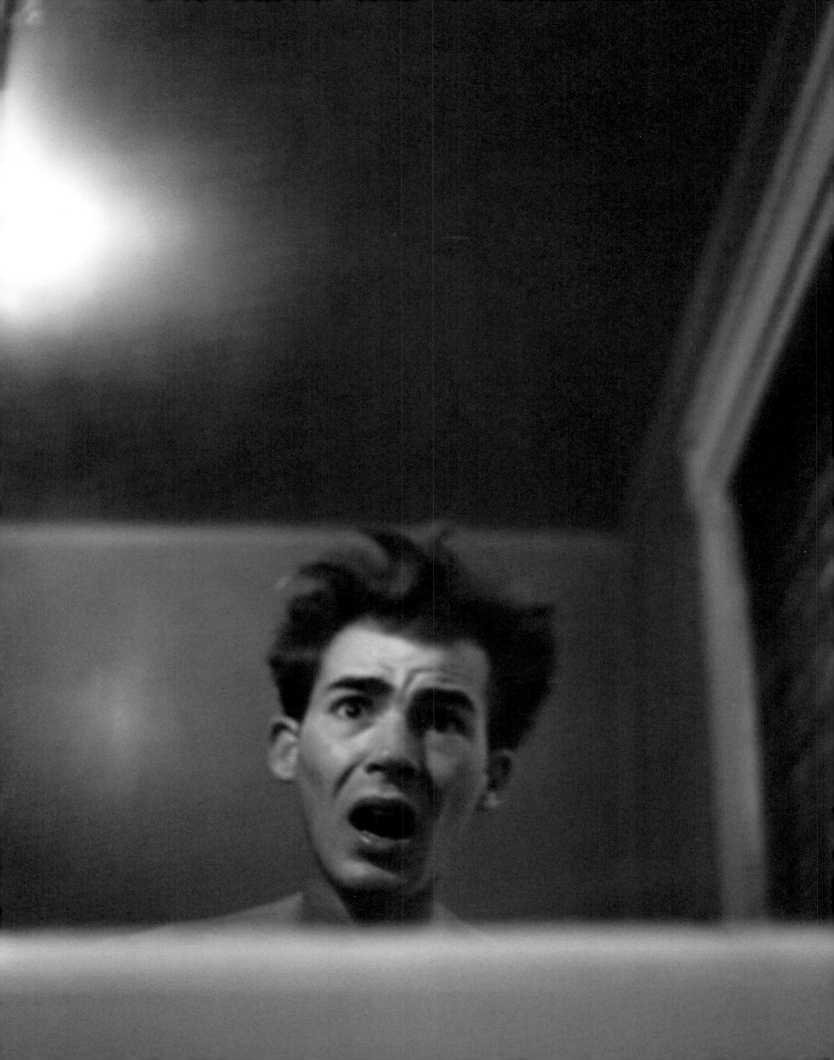

"Through the empty house floats the voice of Joanie Baez, an eerie sound to my restless ears. I expect to look out the window and see the hills or the ocean—but no dice, only Ransdell Avenue, grey and wet and full of so many ghosts and memories that I get the Fear whenever I go outside."

from "The Proud Highway", letter from Louisville, November 10, 1961

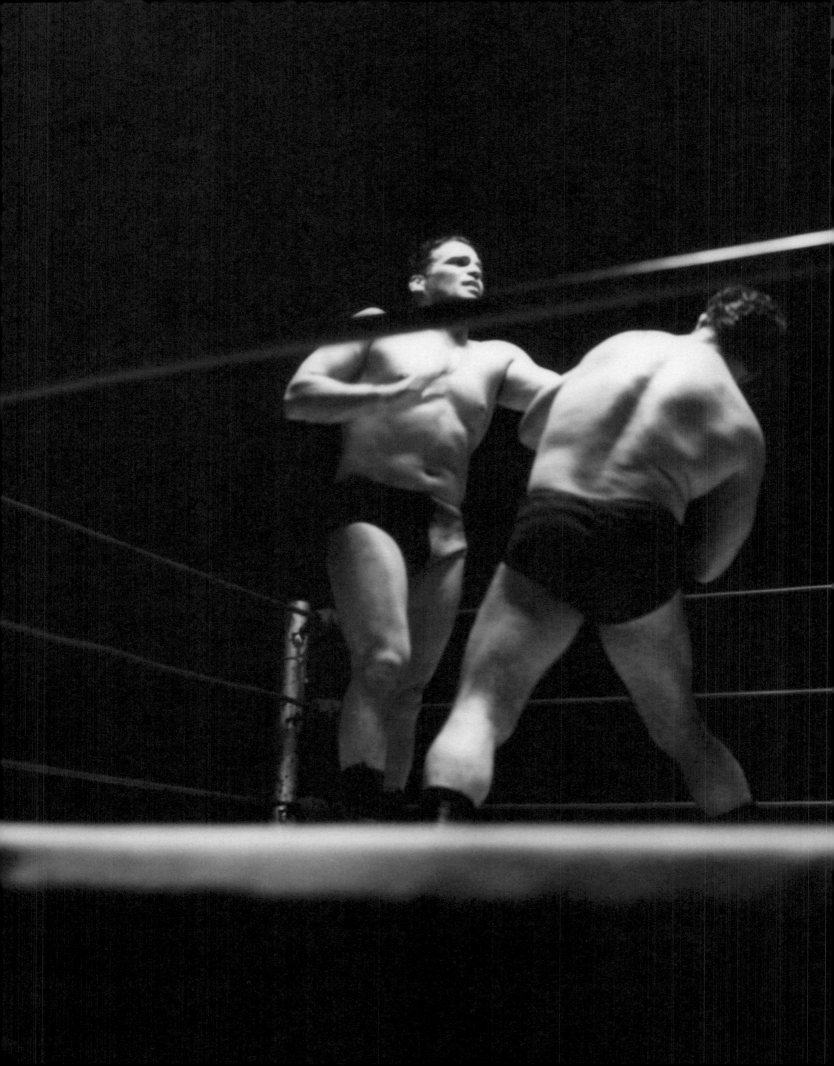

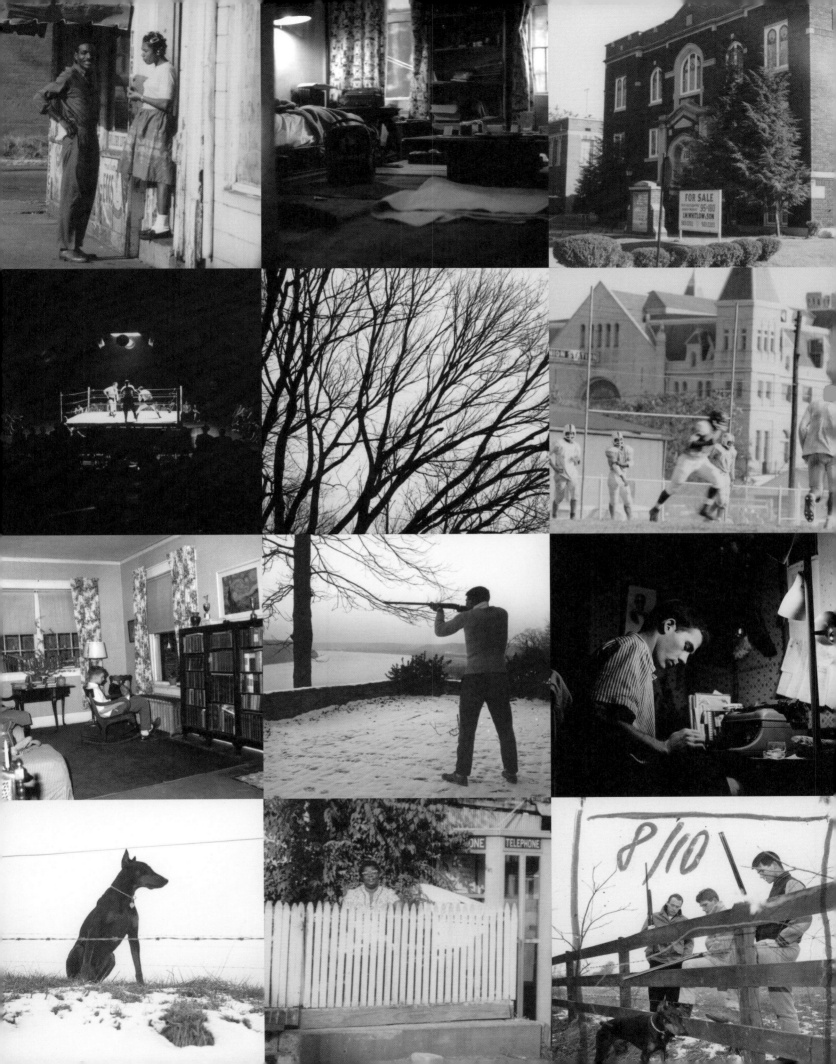

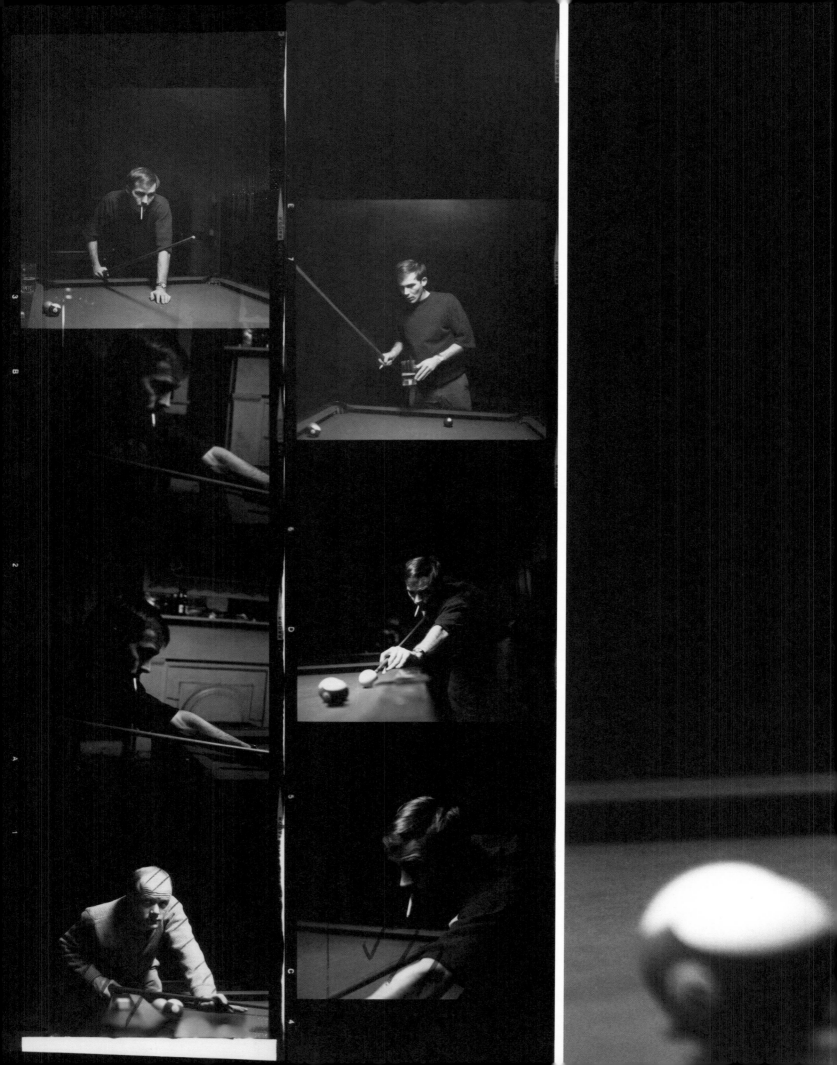

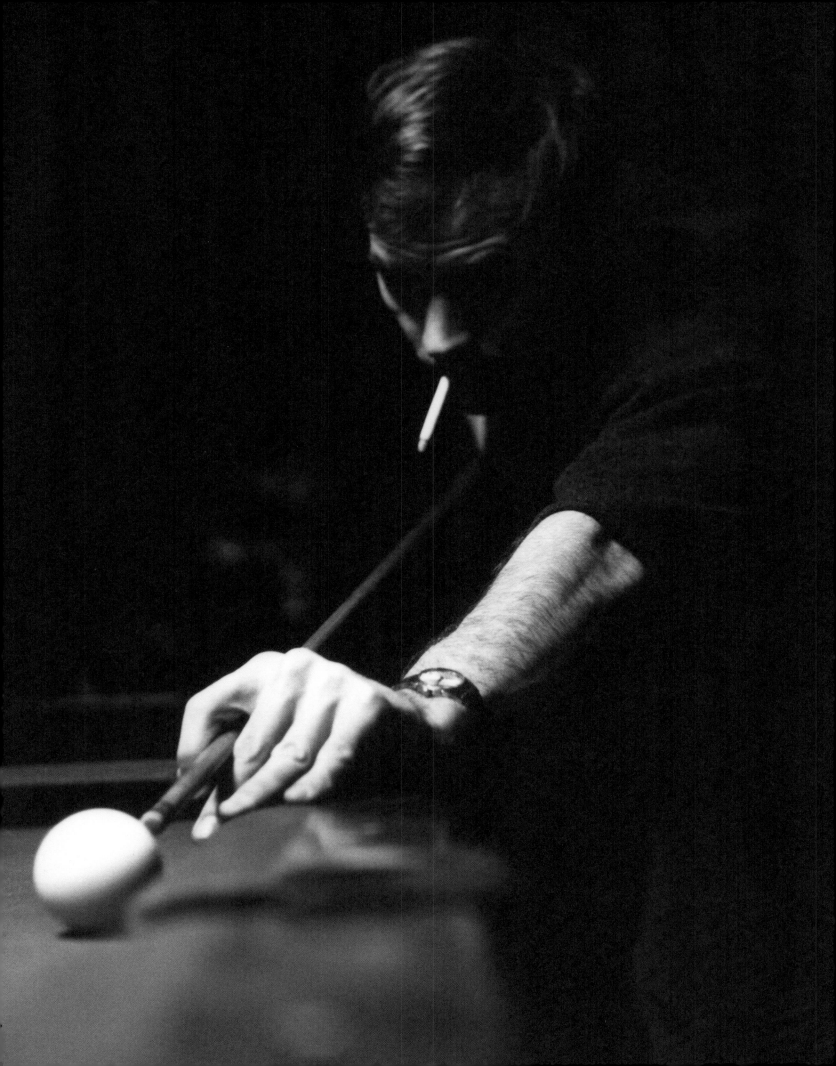

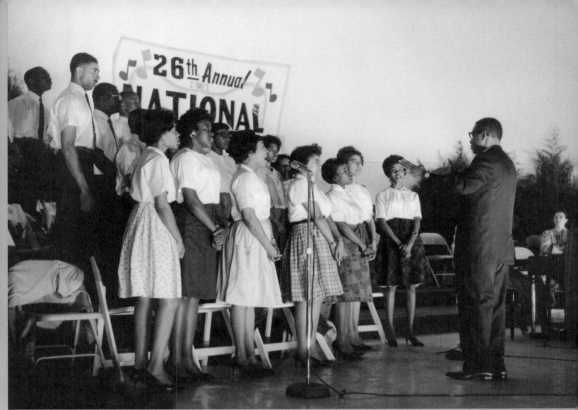

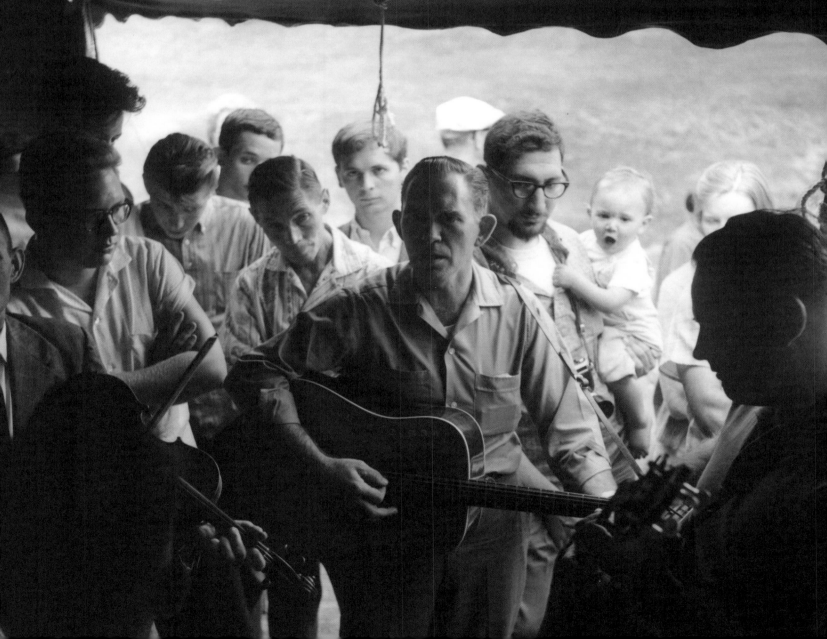

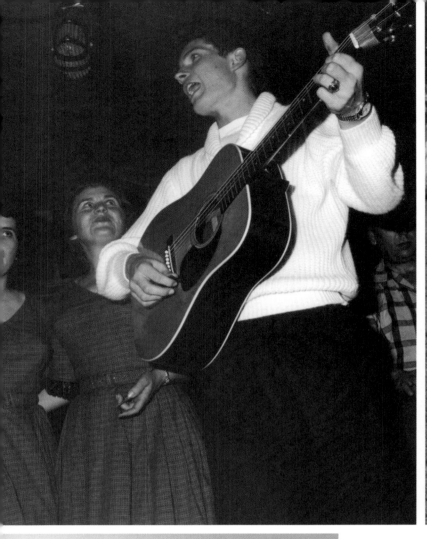
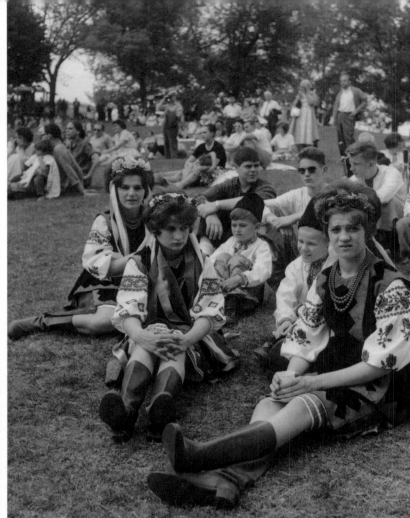
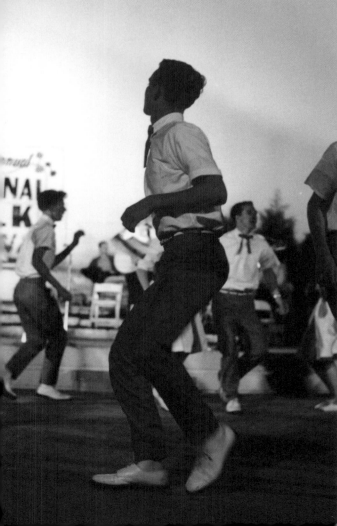
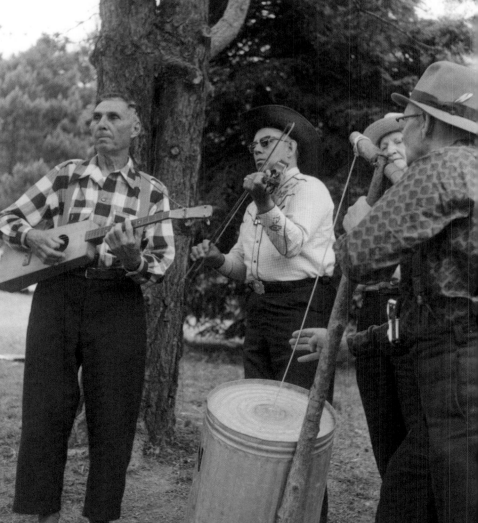

"Music has always been a matter of energy to me, a question of Fuel. Sentimental people call it Inspiration, but what they really mean is Fuel. I have always needed fuel. I am a serious consumer. On some nights I still believe that a car with the gas needle on empty can run about fifty more miles if you have the right music very loud on the radio."

from "Kingdom of Fear", Hey Rube, I Love You, 2003

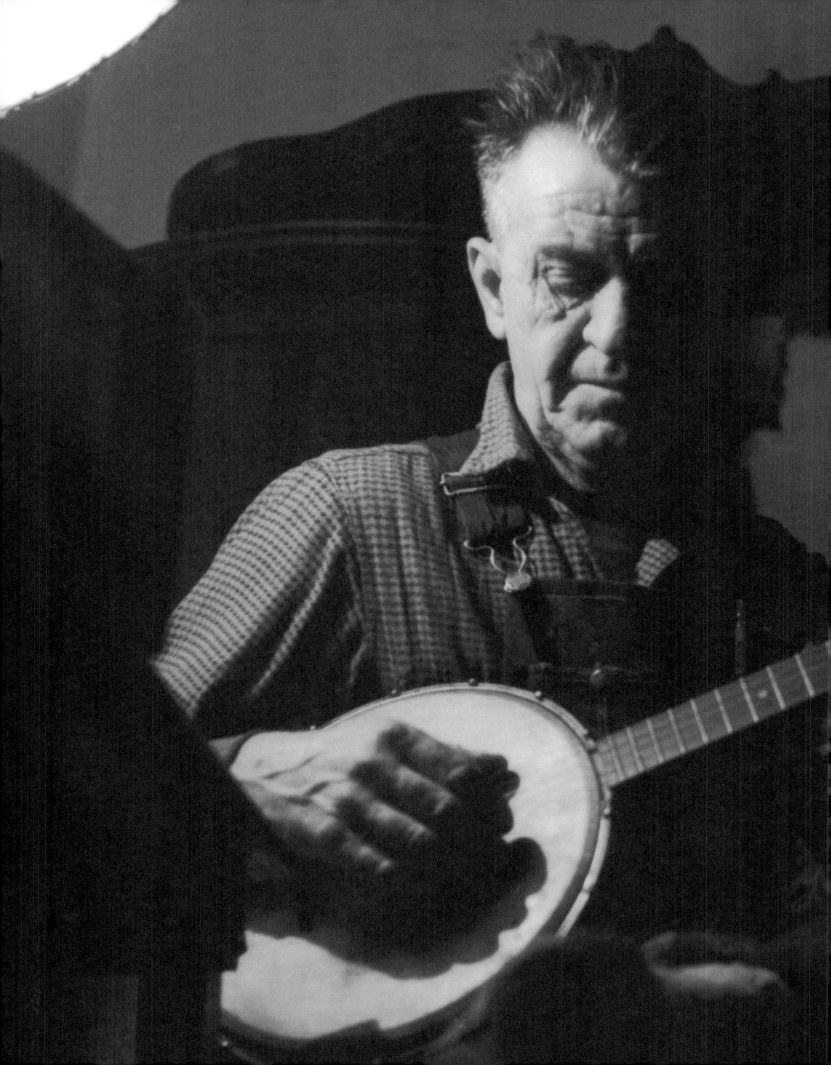

SOUTH AMERICA

Photographs circa 1960s

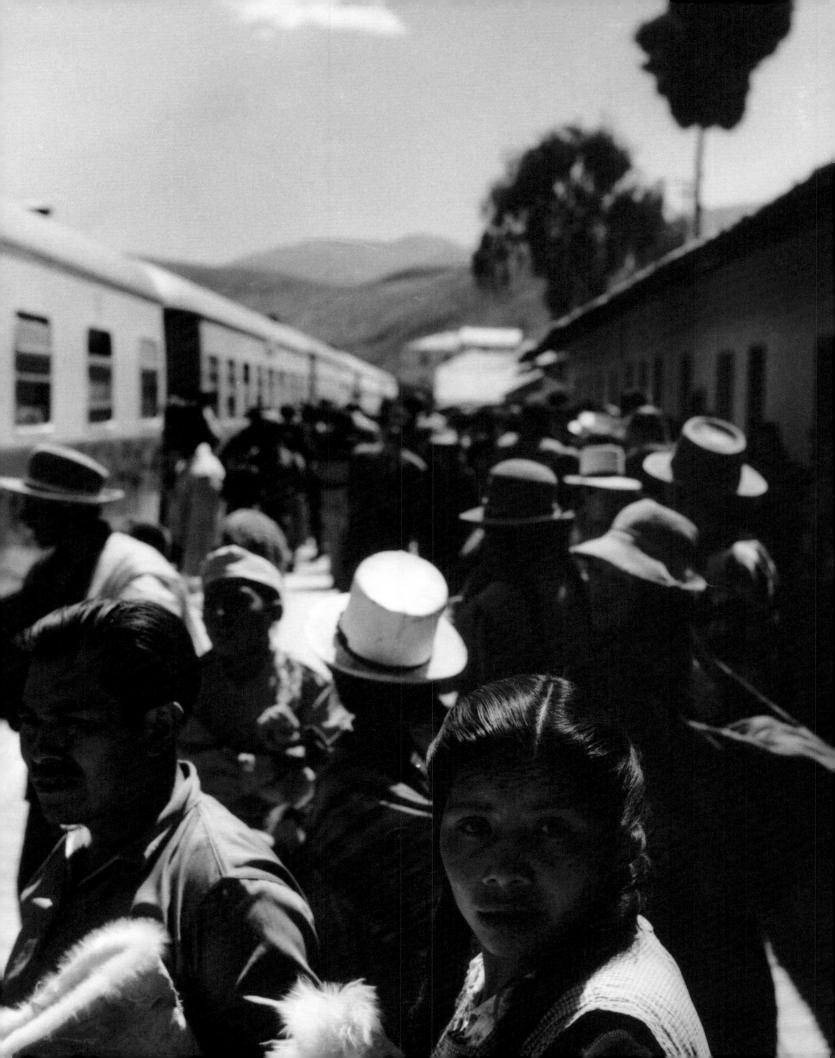

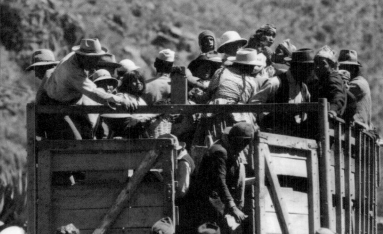

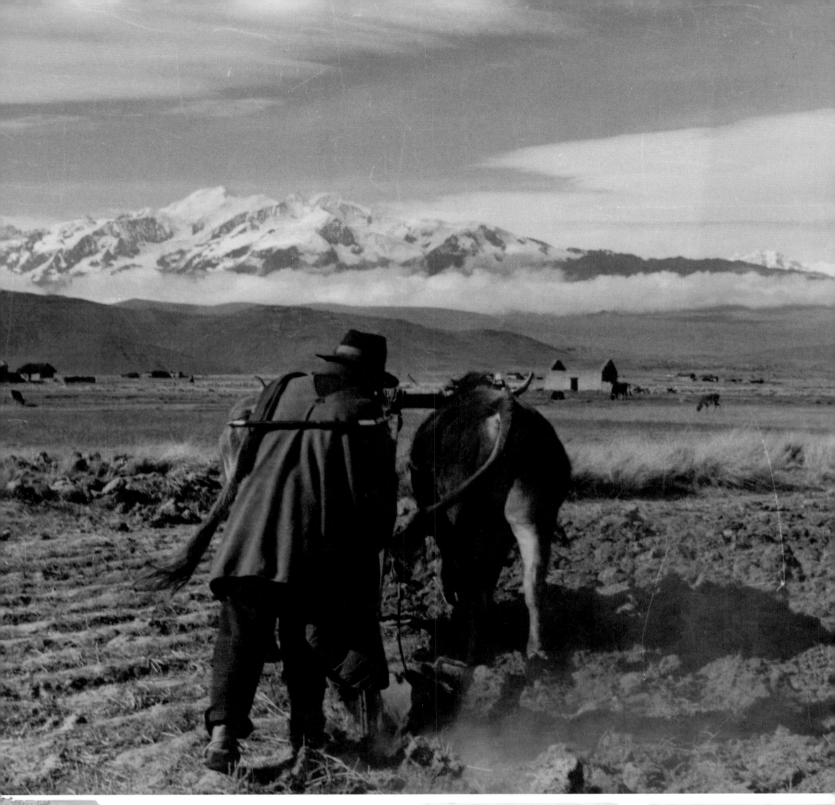

PARAGUAY photos H.S. Thompson

selected negs & contacts:

Plaza-X roll

If it is new to me, I'd run 53 and 54 (on the 35mm roll)
Since it isn't, I can only urge this, and say that these two strike
me as being the most descriptive and representative of the lot.
They were both taken in downtown Asuncion; the man sleeping on the
bench is in Plaza Independencia, and the girl with the parasol is
waiting on Calle Palma. The Stroessner poster says, "Only
Coloradismo will save Paraguay." The Colorado party is
the party of Stroessner, although a large faction of it has split
off; they are still for Coloradismo, but not for Stroessner.

53 and 54 are two more scenes from the Plaza -- typical, etc.

On the Tri-X roll:

26 and 27 are pretty worthless shots from a Liberals Autentico
meeting in Villarica. 28 is a taxi in Villarica, and 25 is another
shot of the same Liberal meeting

from the 120 roll:

one shot of typical Plaza Independencia scene, other of the trolley
and attendant Stroessner posters on Calle Palma

PERU (Cusco) Aug '62 Gev27 (36) ASA 50 Roll 243
H.S. Thompson photos

1 -- indian woman

1 -- beggar

3 -- shots of in Plaza de Armas, historic center of Cusco, site of
 Gonzalo Pizarro's beheading, etc.

5 -- various indians

5 -- Cusco street

6 -- shooting toward street through cafe window, contrast indians
 outside & "cholos" (mestizos) inside life on glass
 of pane

1 -- indian group waiting for bus

6 -- Cusco streets, indians, children (showing hills)

14 -- indians near & in Central market, Cusco; streets, faces.
 This is the market for indian goods; alpaca sweaters, ponchos,
 hats, etc.

PERU (Cusco & Chincheros) Aug '62 Gev27 (36) ASA 50 Roll 244
H.S. Thompson photos

8 -- ragged indian (typical) sitting on porch of Hotel Cusco (the
 sort. Tourist hotel, setting. He has no idea a camera is near
 or he would be asking for "monies." Nor does he have any
 concept of the world inside the hotel, except that people come
 out of it, stare, and give monies. The indians in Cusco are
 hopelessly corrupted by the many years of tourism. 99% of them
 are confirmed, aggressive beggars.

25 -- typical indian village named Chincheros, 2 hour drive from
 Cusco, much-touristed, all indians have to be paid for photos
 (one or two soles per shot if you pay the going price; soles
 is 4 cents.) Most of these shots are unpaid with telephoto
 lens; the indians pose hopelessly at the sight of a camera.
 The farms around the village are run on the old Inca communal
 system (communist, some call it), wherein the families help
 each other work the land, and share the profits. Name of
 village is Chincheros.

PERU (train from Cusco to Puno on Lake Titicaca) Roll 245
H.S. Thompson Aug '62 Gev27 (36) ASA 50

All shots taken from train or at stops along way. Indians beside
tracks, llama, passengers setting off for & foods, truckful of indians
(normal rural transportation, often 60 in a truck. Yeah, 60.)
Peruvian sierra landscapes, shots of engine

Station at Siouani, sort of a midway point -- mostly faces

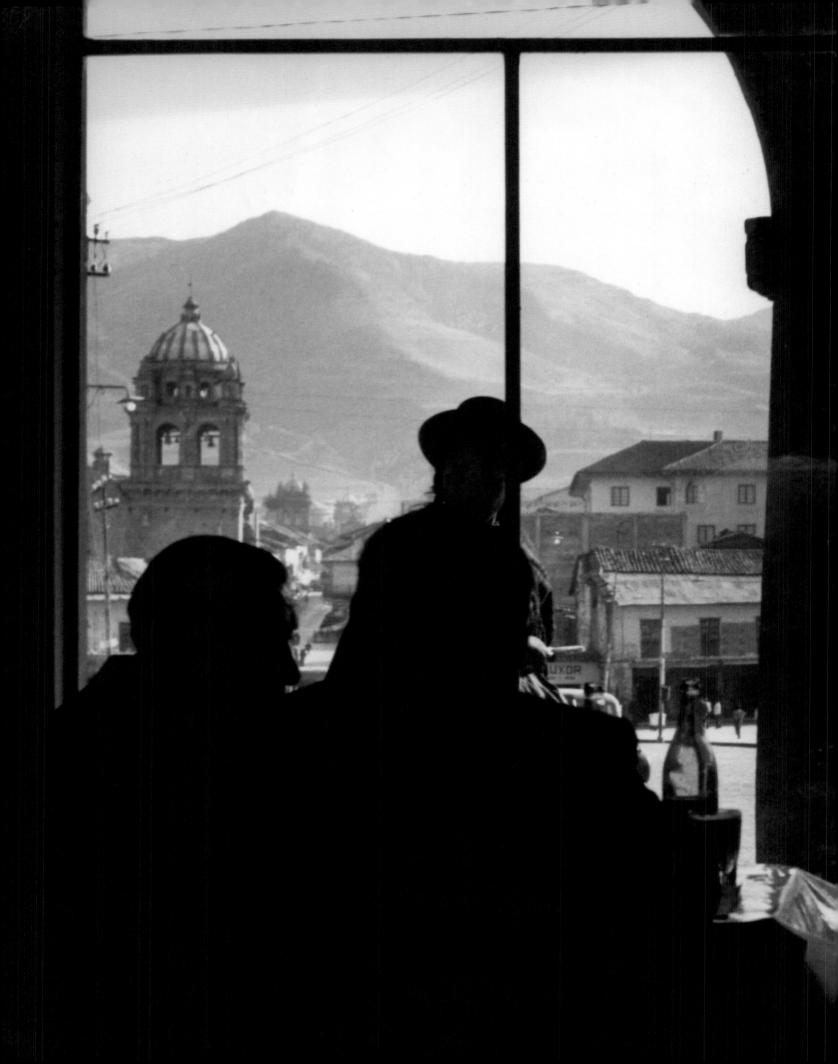

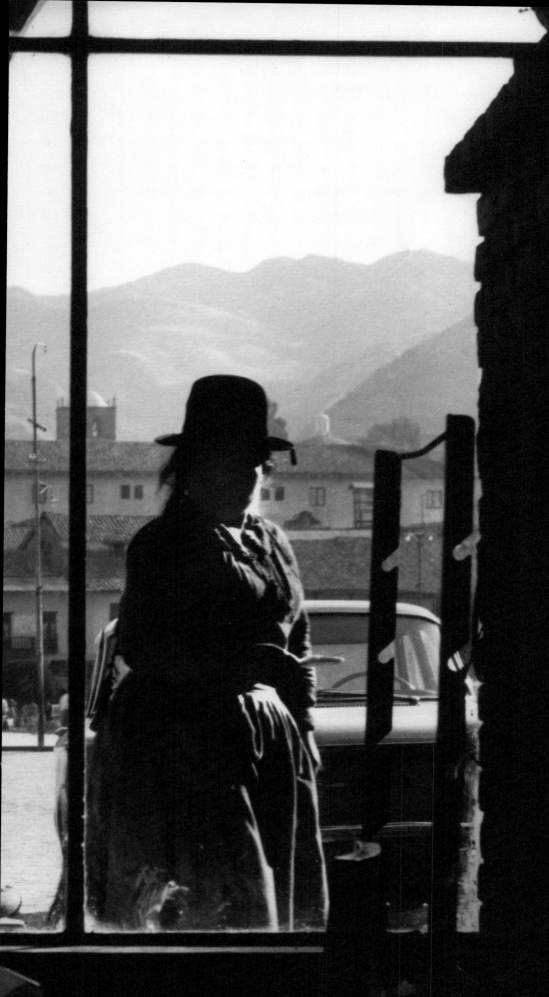

"I am down to 10 U.S. dollars
but have developed a theory which
will go down as Thompson's Law
of Travel Economics. To wit:
full speed ahead and damn the cost;
it will all come out in the wash."

from "The Proud Highway", letter en route to Bogota, May 26, 1962

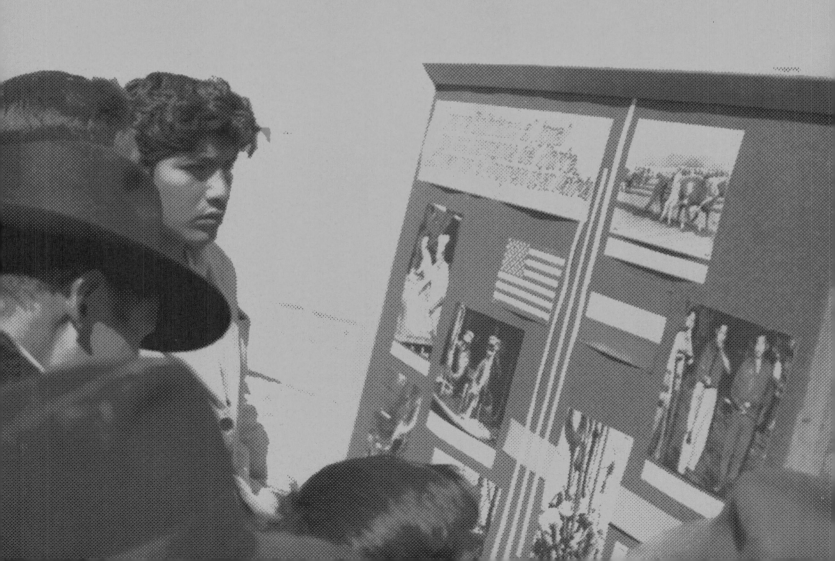

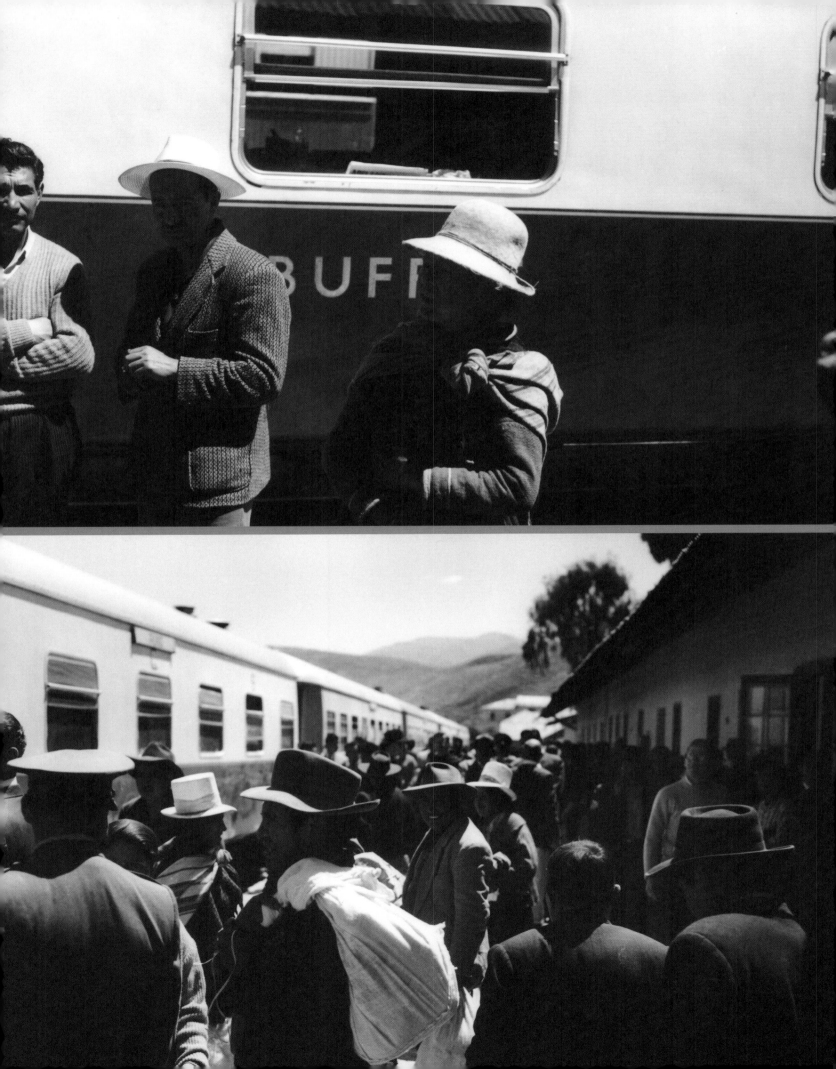

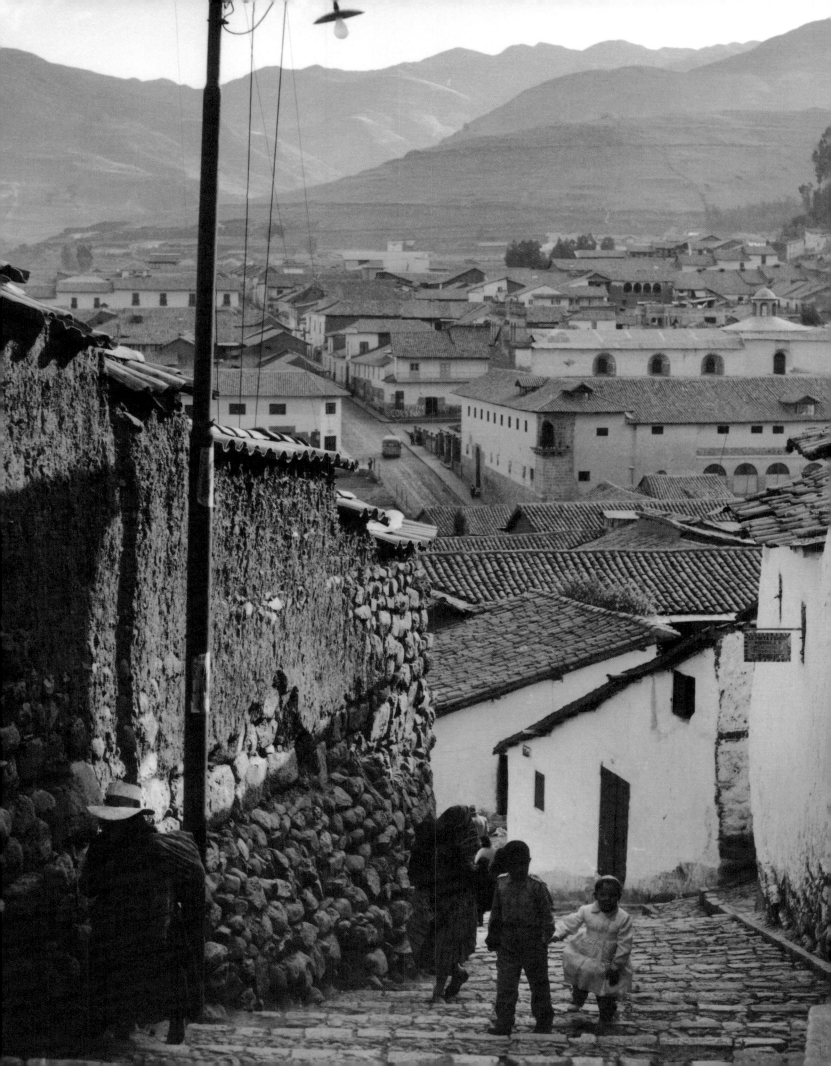

"I am trying to get out of here on the jungle train, but the hotel won't take my check so I can't leave. I just sit in the room and ring the bell for more beer. Life has improved immeasurably since I have been forced to stop taking it seriously."

from "The Proud Highway", letter from La Paz, Bolivia, August 18, 1962

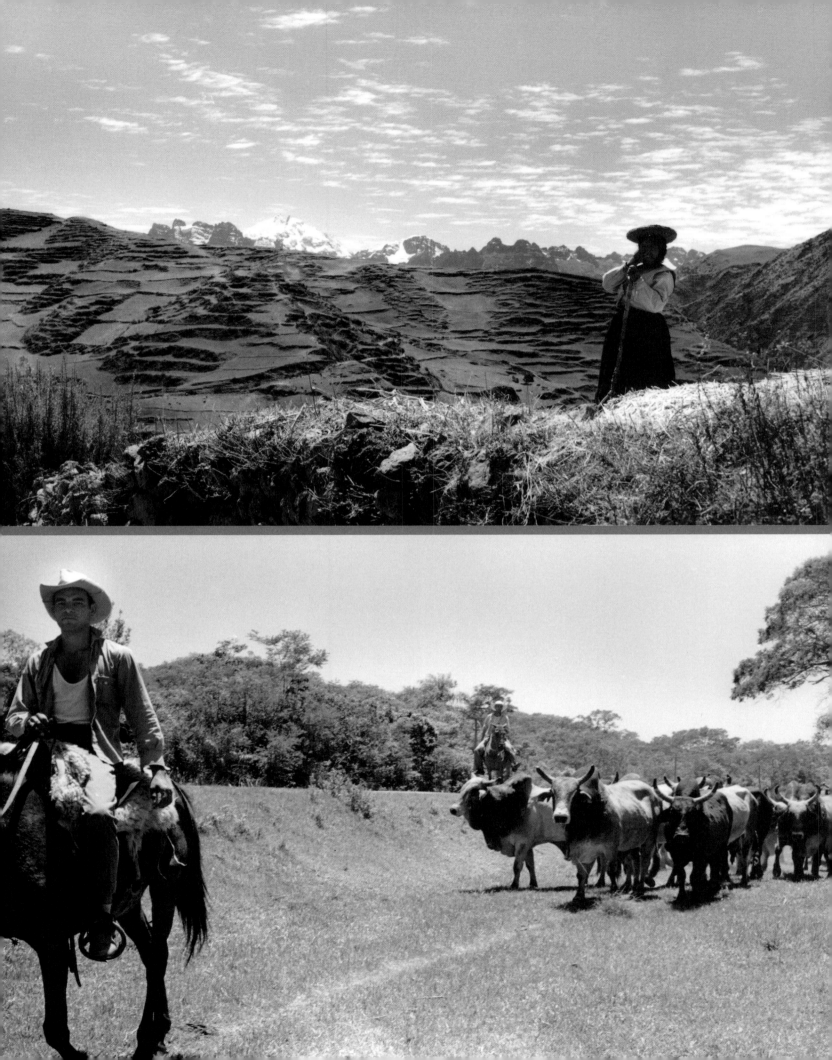

PLUMAS
COUNTY
FAIR

National Observer assignment, 1963

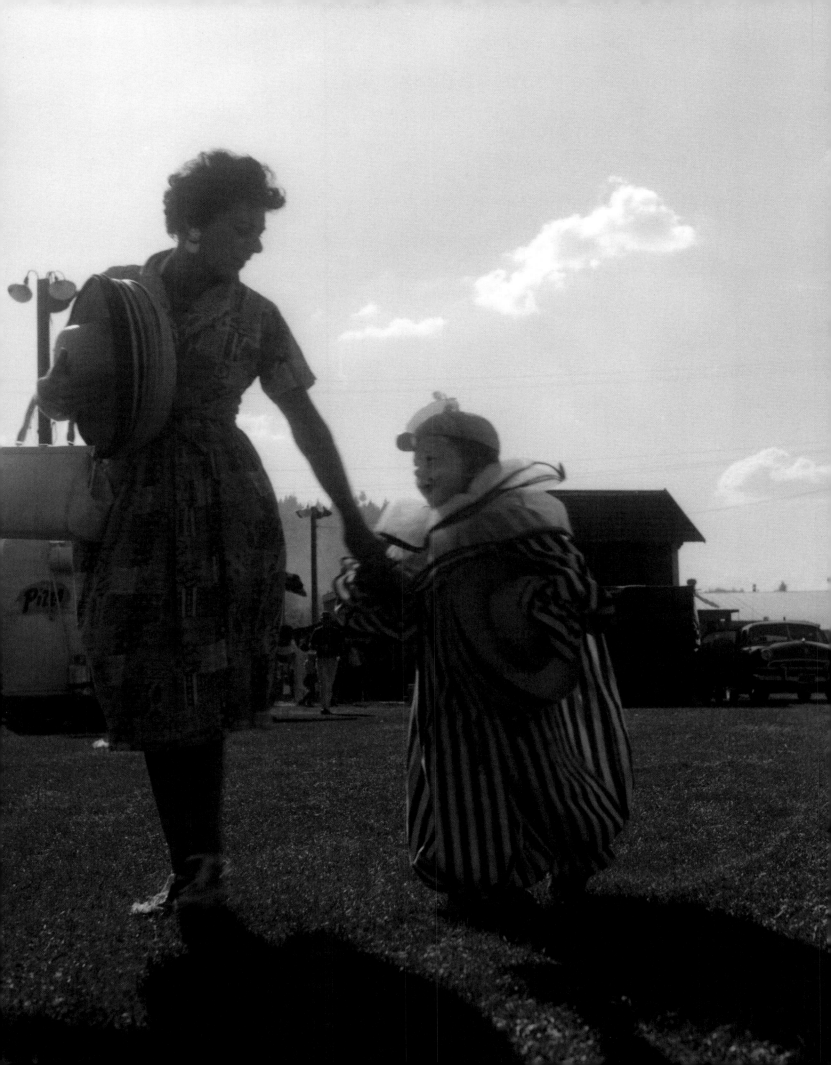

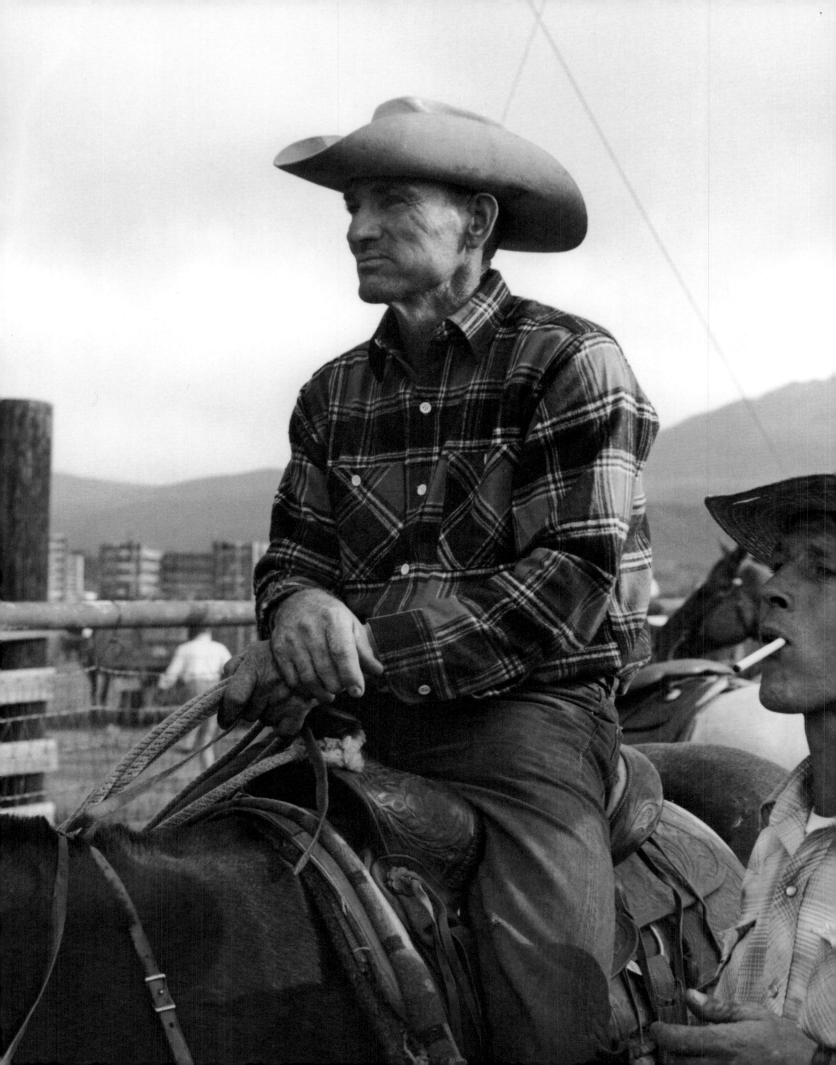

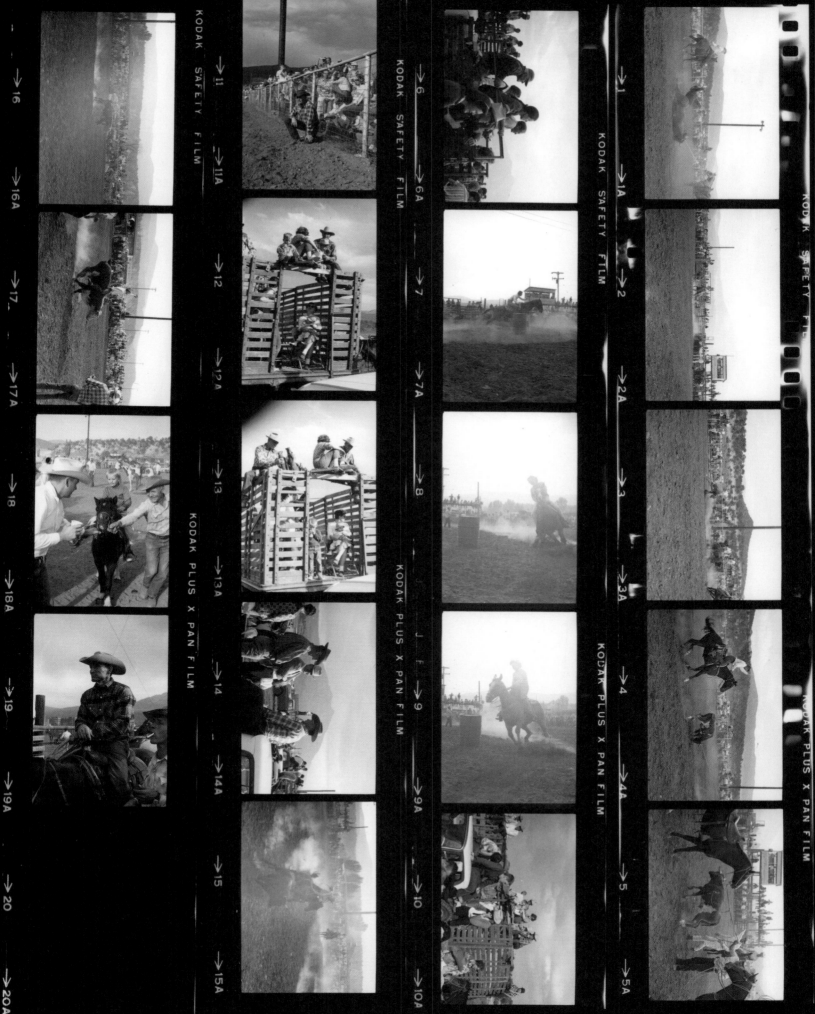

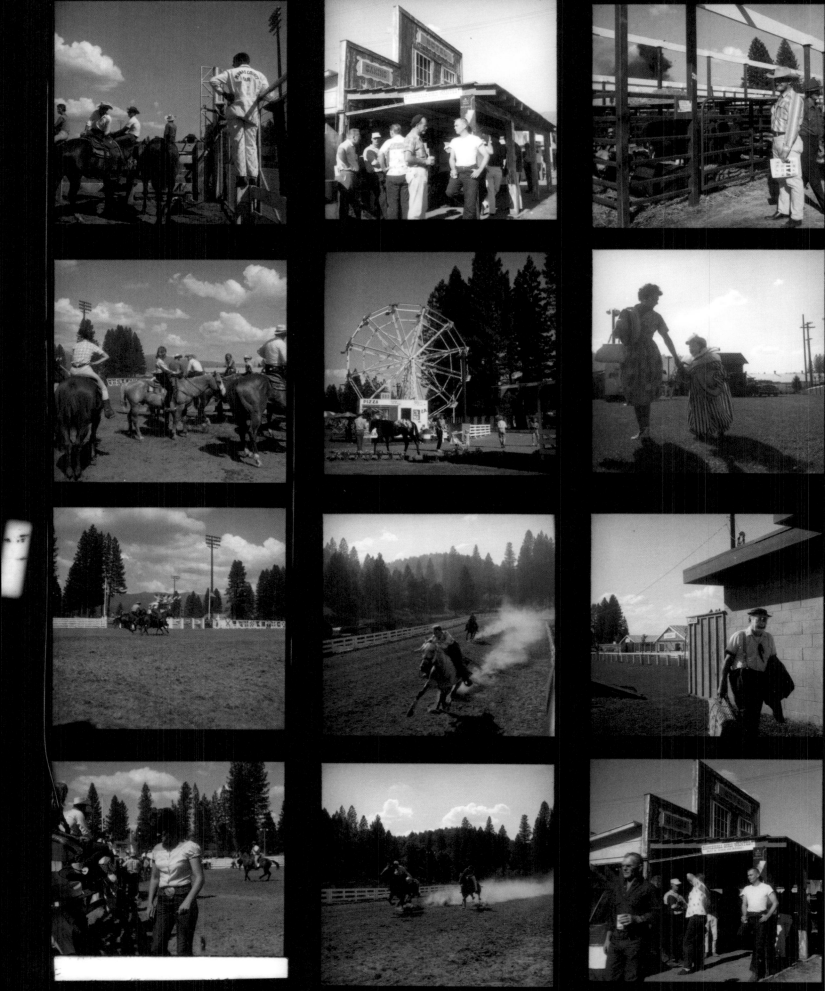

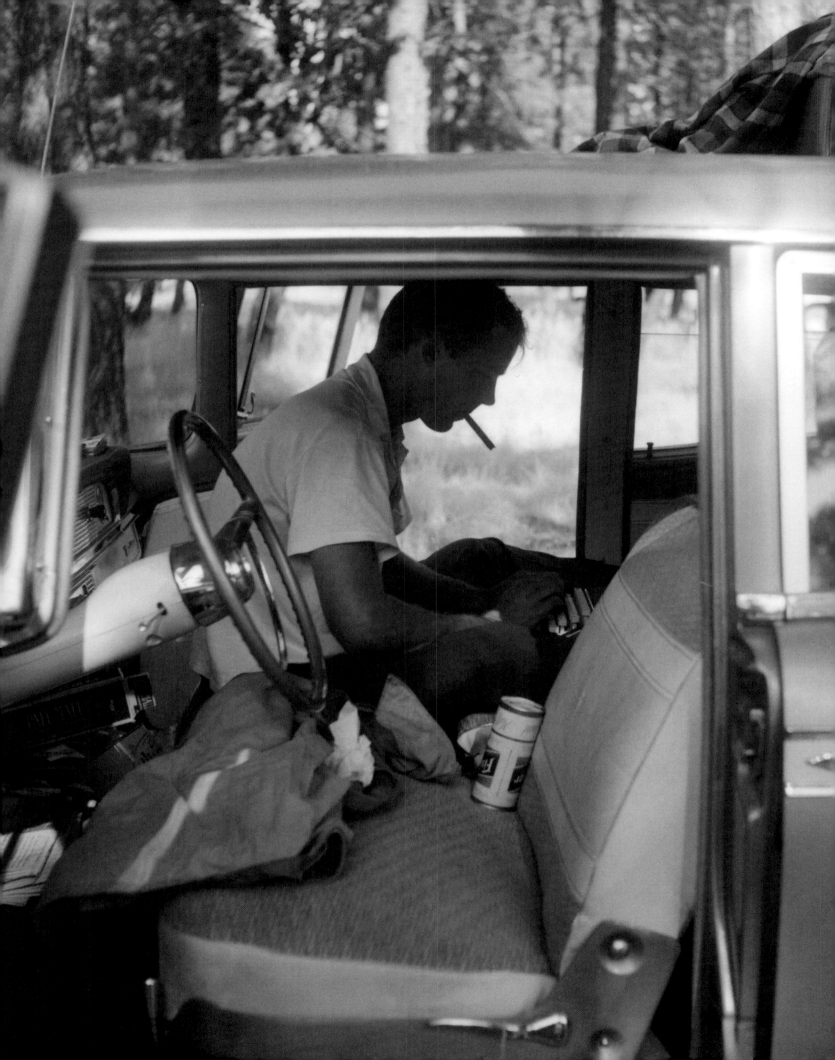

HELL'S ANGELS

Photographs circa 1965

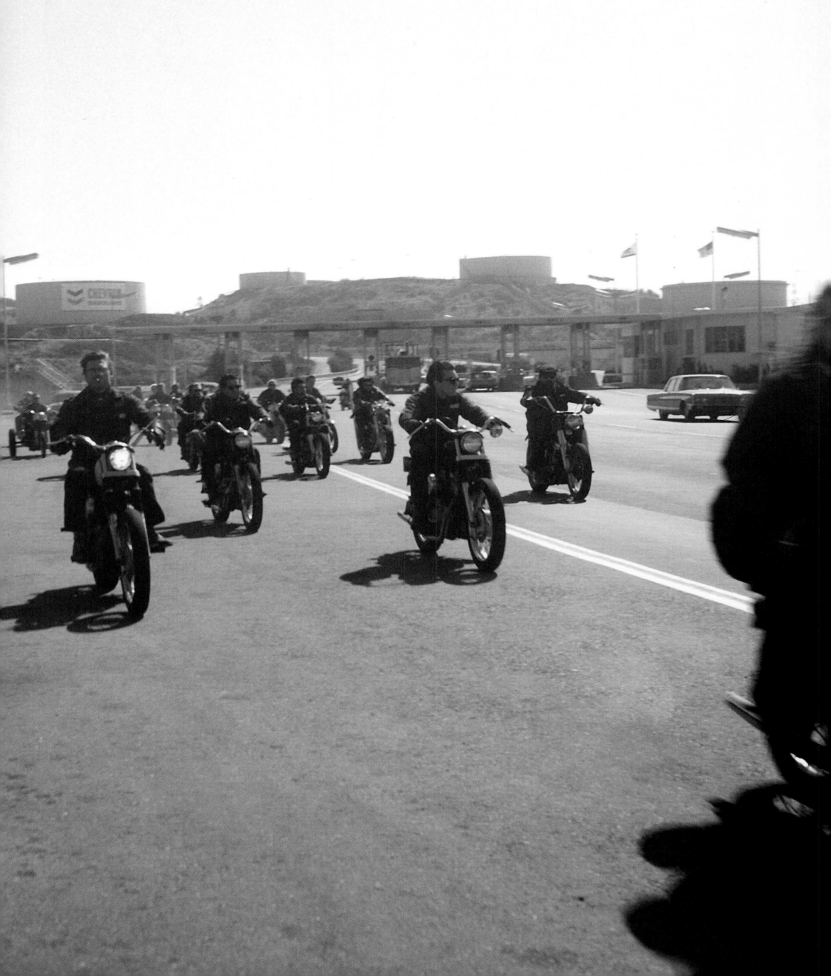

HELL'S

ANGELS

HUNTER S. THOMPSON

The California motorcycle
gang. The real life Wild Ones

ALLEN LANE THE PENGUIN PRESS

HELL'S ANGELS HUNTER S. THOMPSON

'I had never seen people this strange. In a way it was like having a novel handed to you with the characters already developed."

from "Songs of the Doomed", "Hell's Angels: Long Nights, Ugly Days, Orgy of the Doomed…" March 1990

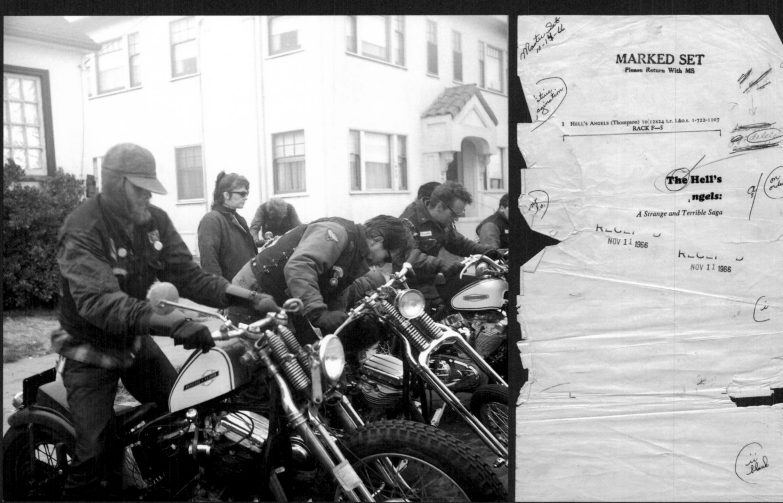

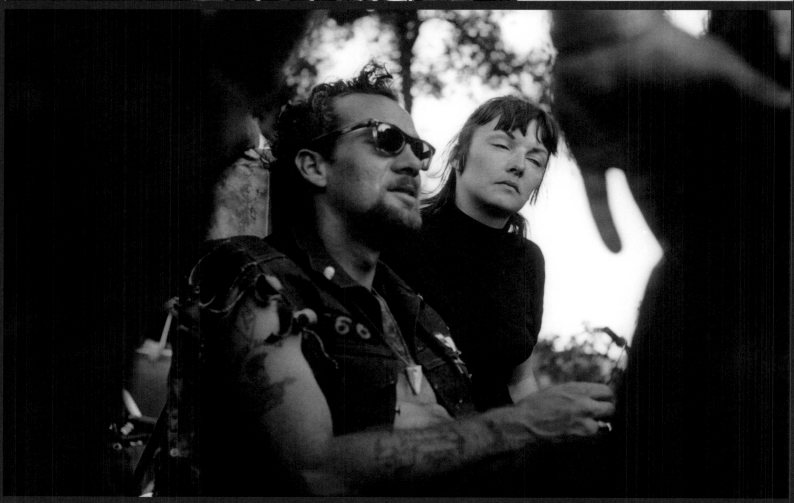

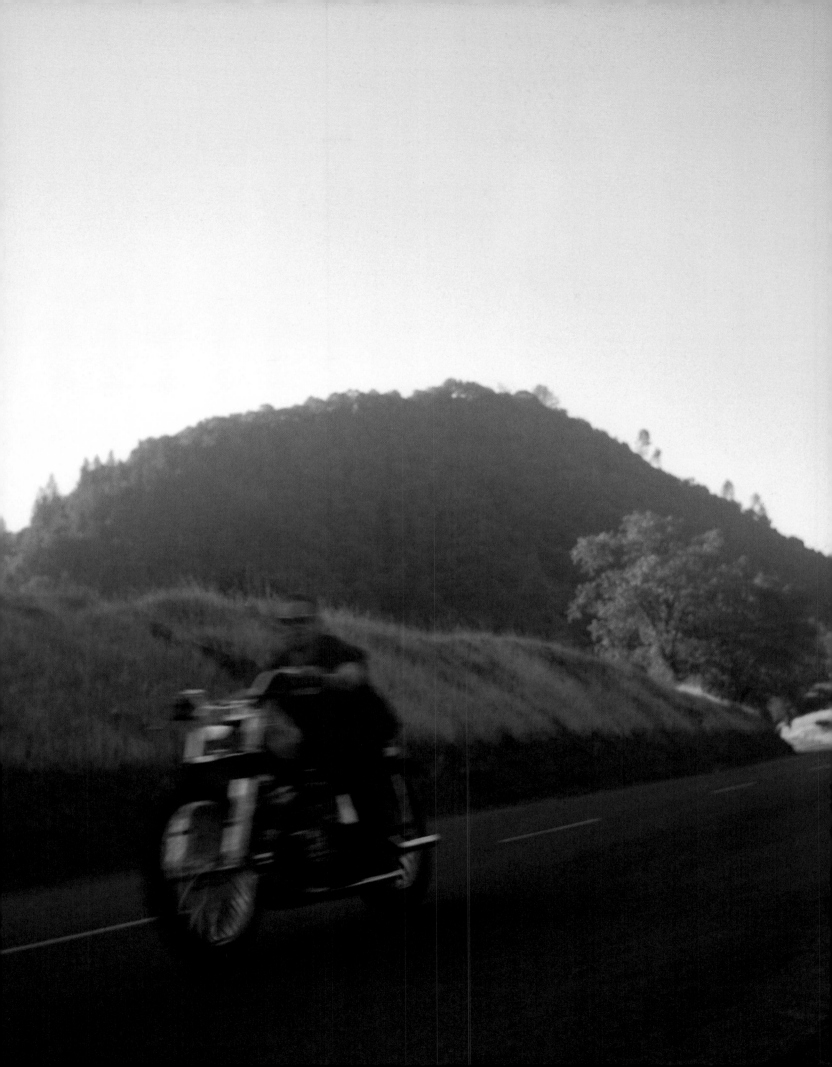

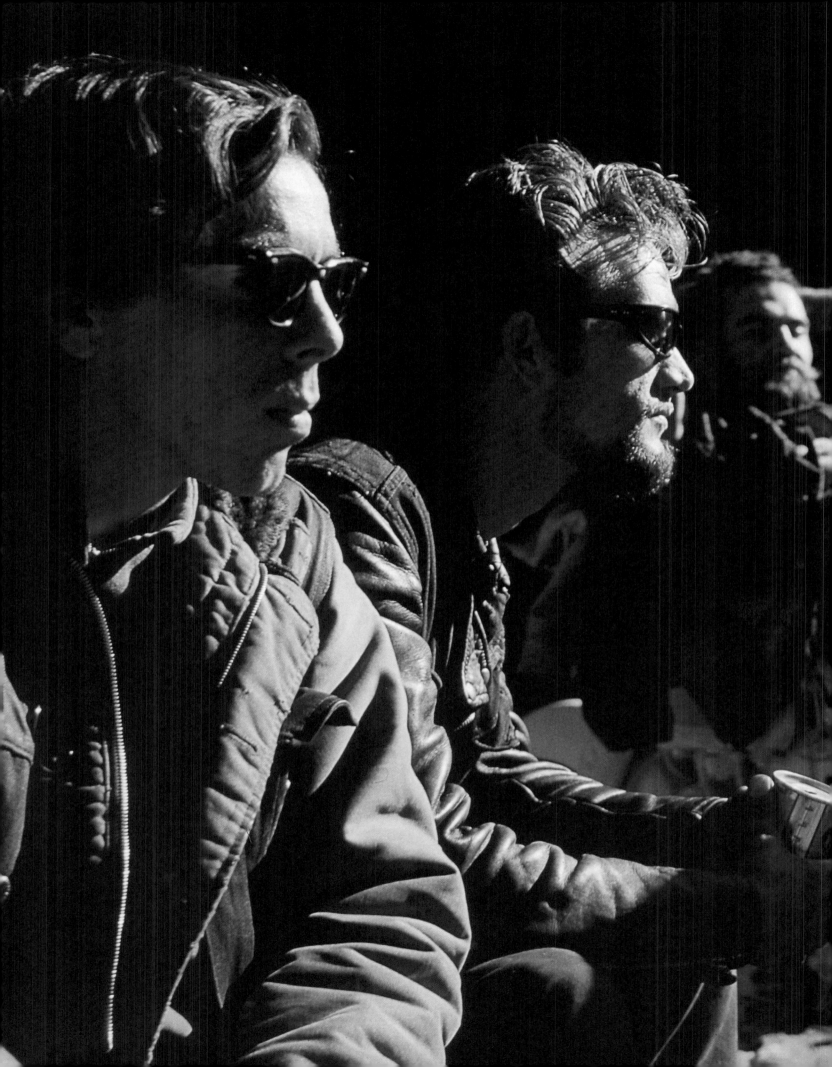

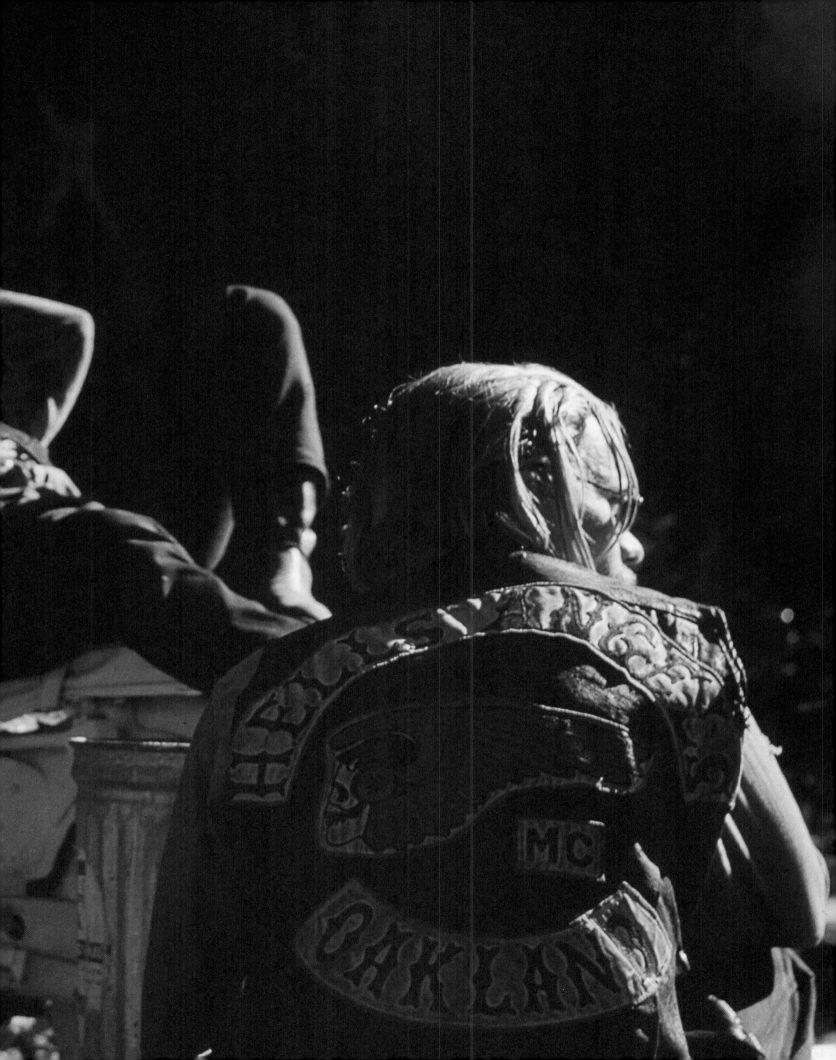

"They seemed a little stunned at the idea that some straight-looking writer for a New York literary magazine would actually track them down to some obscure transmission shop in the industrial slums of south San Francisco. They were a bit off balance at first, but after 50 or 60 beers, we found a common ground, as it were... Crazies always recognize each other."

from "The Playboy Interview", November 1974

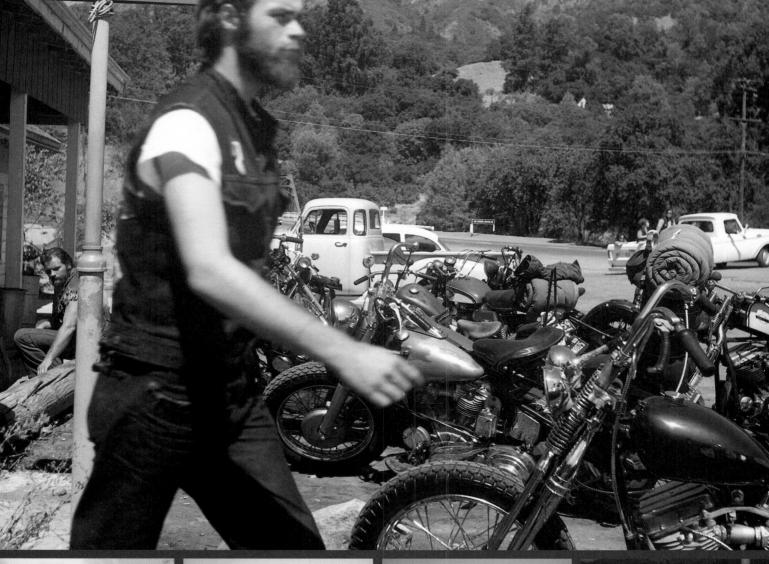

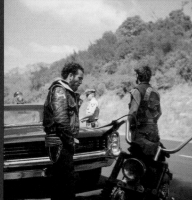

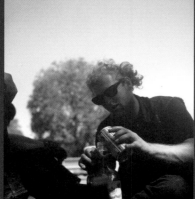

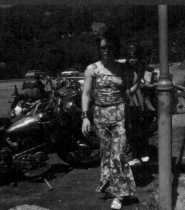

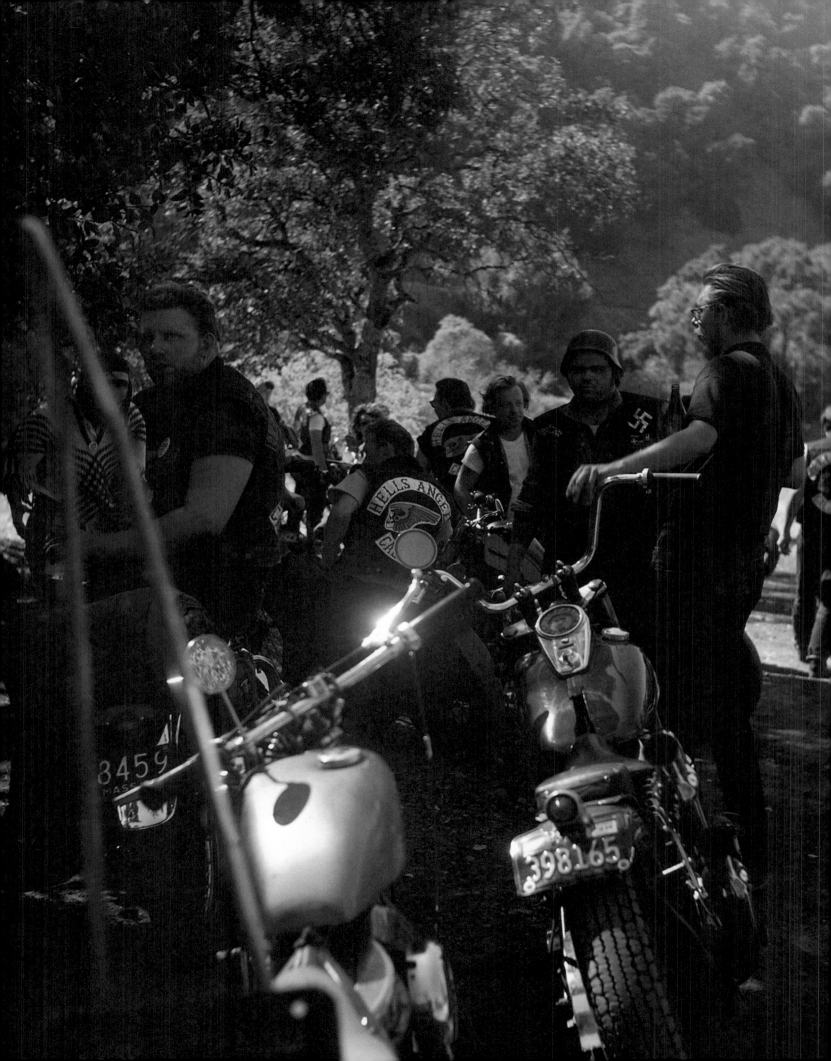

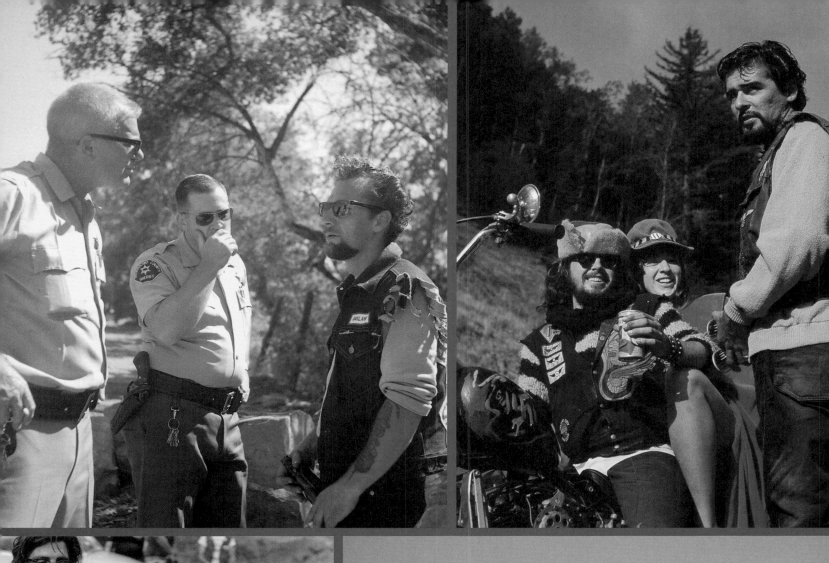

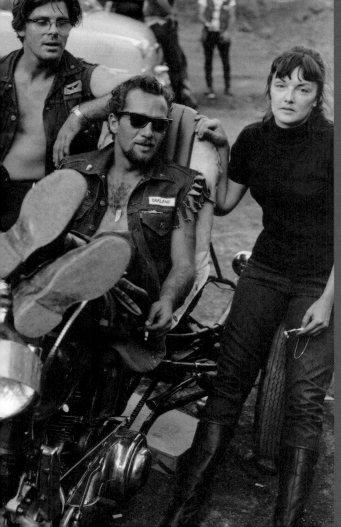

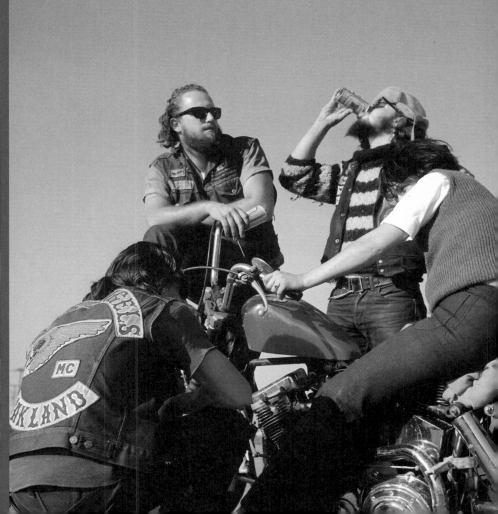

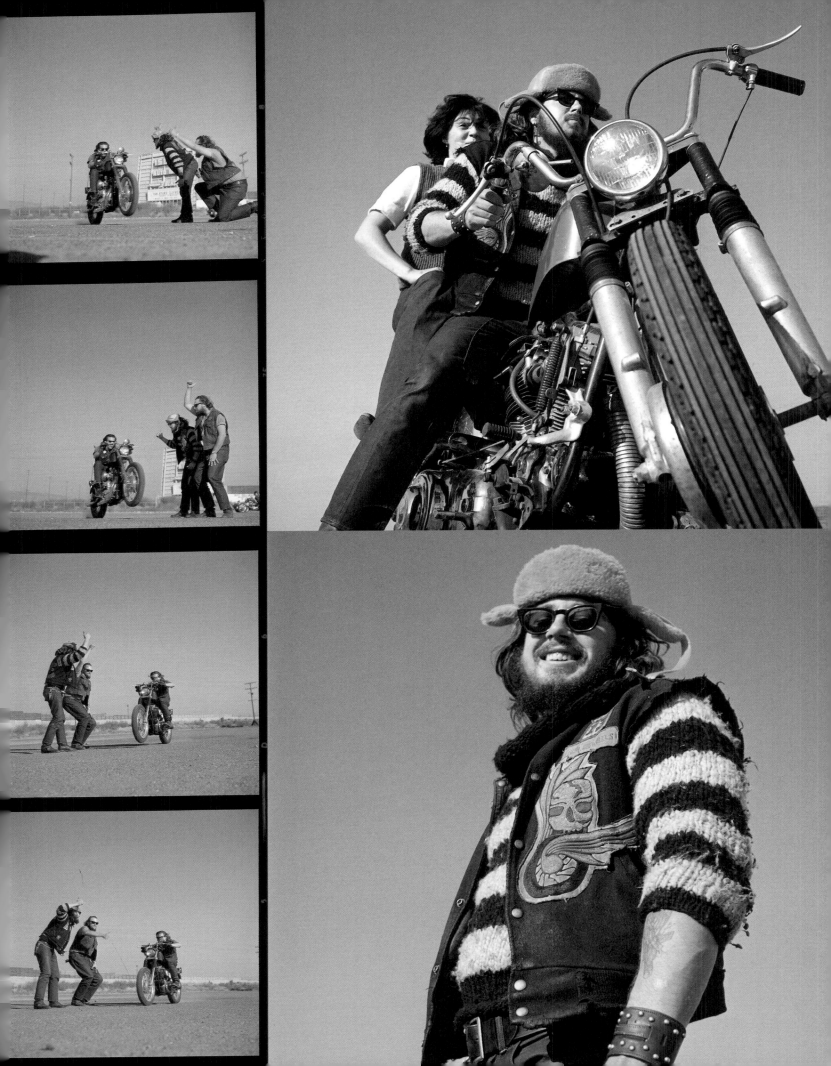

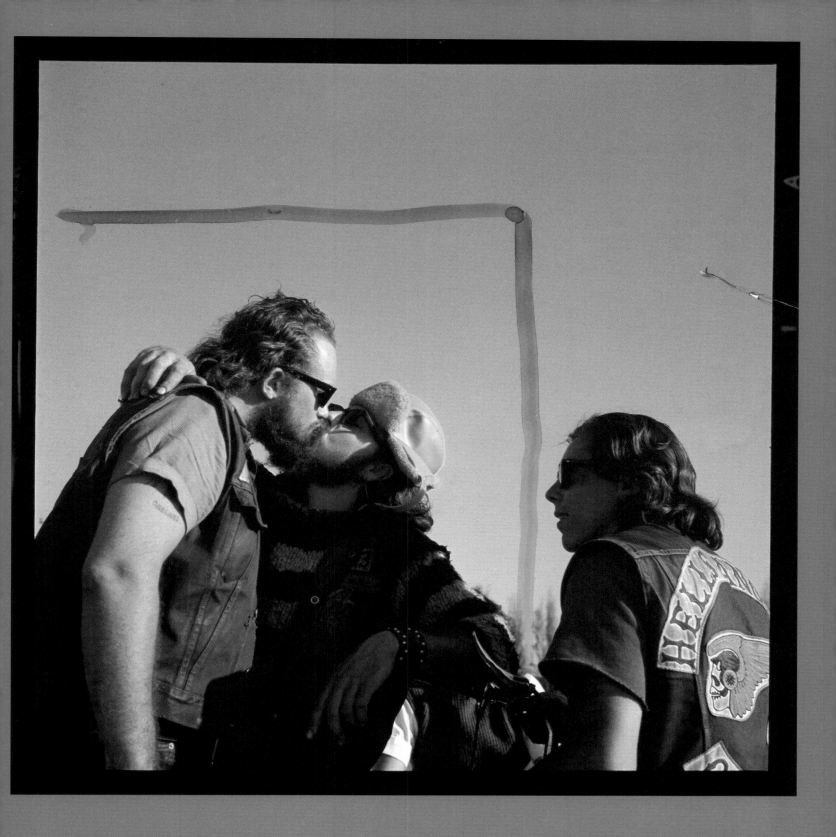

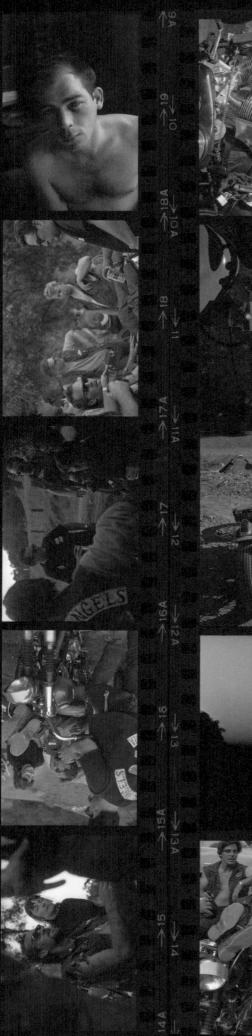

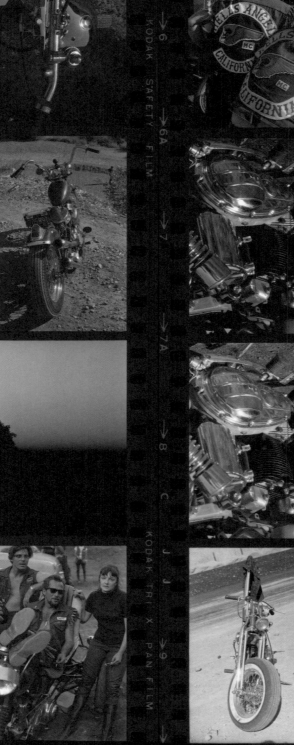
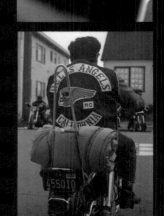

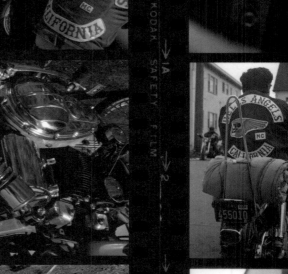
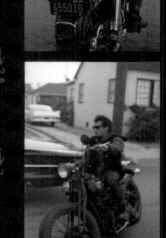

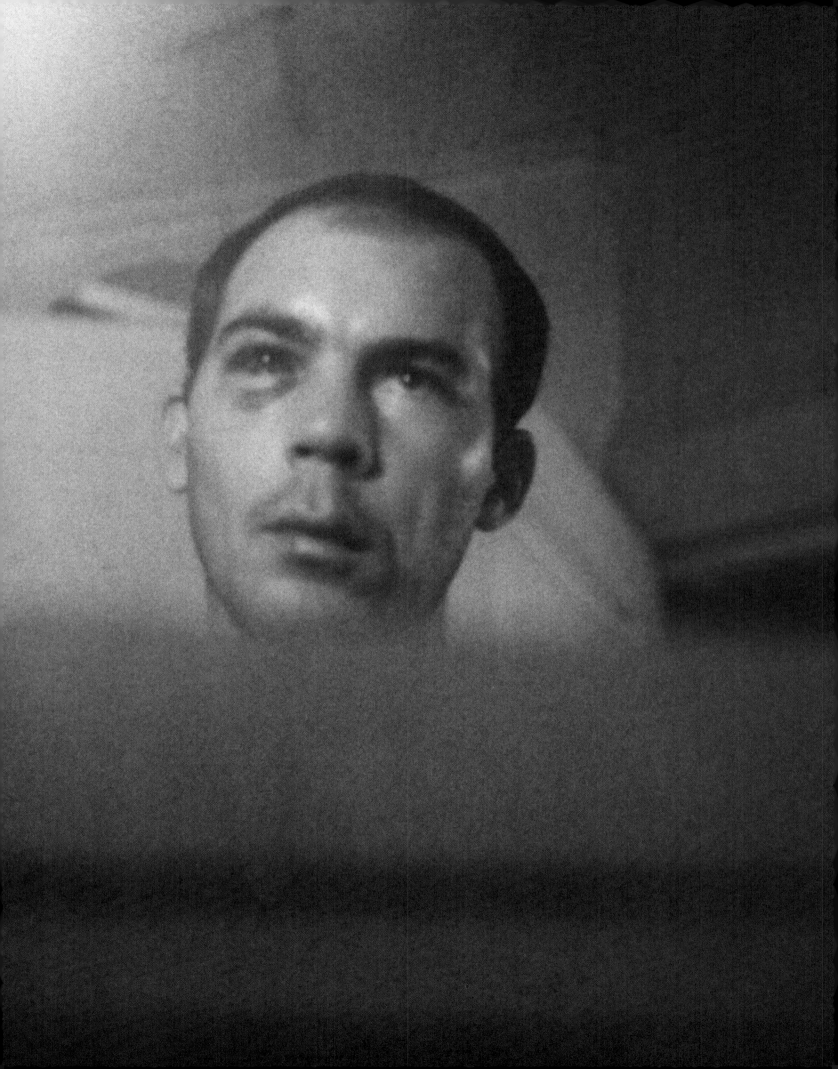

WOODY CREEK

Photographs circa 1960s and 1970s

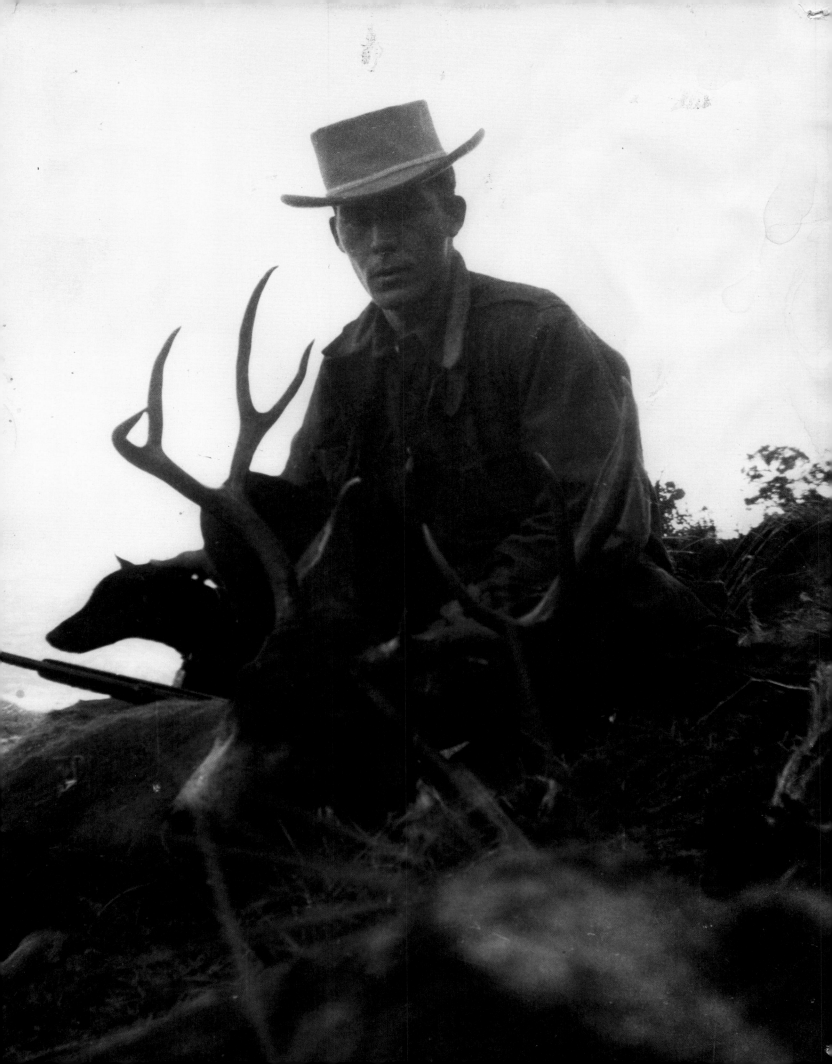

"I have been evicted from every place I've ever lived except the one where I live now. I finally had to buy that so I wouldn't get evicted."

from "Songs of the Doomed", "Wild Sex in Sausalito", May 17, 1985

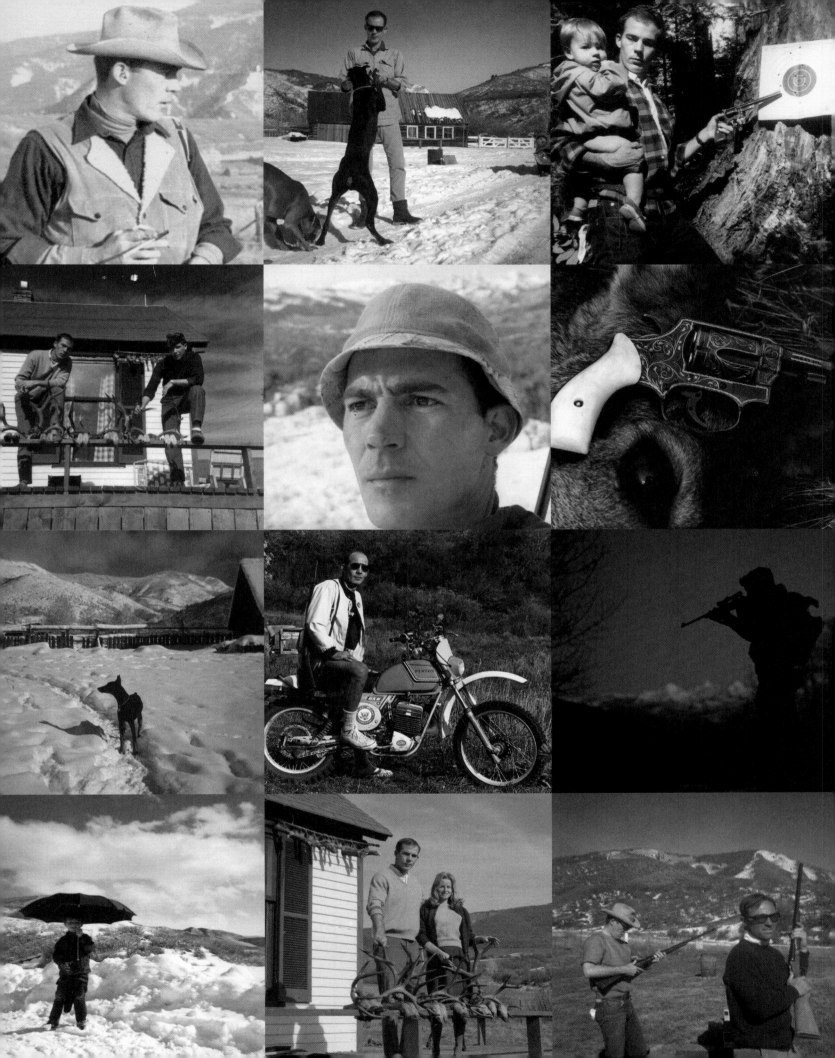

"My main luxury in those years—a necessary luxury, in fact—was the ability to work in and out of my home-base fortress in Woody Creek. It was a very important psychic anchor for me, a crucial grounding point where I always knew I had love, friends, & good neighbors. It was like my personal Lighthouse that I could see from anywhere in the world—no matter where I was, or how weird & crazy & dangerous it got, everything would be okay if I could just make it home. When I made that hairpin turn up the hill onto Woody Creek Road, I knew I was safe."

from "Fear and Loathing in America", authors note, August 20, 2000

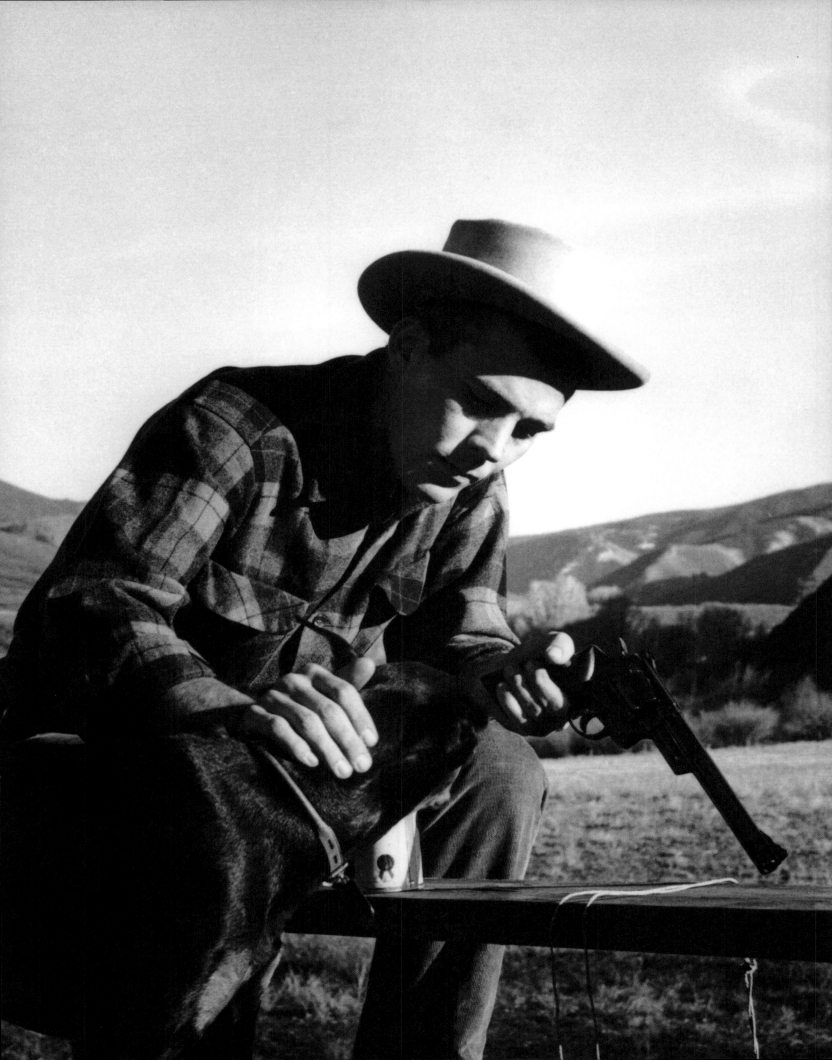

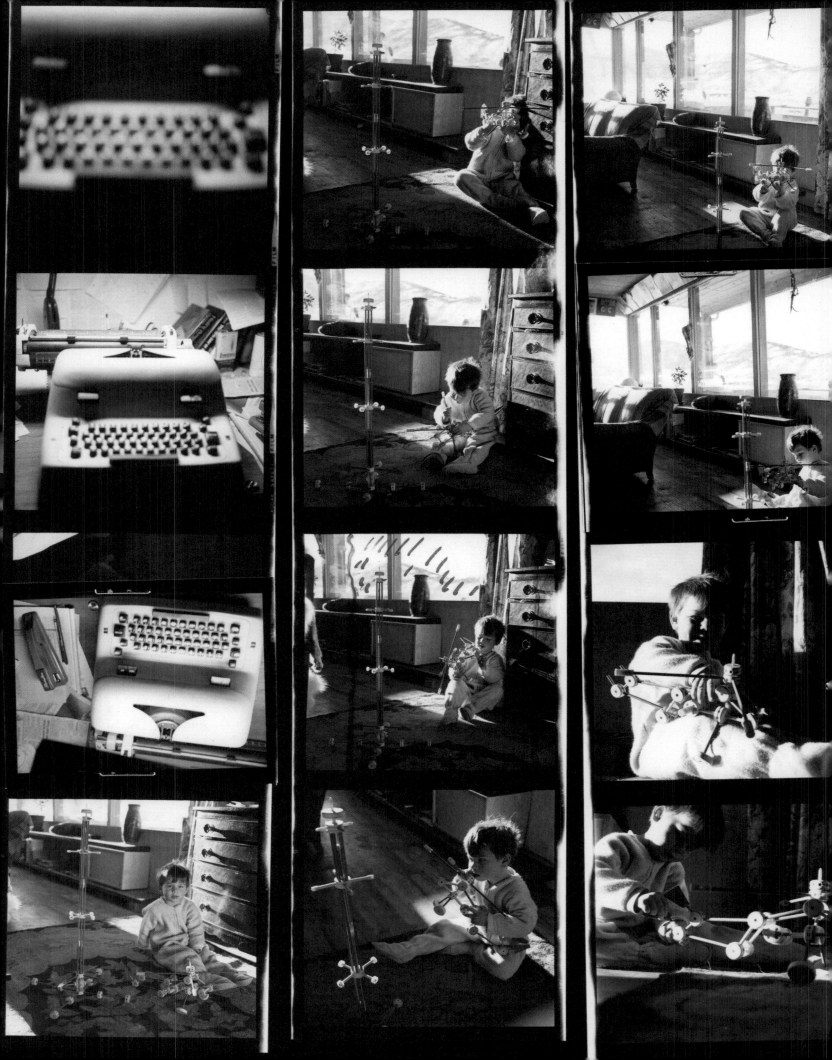

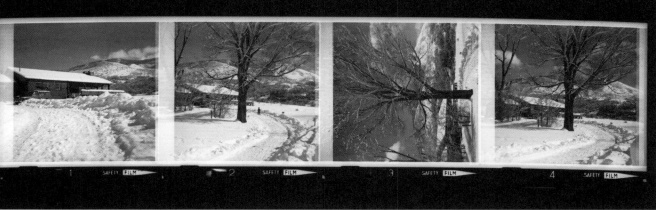

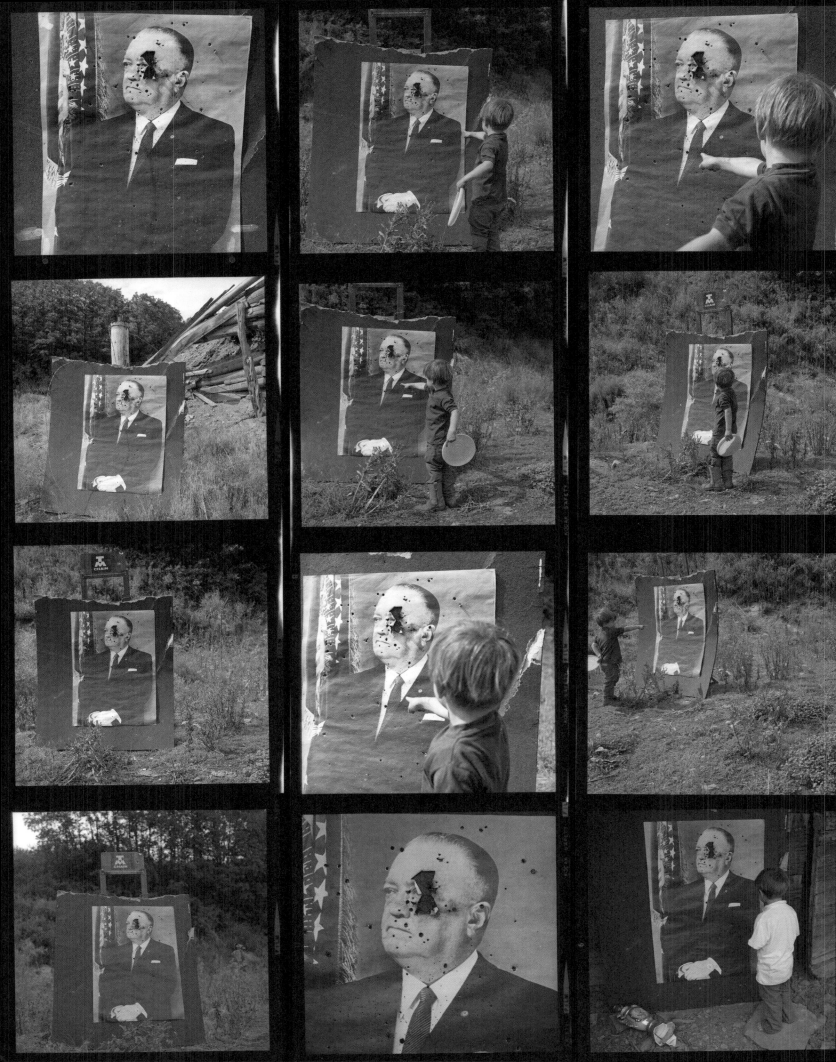

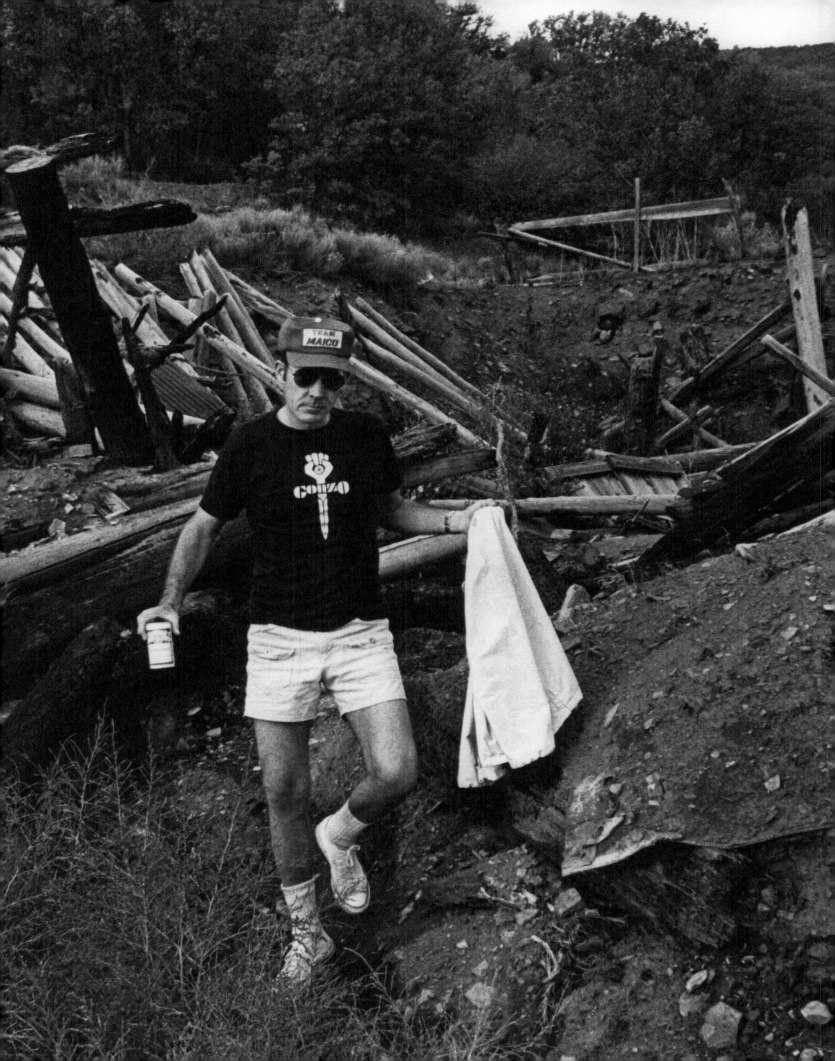

FREAK POWER TICKET

Campaign for Sheriff of Pitkin County, 1970

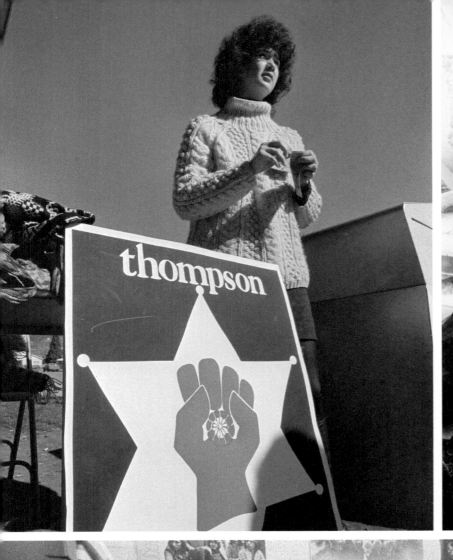

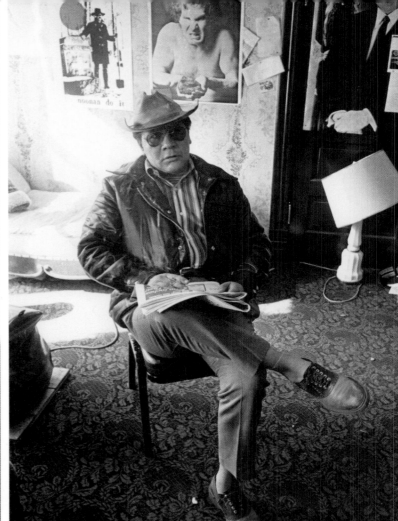

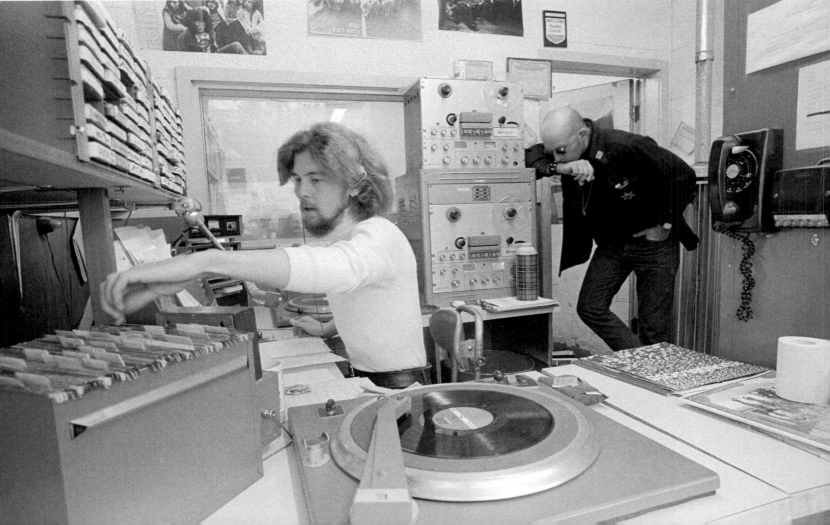

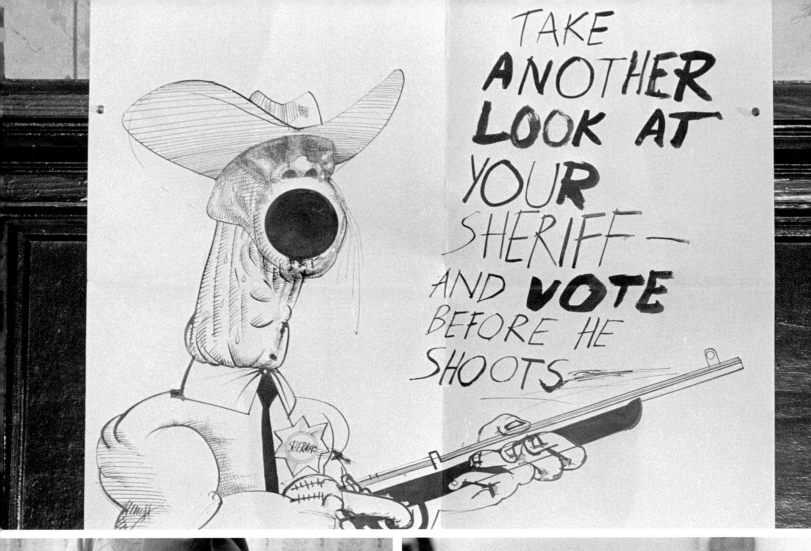

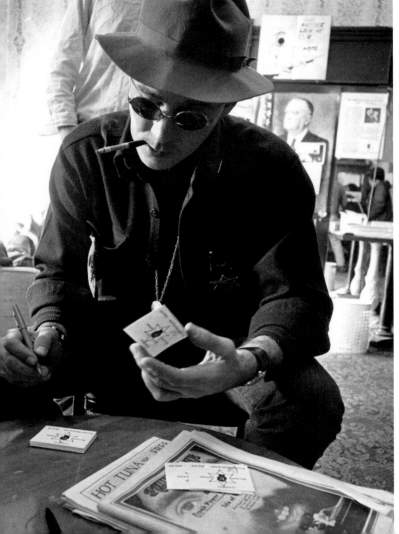

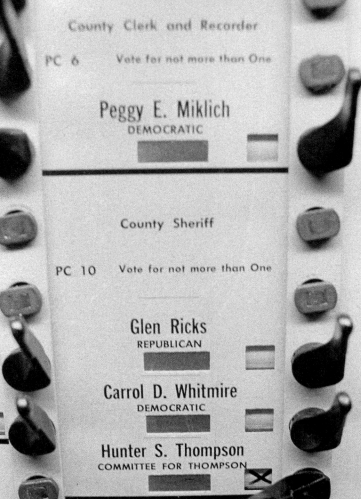

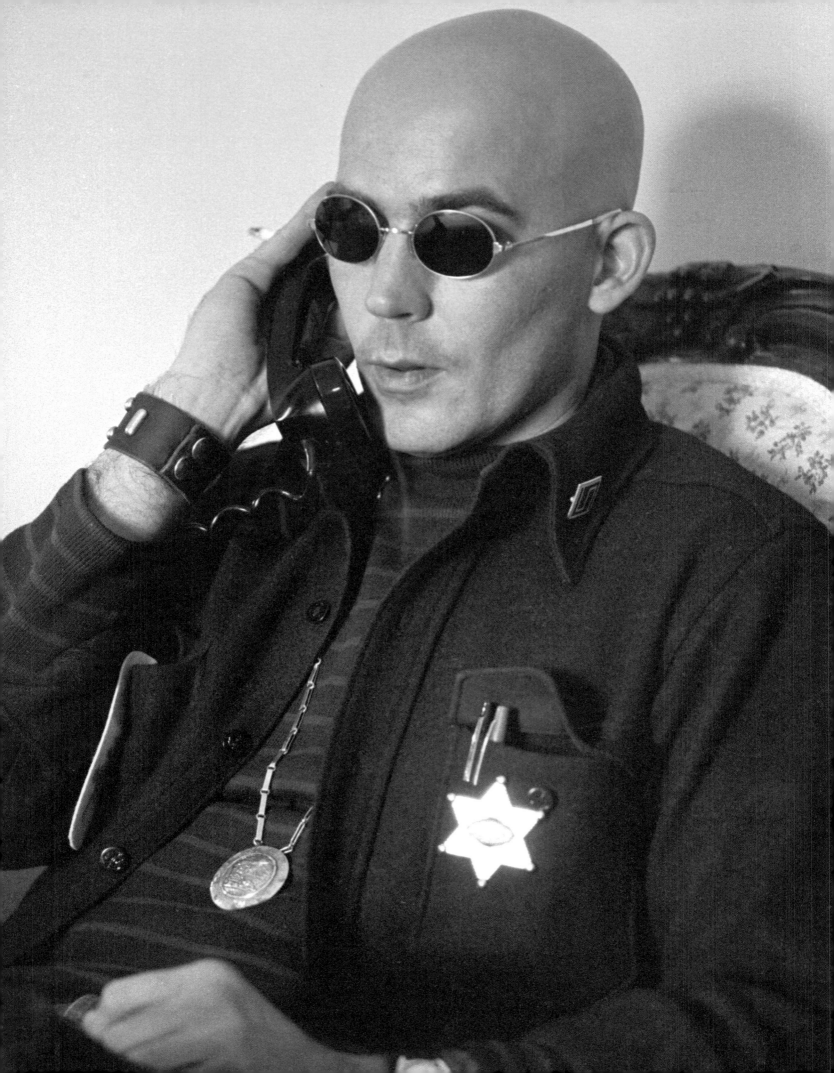

Sheriff's candidate Hunter Thompson in a pensive mood as he carefully considers lenghty list of the articles he will need to make the sheriff's office run smoothly if elected. Among needed equipment Thompson is considering is 50,000 cans of Mace, 400 submachineguns, 90 Browning automatic rifles, 2,000 fragmentation gernades, 500 cannisters of mustard gas, a complete electronic tapping kit(Mark 1V), 200 lead-weighted hand saps, 40 electric cattle prods, 20 3.5 bazookas, a dual purpose halftack with a swivle-mounted Mini-gun capable of firing 6,000 rounds of 20mm ammo per minute, 18 persuit cars equiped with Offenhauser engines, 400 flak vests(in assorted sizes), 4 lazor guns, 40 tons of two-inch thick steel to be used to bullet-proof the court house, 50 200-pound rolls of heavy gage barbed wire, 5,000 sand bags, and other assorted equipment. Asked if he expected trouble if, and when elected, he said bravely, "Of course not. This is a very quiet, law-abiding community."

"But we brought out a massive backlash vote. They couldn't handle a mescaline-eating sheriff who shaved his head and looked like the devil."

from "Songs of the Doomed", "Chicago 1968: Death to the Weird", March 1990

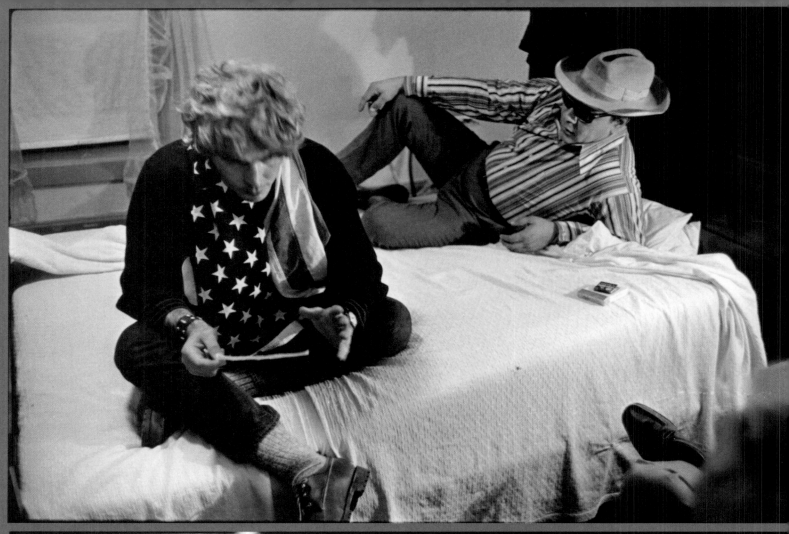

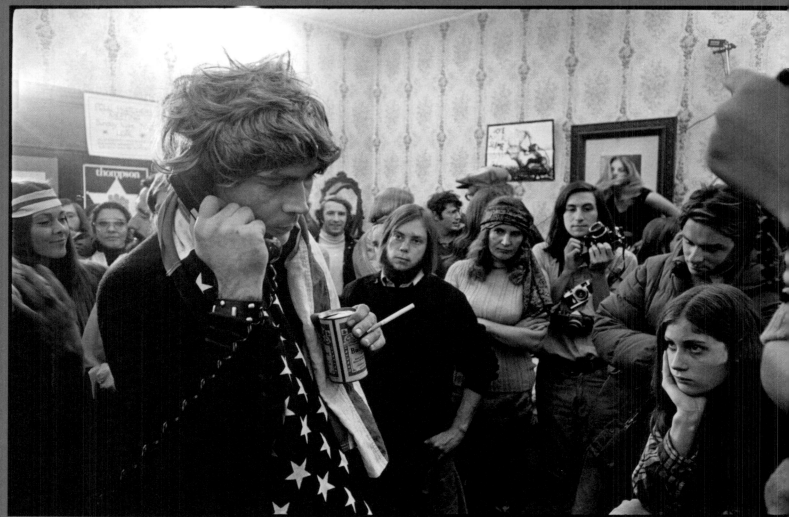

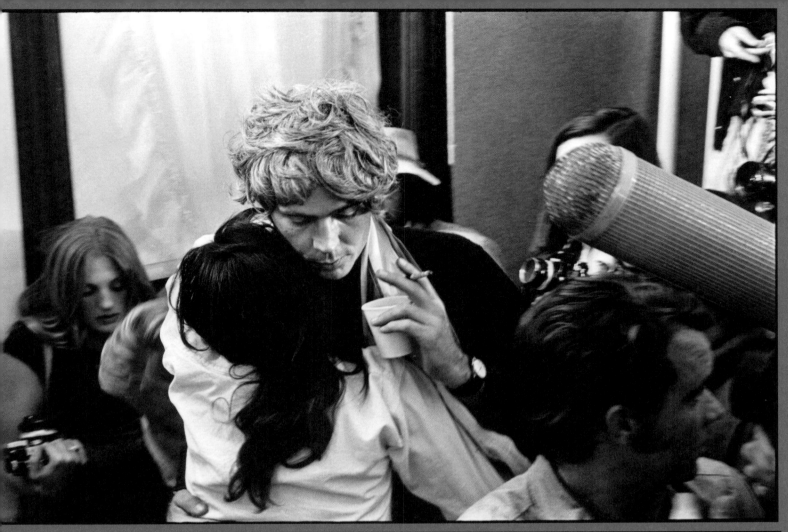
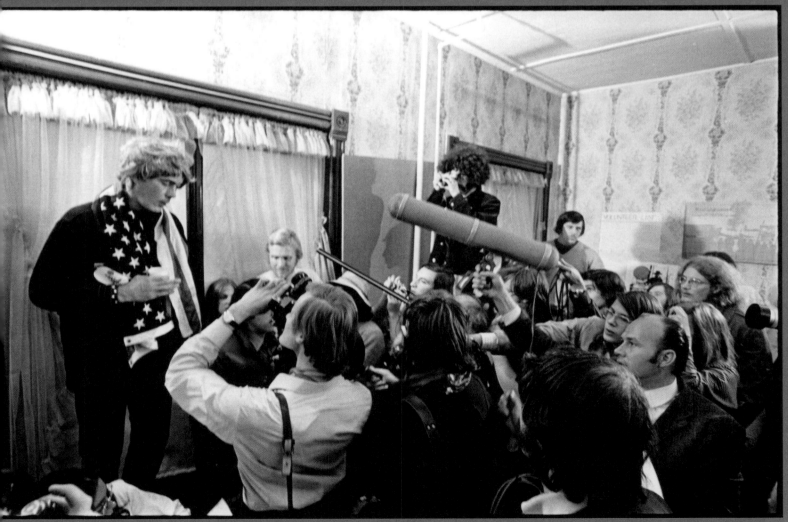

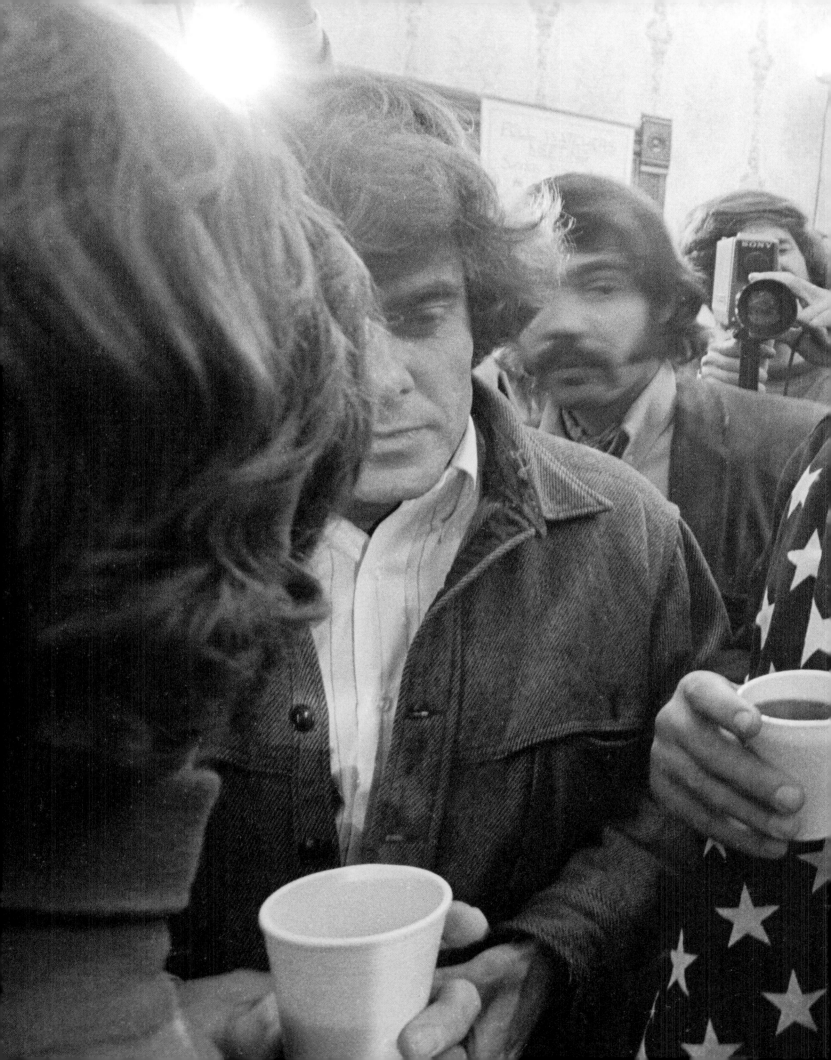

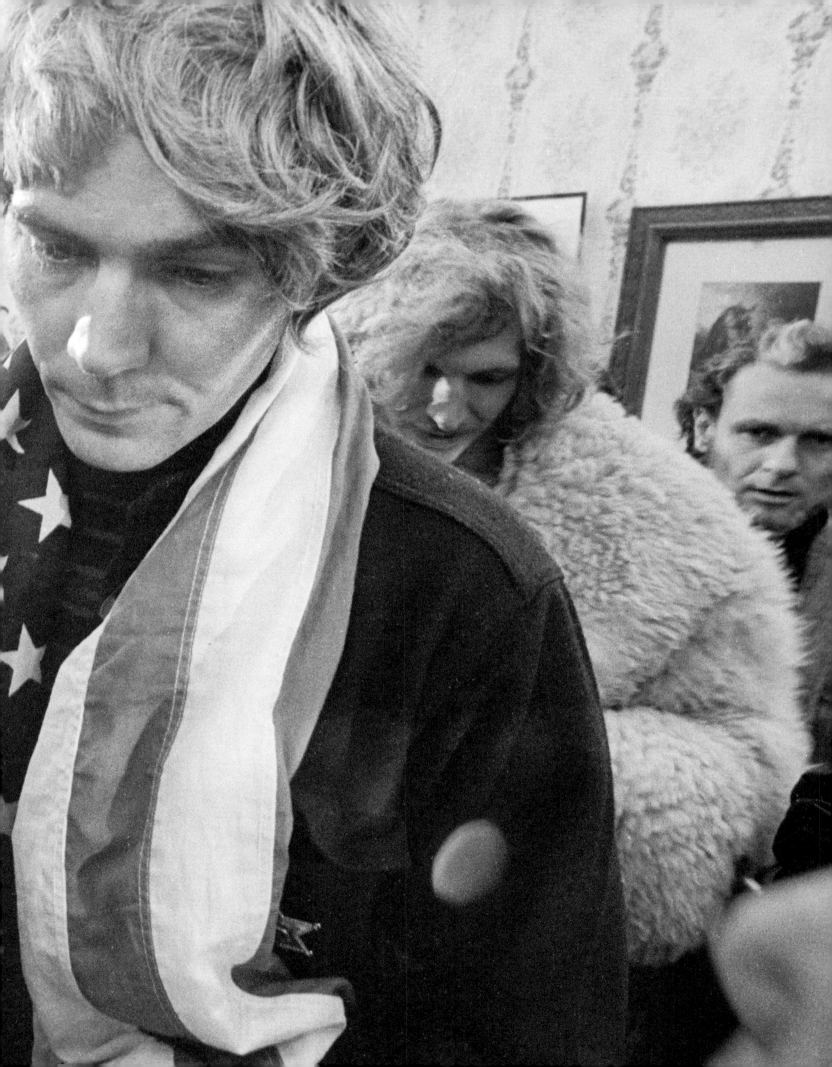

"When I ran for sheriff of Aspen on the Freak Power ticket, that was the point. In the rotten fascist context of what was happening to America in 1969, being a freak was an honorable way to go"

from "The Playboy Interview", November 1974

FEAR AND LOATHING IN LAS VEGAS

Photographs and memorabilia circa 1970s

"As true Gonzo Journalism, this doesn't work at all—and even if it did, I couldn't possibly admit it. Only a goddamn lunatic would write a thing like this and then claim it was all true."

from "Fear and Loathing in Las Vegas", jacket copy, 1972

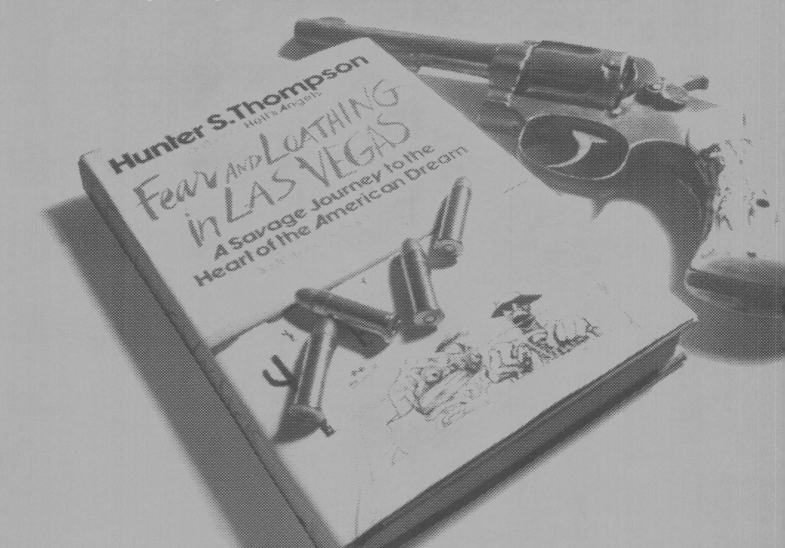

13 = 8 pt

 We were somewhere around Barstow on the edge

of the desert when the drugs began to take hold. I

remember saying something like "I feel a bit light-

headed; maybe you should drive...." And ~~then~~ suddenly

there was a terrible roar all around us and the sky was

full of what looked like huge bats, all swooping and

screeching and diving around the car, which was going

about 100 miles an hour with the top down to Las Vegas.

And a voice was screaming: "Holy Jesus! What are these

goddamn animals?"

(more)

Monday – 4/26
"On behalf of the prosecuting attys of this country – welcome."
— Patrick Healy
1000 cops! 2000? [½ from "academic community" – hands]
my atty. checked us in —
I couldn't handle it —
without funds
— no checkbook
— wild telegrams in the night.
— must get the white Cadillac convertible
— yes, finally $20/20 mi.
— white Killer whale

Horrible scene at C-Palace —
— Roll up in White whale + send it off for parking —
— Need Photo
— Rush into bar + sit flabby wired-in waiting bunny/waitress appears + asks for Dusty —
"I don't know her" Do you want drinks"
what the hell
"Yes — we'll have —

ROOM SERVICE
THE Flamingo HOTEL

"around Las Vegas" THE FABULOUS Flamingo HOTEL SHOWPLACE OF THE NATION

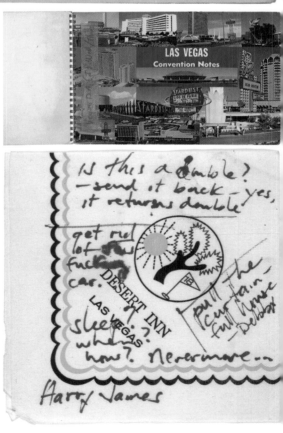

LAS VEGAS Convention Notes

is this a double? – send it back – yes, it returns double?
get rid of fucking car.
DESERT INN LAS VEGAS sleep? where? how? Nevermore...
pull the curtain full house – Debbie

Harry James

Wed 4/28
9:20 AM — brief
pause at Dunes
casino bar — enroute
to Drug Conf.
— half crazy on
booze + speed
— after taking
my atty. to airport
for 8:00 plane
— missed the plane —
missed the
airport — almost
to Calif. state line
running 120 before

Friday 4/30
— leaving
Fat City for the Sqeeze Hustle
collapse, pass out,
11/11 threats, house
phone, Circus-Circus
+ (Discovery), etc
A.D.
then to Airport
with generator
failing — windows
jammed, engine
sputtering, but
Radio on
"One Toke Over The Line"

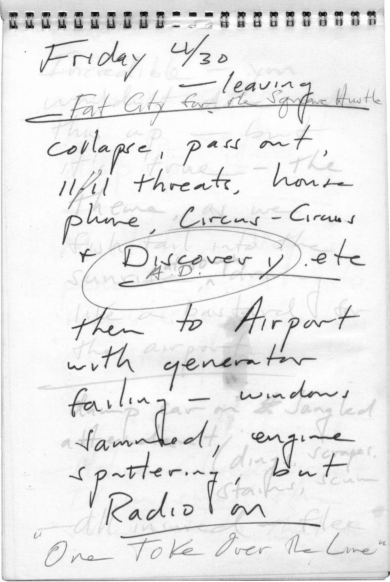

National District Attorneys Association

Awards
this
Certificate of Achievement
to
Hunter Thompson

for his contribution to and participation in the

Third National Institute
Narcotics and Dangerous Drugs

dedicated to the purpose of preventing the nation's youth from succumbing to, and the rehabilitation of those already in, the abyss of drug abuse.

Las Vegas, Nevada
April 25-29, 1971

Patrick F. Healy
Executive Director
National District Attorneys Association

William B. Randall
President
National District Attorneys Association

BUILD RESPECT FOR LAW & ORDER AT ANY EARLY AGE
(The impressionable age — 5 to 9 years old)

"OFFICER BILL"

THE COMPLETE, TESTED AND PROVEN
POLICE PROGRAM FOR LOWER ELEMENTARY GRADES.

Plus making "friends" with the children, "Officer Bill" teaches them safety rules, respect for parents and teachers, about good people and bad people, etc., and explains the role of the peace officer in a "let's get acquainted" manner.

"Officer Bill" is a nickname the children can call all of their policemen friends!

EDUCATIONAL MATERIALS FOR
THE PREVENTION OF DRUG ABUSE!

Accredited and Recommended by
law enforcement agencies and educators!

"USERS ARE LOSERS!"

Education, Facts, and Understanding provide the main key!

Beginning at a very young age, we should teach children respect for drugs of all kinds, even aspirin, which can cause death by overdose. "Users Are Losers!" is a new, innovative approach that is factual, authoritative, covering drug abuse from many angles . . . presented in a mod, colorful, easy to read, easy to understand, effective manner that youth reads and accepts.

"Users Are Losers" is a PREVENTATIVE drug abuse program!

Lays out the facts! Easy to understand! Profusely illustrated! Colorful and interesting! Does not use fright photos or scare tactics. Youth can associate with these materials . . . this is important!

THE AQUARIAN EFFORT

A REALISTIC APPROACH TO DRUGS

THE AQUARIAN HOUSE
1239 Q Street Sacramento, California

Crisis Line 444-6294 Business Line 444-6297

A COMMUNITY
GUIDE
TO DRUG ABUSE
ACTION

Drug Facts

GET
WISE
not weird

NARCOTICS
AND
DANGEROUS
DRUGS

the National
District Attorneys Association
presents the
third national institute on
narcotics and dangerous drugs

THE NOW
DRUG SCENE
WHAT EVERY TEENAGER
AND PARENT
SHOULD KNOW

DISTRIBUTED THROUGH THE COURTESY OF THE
HADDON TOWNSHIP POLICE DEPT.
854-0011 854-0012

MARIJUANA

Comprehending a COMPENDIOUS and
VERACIOUS SCRUTINY of the growth and
cultivation of CANNABIS SATIVA, a sober
survey of its HISTORY, a whirl around the
MARIJUANA world, a VOYAGE on the
S.S. MARIJUANA TRIP and a GAZE whole
and steady at the CONTROVERSIES, CONTENTIONS,
COLLISIONS, LOGOMACHIES, DEBATES,
DISSENT, and DISPUTATIONS concentering upon...
THE WEED, together with divers CATECHISMS,
EXEGESES, SCHOLIA, LEXICONS, and
ILLUMINATIONS that TELL IT LIKE IT IS.

E. R. BLOOMQUIST, M. D.

"Oscar was one of God's own prototypes—a high powered mutant of some kind who was never even considered for mass production. He was too weird to live, and too rare to die."

from "Rolling Stone", "The Great Shark Hunt", December 15, 1977

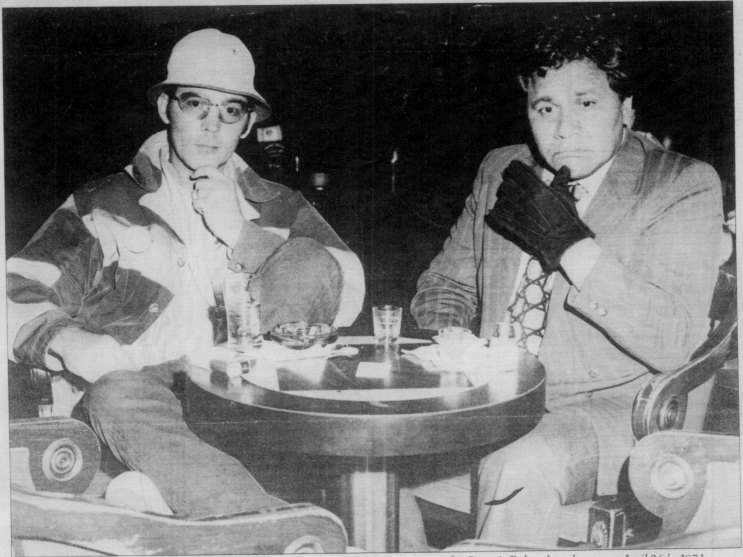

Dr. Hunter S. Thompson and his best friend and attorney, Oscar Zeta Acosta, at the Caesar's Palace bar, three a.m., April 26th, 1971

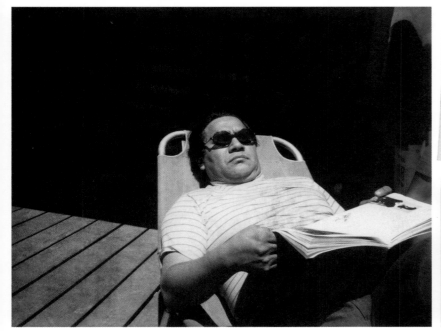

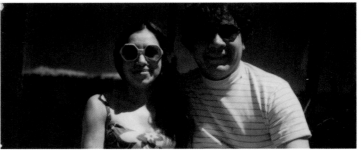

ROLLING STONE

IND 33630

No. 95
November 11, 1971
60¢
UK 15 p

Our Fourth
Anniversary Issue:

Fear and Loathing in Las Vegas: A Savage Journey to the Heart of the American Dream by Raoul Duke

Beach Boys:
Part Two of A California Saga

The Band: "It's The Restless Age" by Jon Landau

C, S, N & Y Come Together Again

At Work with Fellini On His Next Epic

From Texas: The Young Americans For Freedom in Congress

ROLLING STONE

No. 96 November 25, 1971 UK 15 p 60¢

Duane Allman's Final Days on the Road ✎✎✎ The Five Year Plan of Donovan P. Leitch ✎✎✎ The Conclusion of ✎✎ Fear and Loathing in Las Vegas, A Savage Journey to the Heart of the American Dream

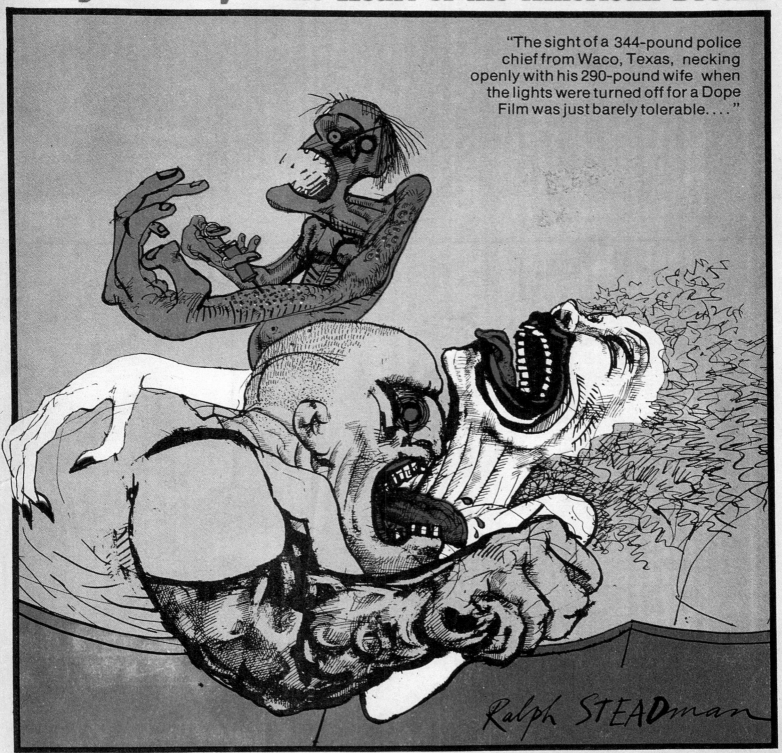

"The sight of a 344-pound police chief from Waco, Texas, necking openly with his 290-pound wife when the lights were turned off for a Dope Film was just barely tolerable. . . ."

Ralph STEADman

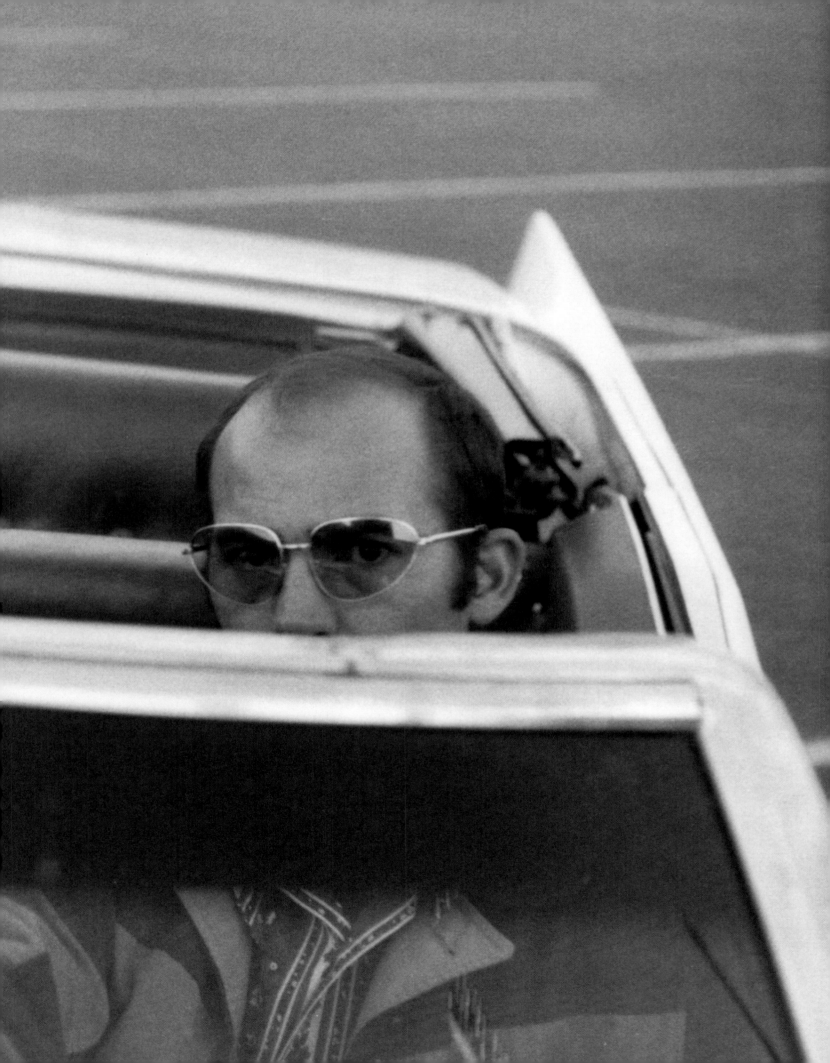

Vegas/Spring '71
— HST in
white whale
with Bliss
Mackey, guitar-
player from
Bruce Innes'
"Original Caste"
— dawn, drunk

HST & Bliss
Mackey — Vegas
dawn '71
— self-timer
foto by HST
— White Whale

return to: HST
Box 37 — Woody Creek
Colo 81656

Return to
H.S. Thompson
Box 37
Woody Creek
Colo 81656

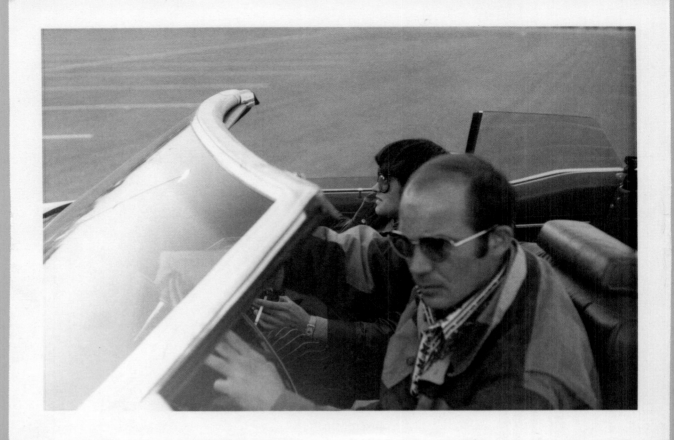

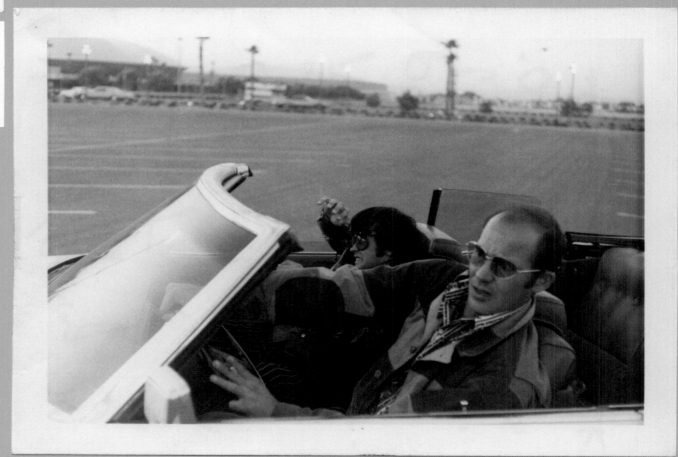

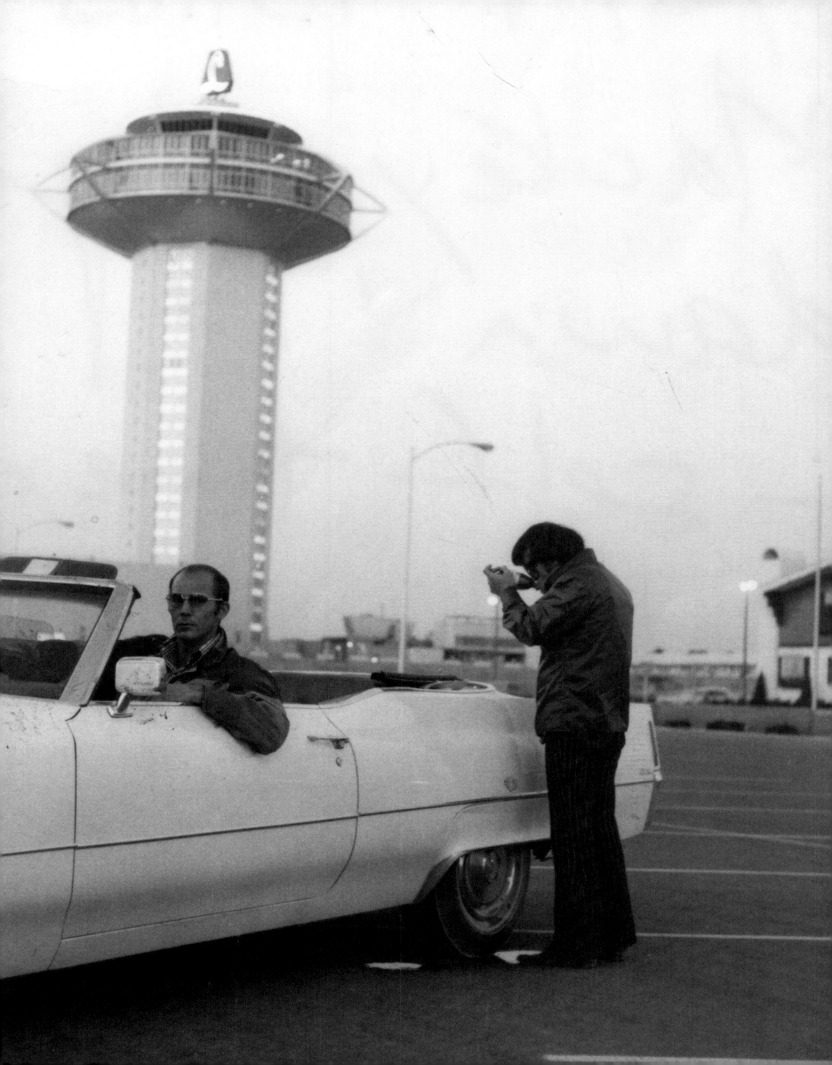

FEAR AND LOATHING: ON THE CAMPAIGN TRAIL '72

Photographs circa 1970s

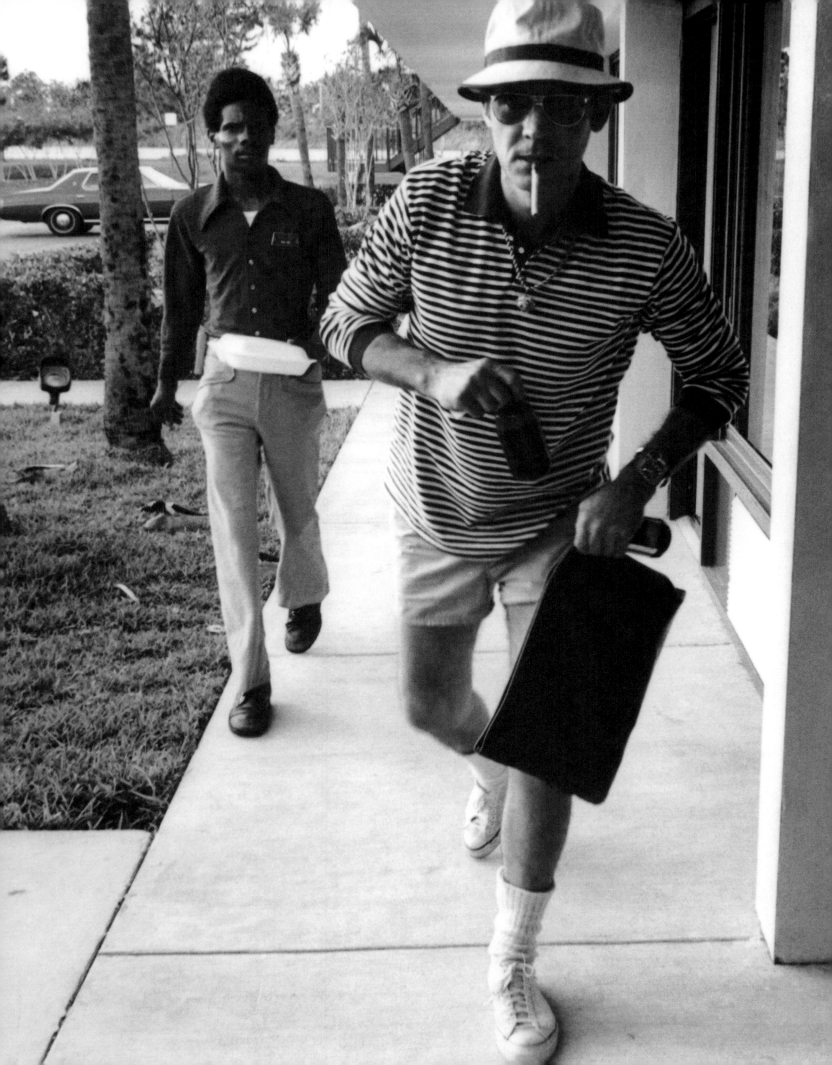

"When I went to Washington to write "Fear and Loathing: On the Campaign Trail '72", I went with the same attitude I take anywhere as a journalist: hammer and tongs—and God's mercy on anybody who gets in the way."

from "The Playboy Interview", 1974

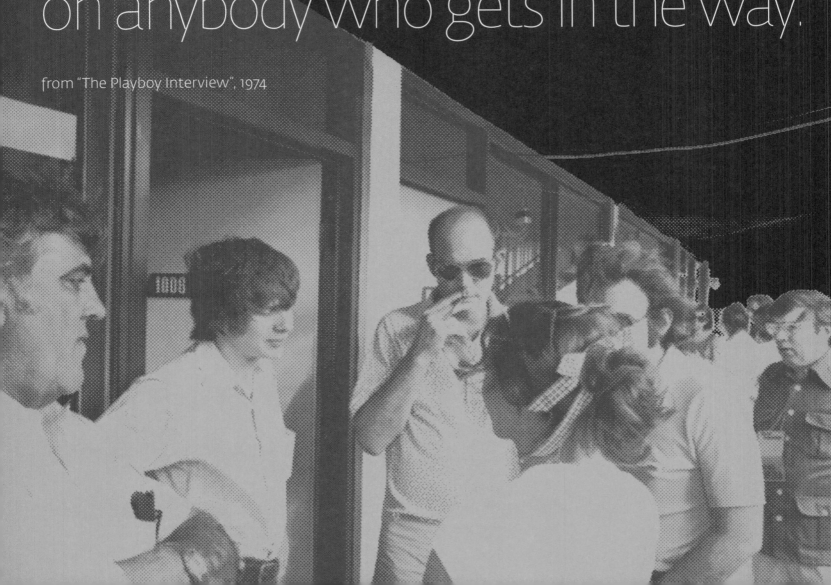

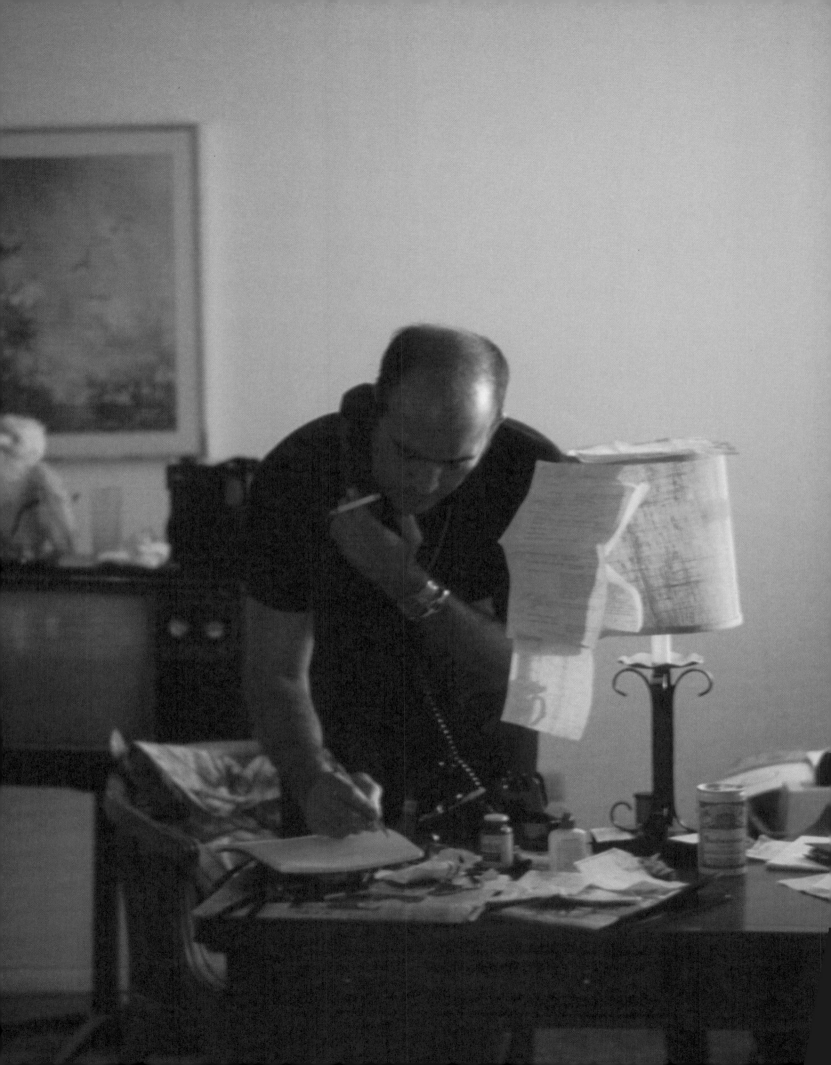

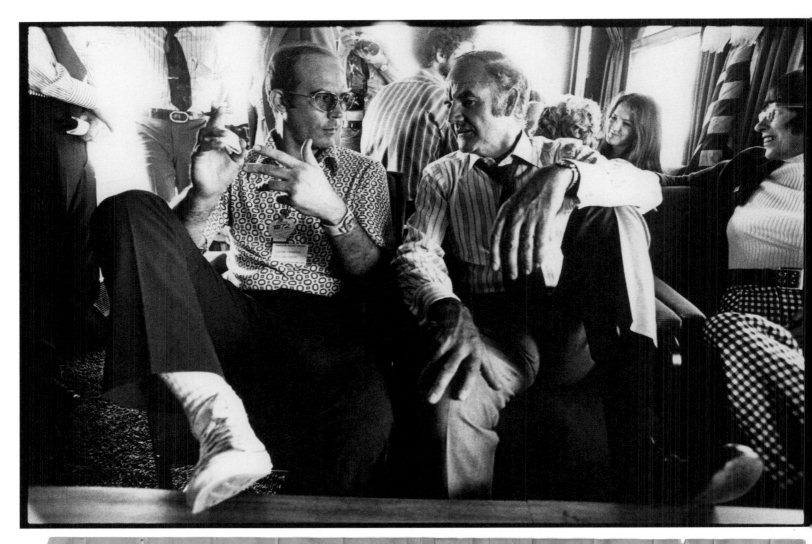

FUCK COMMUNISM!

ADDITIONAL COPIES AVAILABLE FROM THE MOTHERS OF THE AMERICAN REVOLUTION, WASHINGTON, D.C.

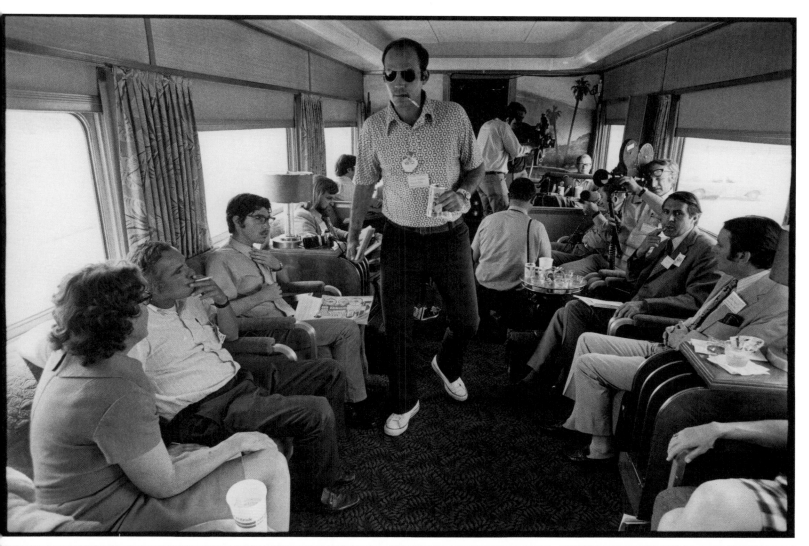

THE
DEMOCRATIC
PARTY OF THE
UNITED STATES
IN CONVENTION

Robert S. Strauss/Chairman
New York City
Madison Square Garden
July 12-15,1976

NEWS-PERIMETER

This credential will permit
access to restricted areas
of Madison Square Garden

Monday, July 12 - Thursday, July 15

16879

"Nixon had the unique ability to make his enemies seem honorable, and we developed a keen sense of fraternity. Some of my best friends have hated Nixon all their lives. My mother hates Nixon, my son hates Nixon, I hate Nixon, and this hatred has brought us together."

from "Rolling Stone", "Memo from the National Affairs Desk, Notes on the Passing of an American Monster", June 16, 1994

Audio Pullout: Weird Wizards of Hi-Fi ⊛ **The Ear Explained** ⊛ **Edison's Secret Life**

ROLLING STONE

SM14170 ISSUE NO. 144 SEPTEMBER 27, 1973 75¢ UK 20p

FEAR AND LOATHING AT THE WATERGATE
By Dr. Hunter S. Thompson Illustrated By Ralph Steadman

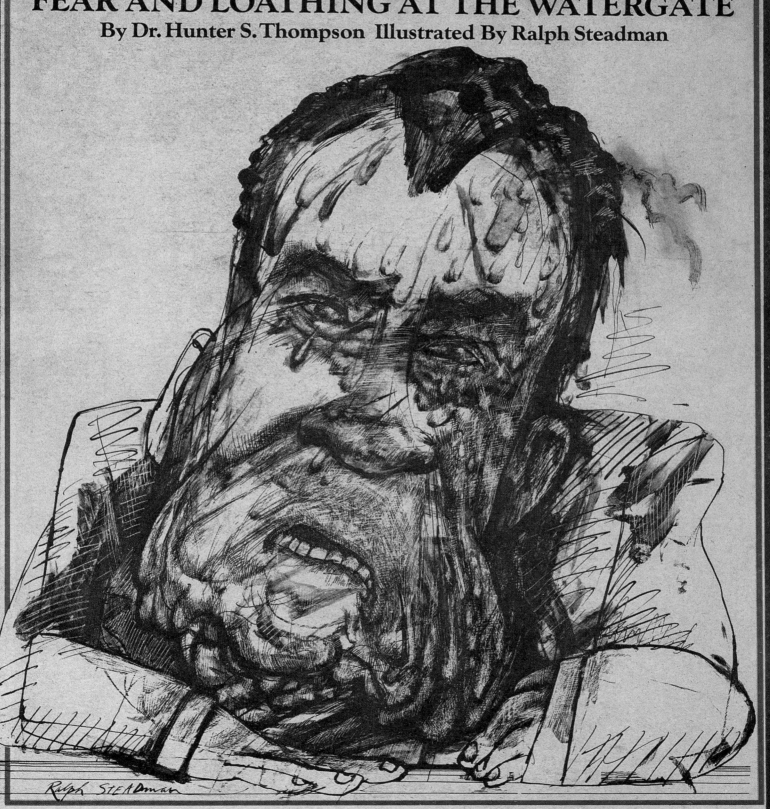

Ralph STEADMAN

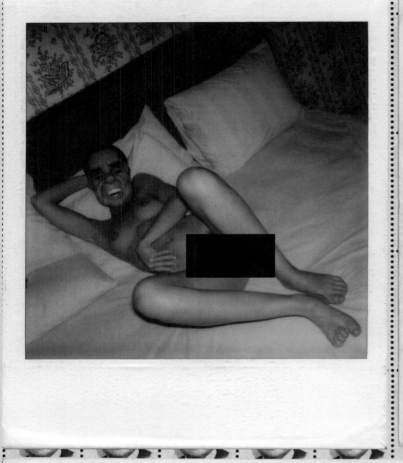

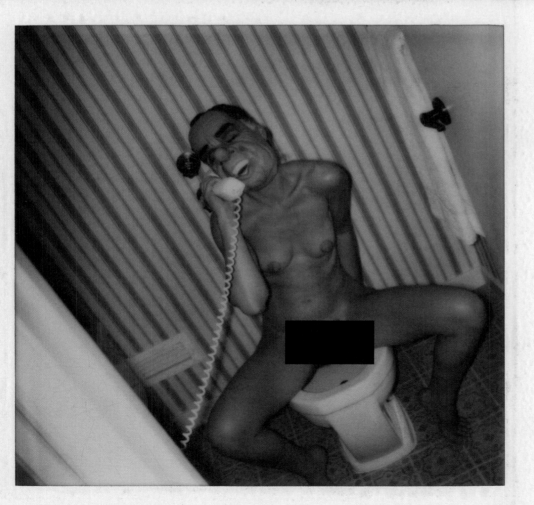

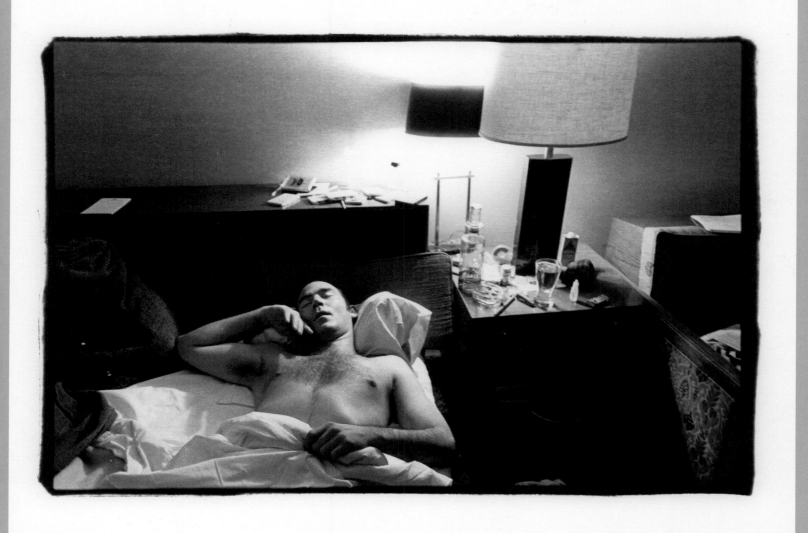

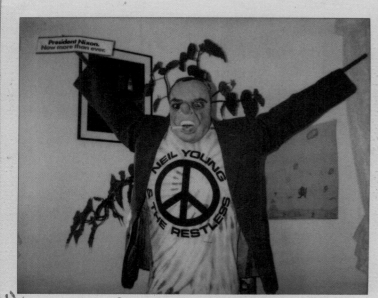

"Hypocrisy is necessary in order to get into office and in order to retain office."
— Richard M. Nixon

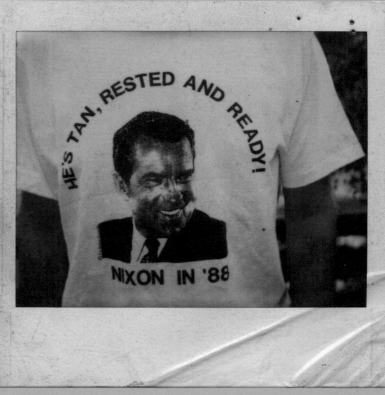

THE 1970s

Photographs and memorabilia circa 1970s

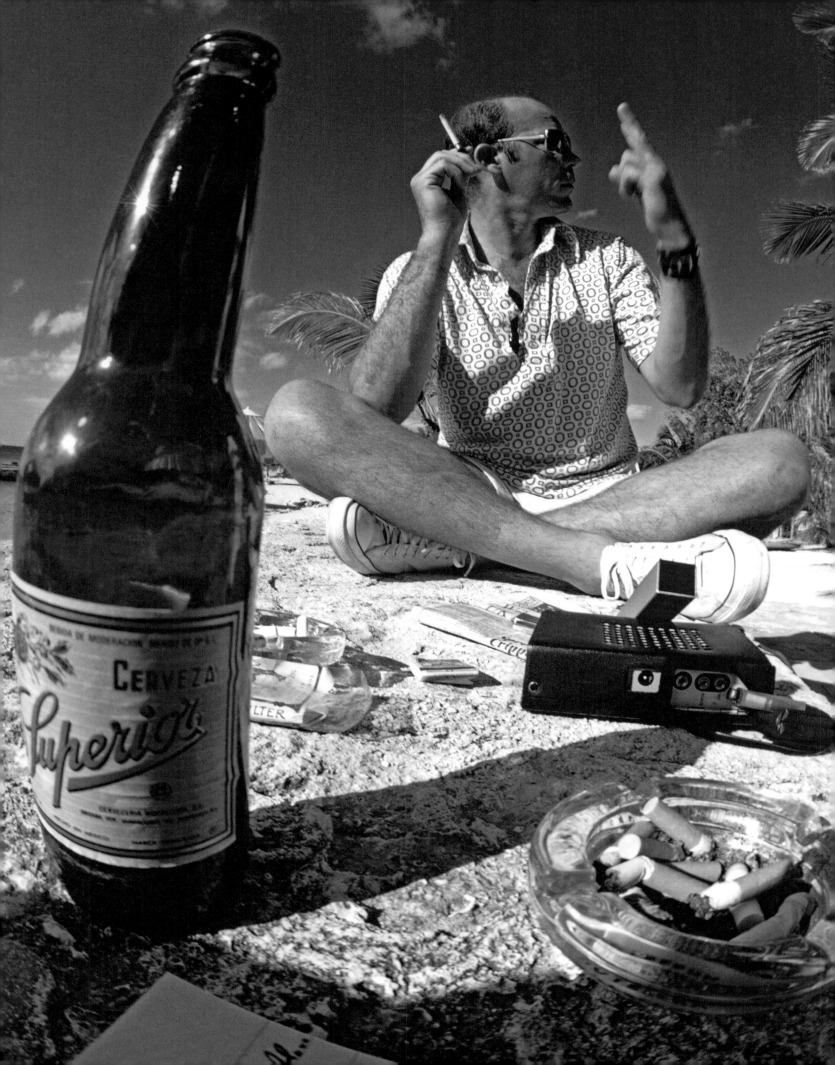

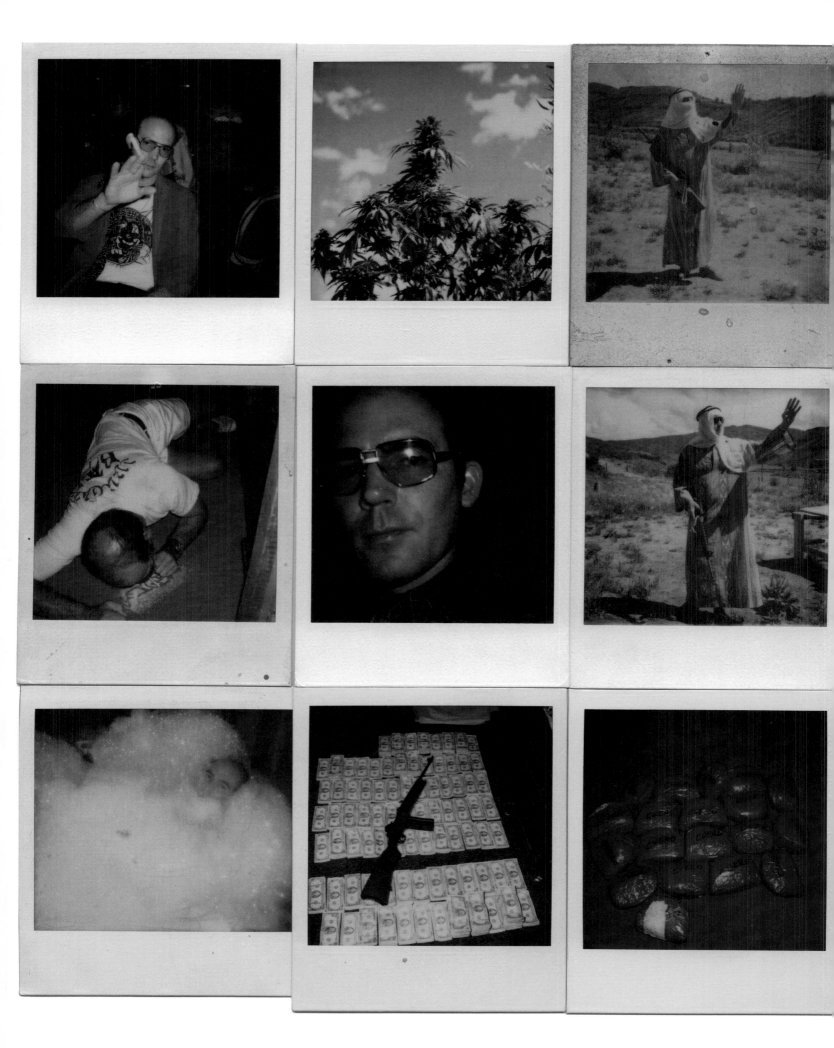

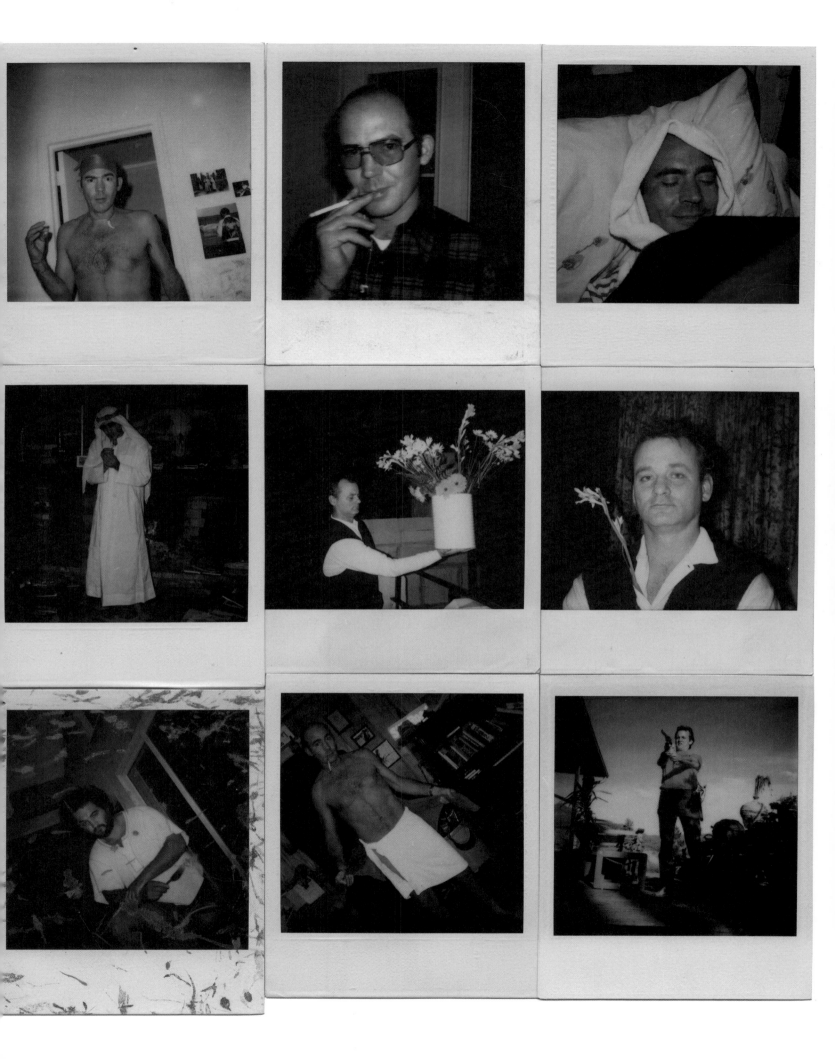

"The 70's, it was unbelievable and wild. That was rock n roll."

from "Rocky Mountain News", interview with Jeff Kass, December 18, 2000

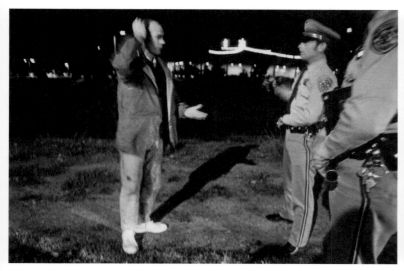

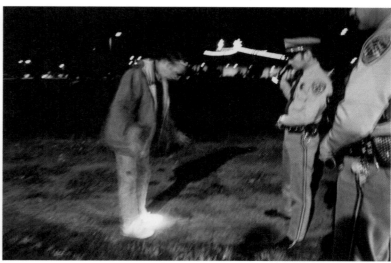

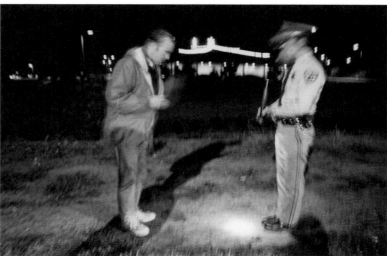

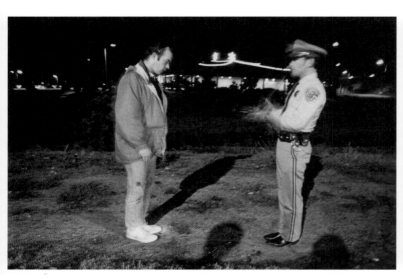

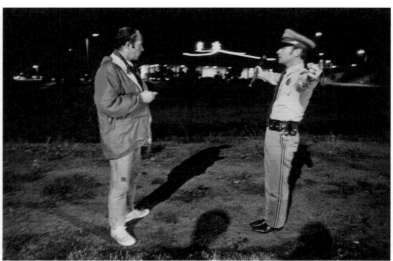

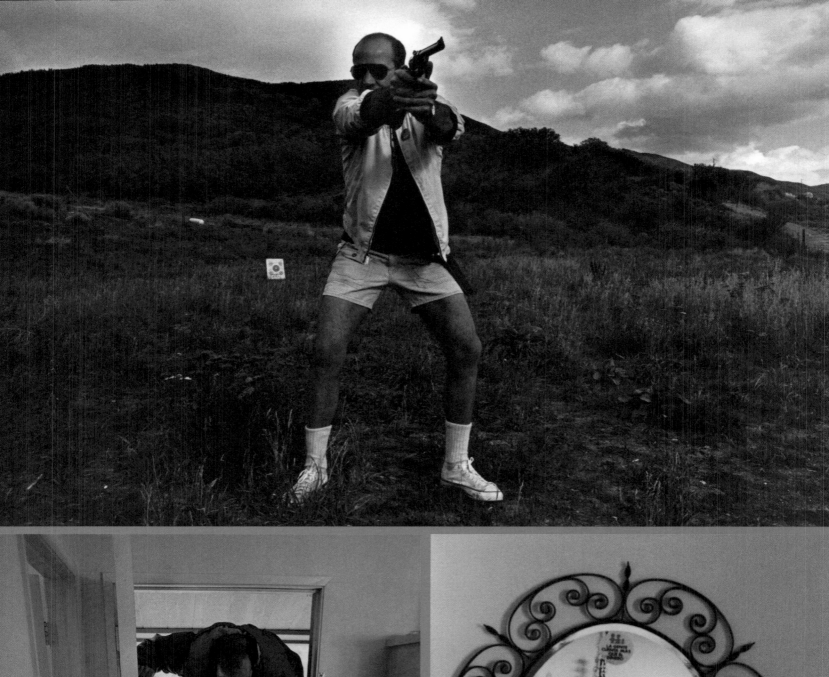

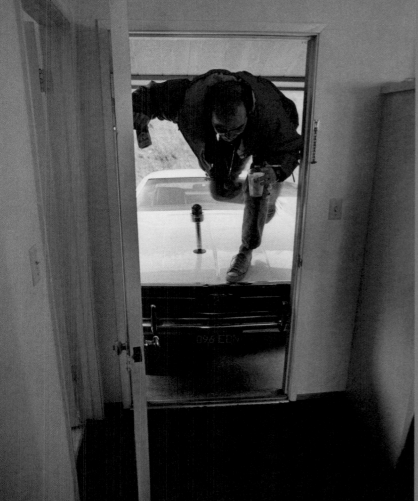

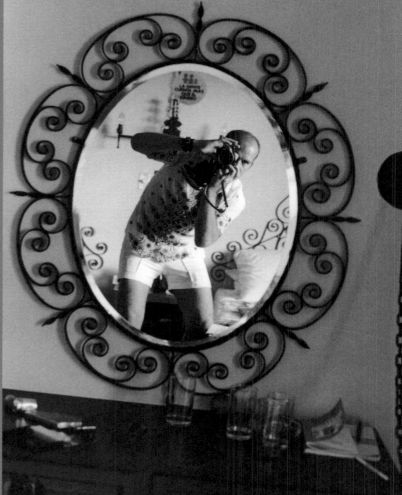

NEW TRUTH

ON RECOMMENDATION OF THE FACULTY OF THE

MISSIONARIES of the NEW TRUTH SCHOOL

THE SCHOOL HAS CONFERRED THE RANK OF

Doctor of Divinity

UPON

Hunter S. Thompson

who has honorably fulfilled all the requirements prescribed by the school for that rank and is hereby granted all the rights and privileges of that rank.

Done at Chicago, Illinois this _10th_ day of _July_ in the year _1970_.

A. M. Essary
ARCHBISHOP

A. W. Zurndorfer
DEAN

© GOES 463 LITHO IN U.S.A.

"I figure the Lord put us here for purely experimental reasons."

— Black acid-freak in G.G. Park — SF

Sex is Death
"Call 920-7721"

FLOAT

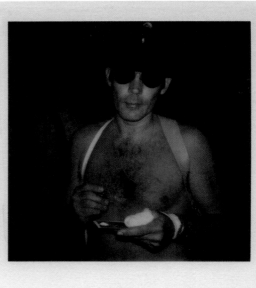

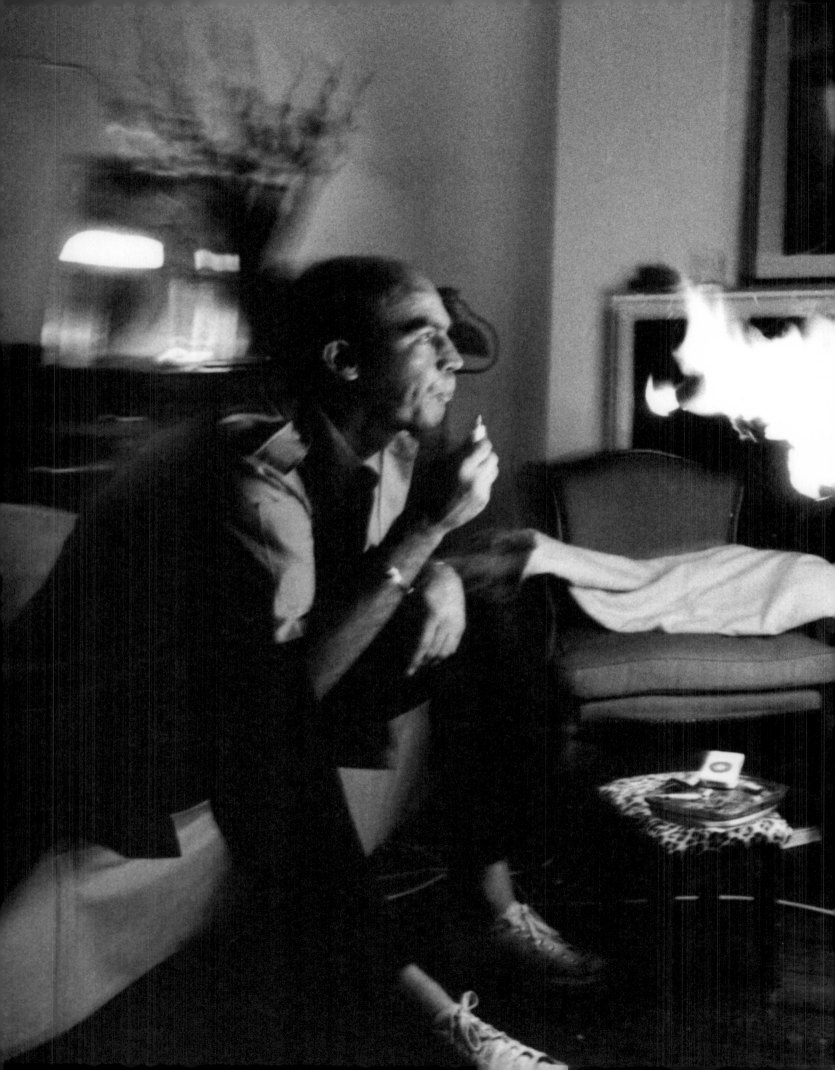

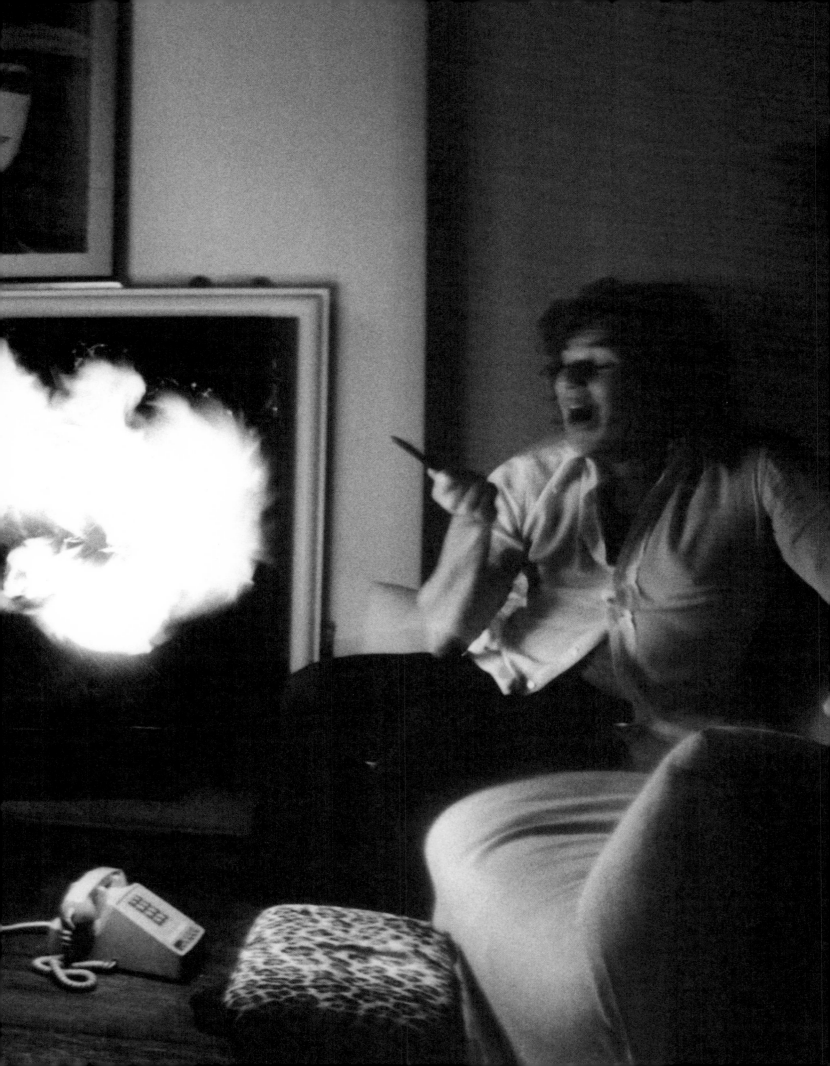

"That's why it's hard to write on mescaline, too, because your mind is going four times as fast as your hands can go, and you get disorganized and you can't keep your mind in phase with your fingers. That's why I have to get increasingly faster typewriters. Whatever they make, if it's faster, I'll buy it"

from "Songs of the Doomed", "LSD-25: Res Ipsa Loquitor", March 1990

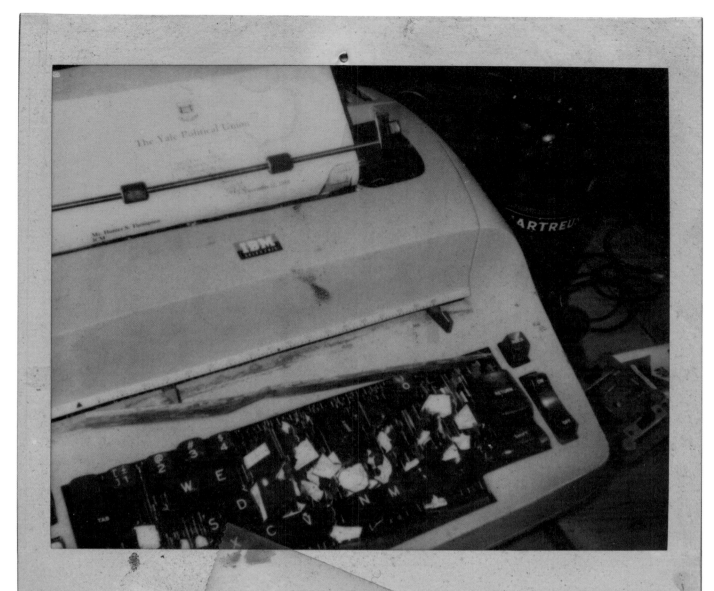

His
best shot
yet.

KEY WEST

Photographs circa 1979–1980

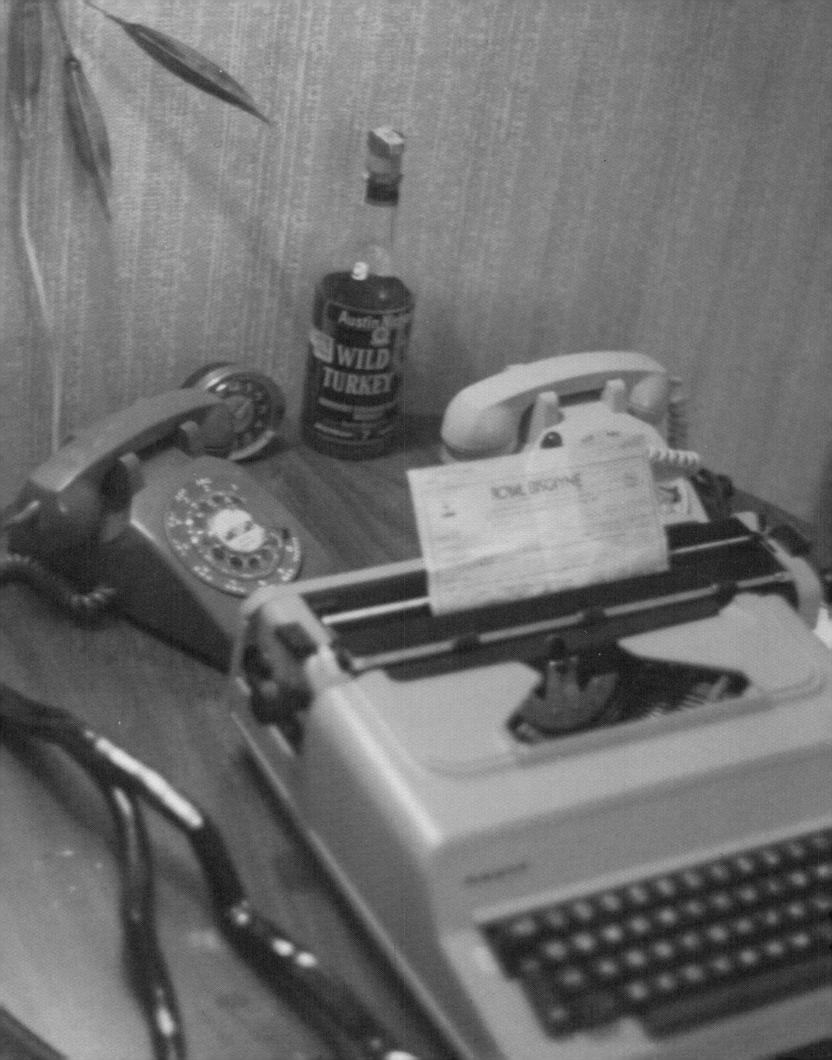

"My own boat—a 17-foot Mako with a big black Mercury engine on the back—is tied up about twenty feet in front of my typewriter, and I know the gas tank is full. I filled it up last night around seven o'clock in the evening, and when they asked me why I was gassing my boat up at the start of a bad moonless night I said I might want to go to Cuba. The fishhead woman laughed but I didn't."

from "Songs of the Doomed", "Sugarloaf Key: Tales of the Swine Family", March 18, 1983

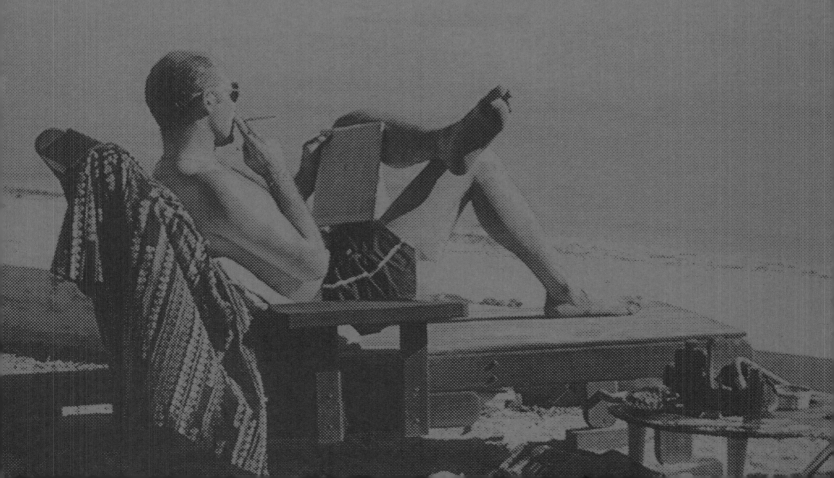

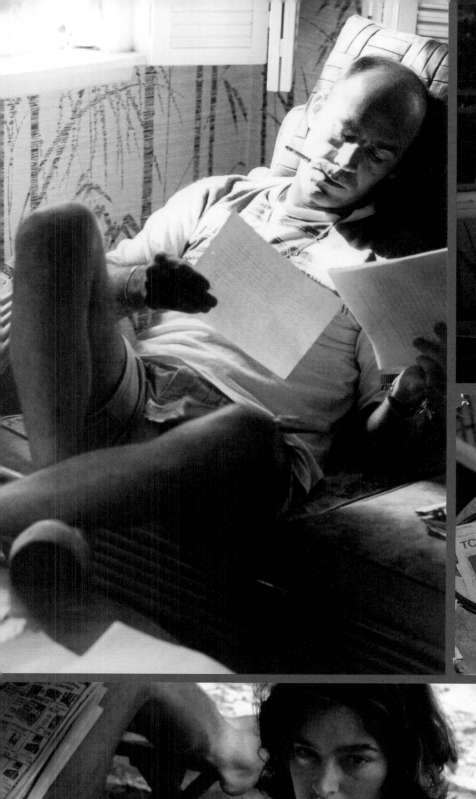
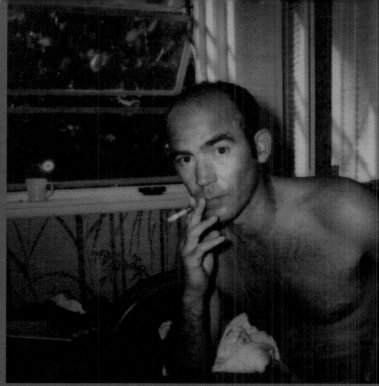
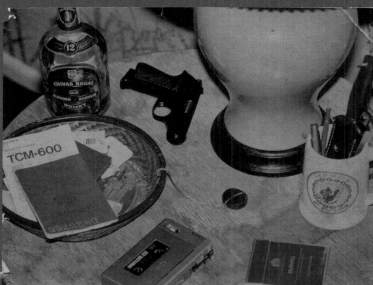
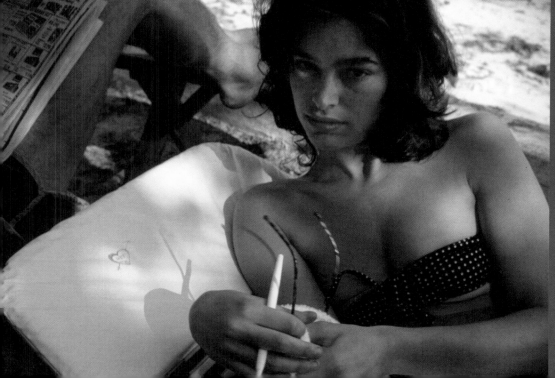
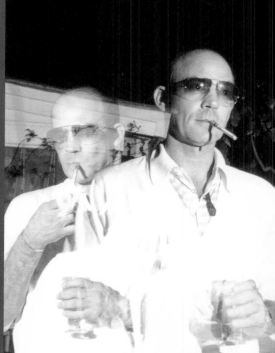

THE SILK ROAD
by Hunter S. Thompson

A fast, strange + occasionally violent story... Set in the Florida Keys during the Great Cuba-to-Key West "Freedom Flotilla" in the spring of 1980.

A novel (of 80,000 to 90,000 words) that will attempt to combine the narrative precision of "The Great Gatsby" + the high humor of "Fear + Loathing in Las Vegas" with a starkly elegant character-development — in the style of "Key Largo" + the movement of "Lord Jim."

— Key Biscayne: Skinner a good guy or a bad guy?

— Is it bad to work for the CIA? Nevermind the CIA

— Was Gatsby a good guy or a bad guy? He was a criminal + had worked with the mob...

Skinner should fit the 80's like Gatsby to fit the 20's.... the process of fitting Skinner to his time is what will keep me in the eye of the story... If living in a program now, I couldn't write the book. I wouldn't have to wait + see... the slower the gambler who survived the 60's + 70's) (Skinner is a good guy...

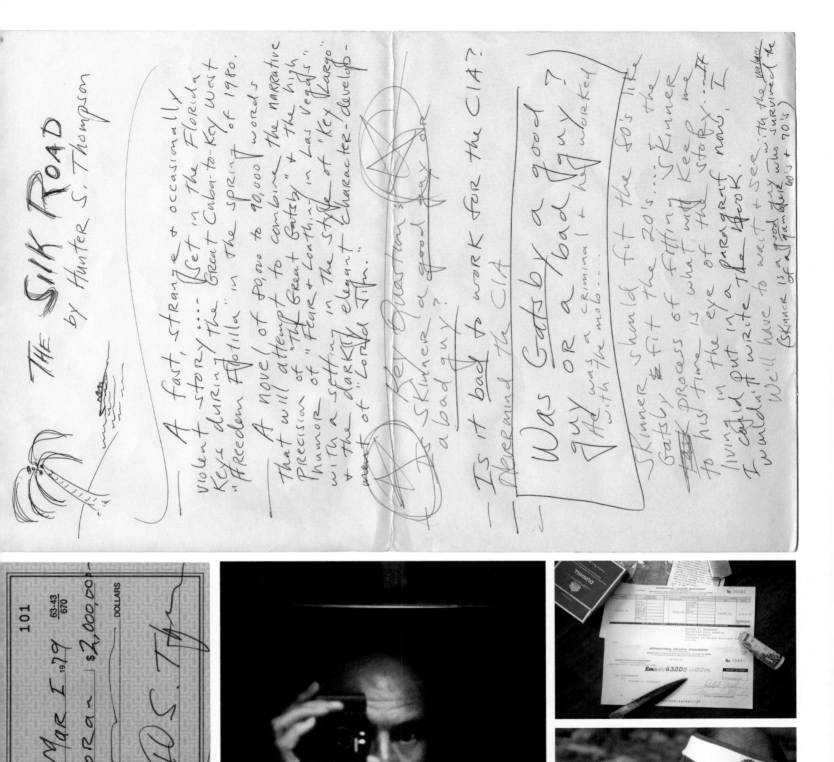

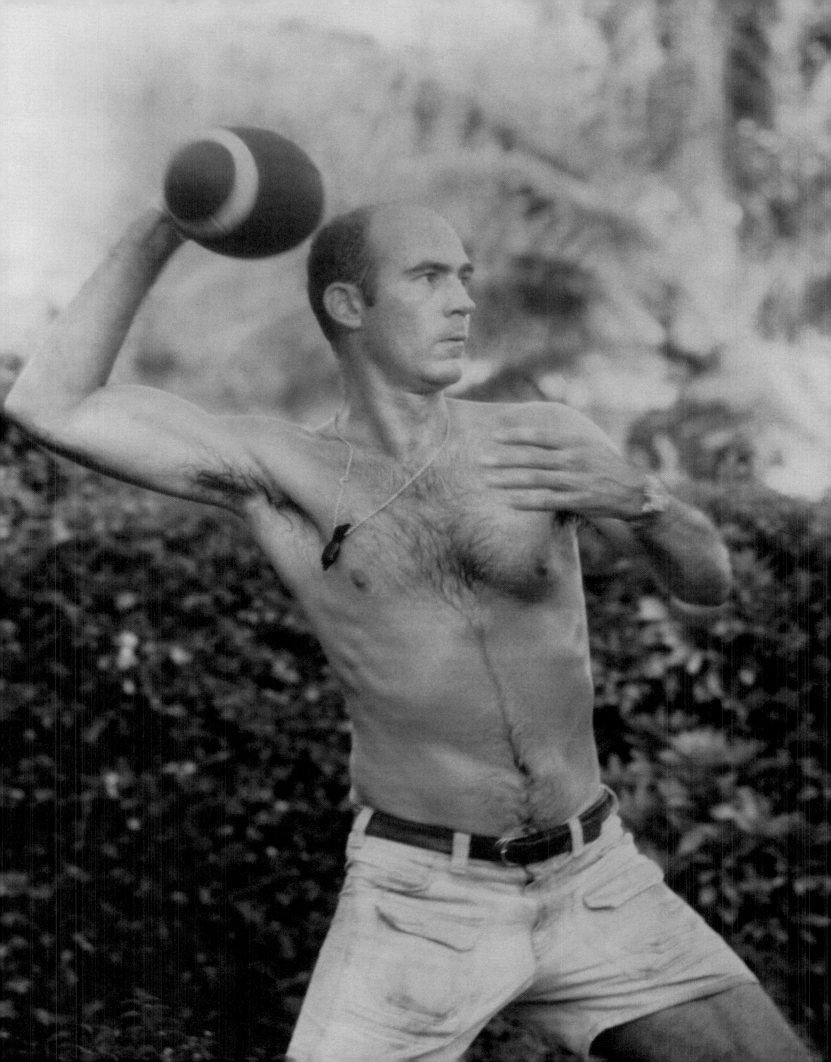

"I never claimed to be anything more than a nice guy and an athlete."

from "Sound Bites from Counter Culture", 1990

THE
CURSE
OF LONO

Photographs and memorabilia circa 1980s

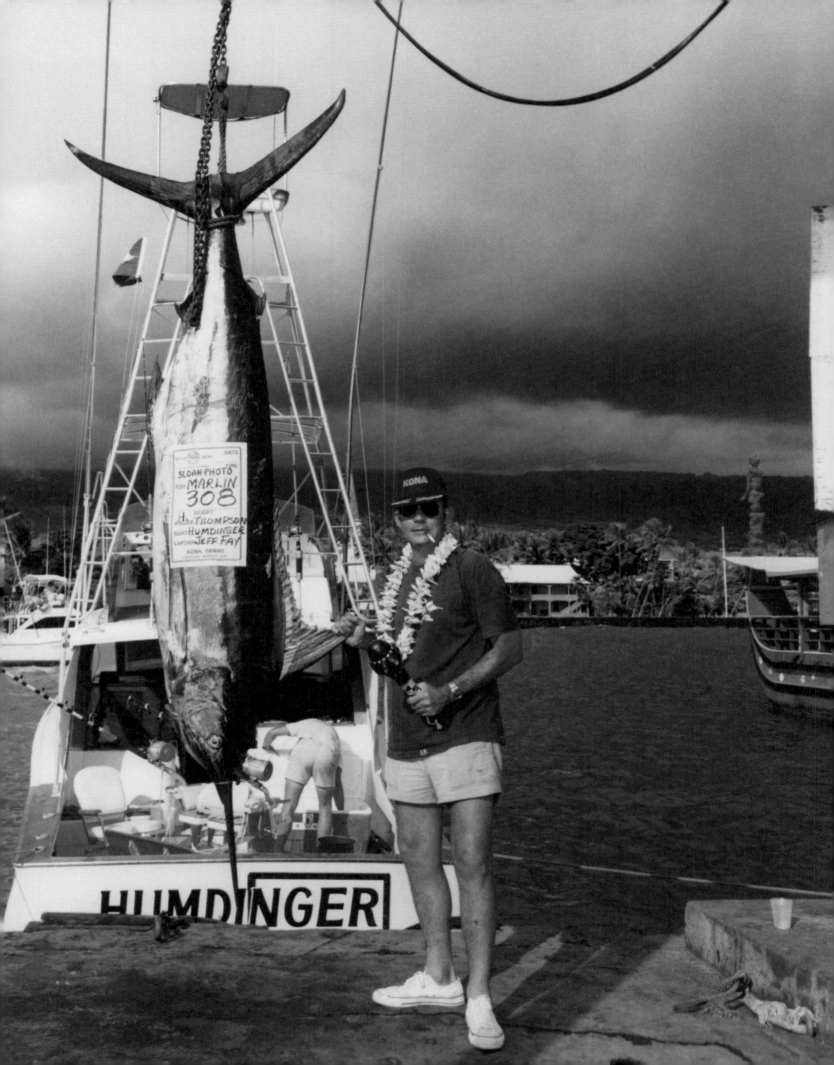

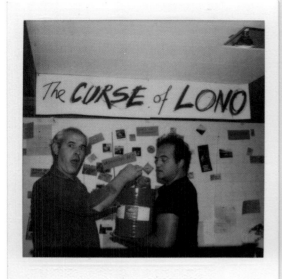

The CURSE of LONO

KONA COAST WITH GREEN
BANANAS ON DIVING BOARD.
AN H.S.T. ORIGINAL CONCEPT.

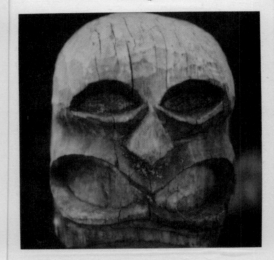

Sampan War Club
— The Long Wait.

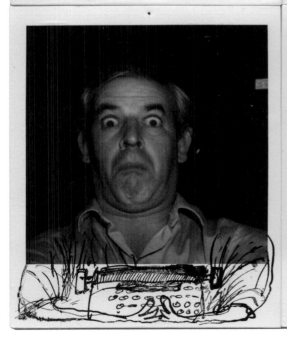

When the going gets
weird — RT.

Hawaiian Bait.

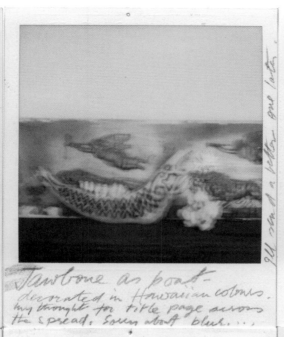

Jawbone as boat —
decorated in Hawaiian colours.
my thought for title page across
the spread. Sorry about blue....

Self portrait — a morning
after — on assignment.

Hunter fighting the black
rocks of KONA

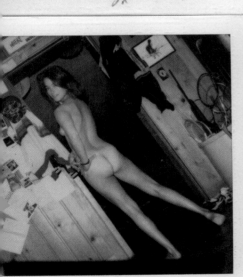

Victory through
shame

I HAVE A DEEP ROOTED
HORROR OF BEGINNING NEW
ASSIGNMENTS — PARTICULARLY
H.S.T. ONES — Ralph Steadman 4 April 81

"It's a queer life, for sure, but right now it's all I have. Last night, around midnight, I heard somebody scratching on the thatch and then a female voice whispered, "When the going gets wierd, the Weird turn pro". "That's right!" I shouted. "I love you!" There was no reply. Only the sound of this vast and bottomless sea, which talks to me every night, and makes me smile in my sleep."

from "Songs of the Doomed", letter to Ralph Steadman, June 30, 1981

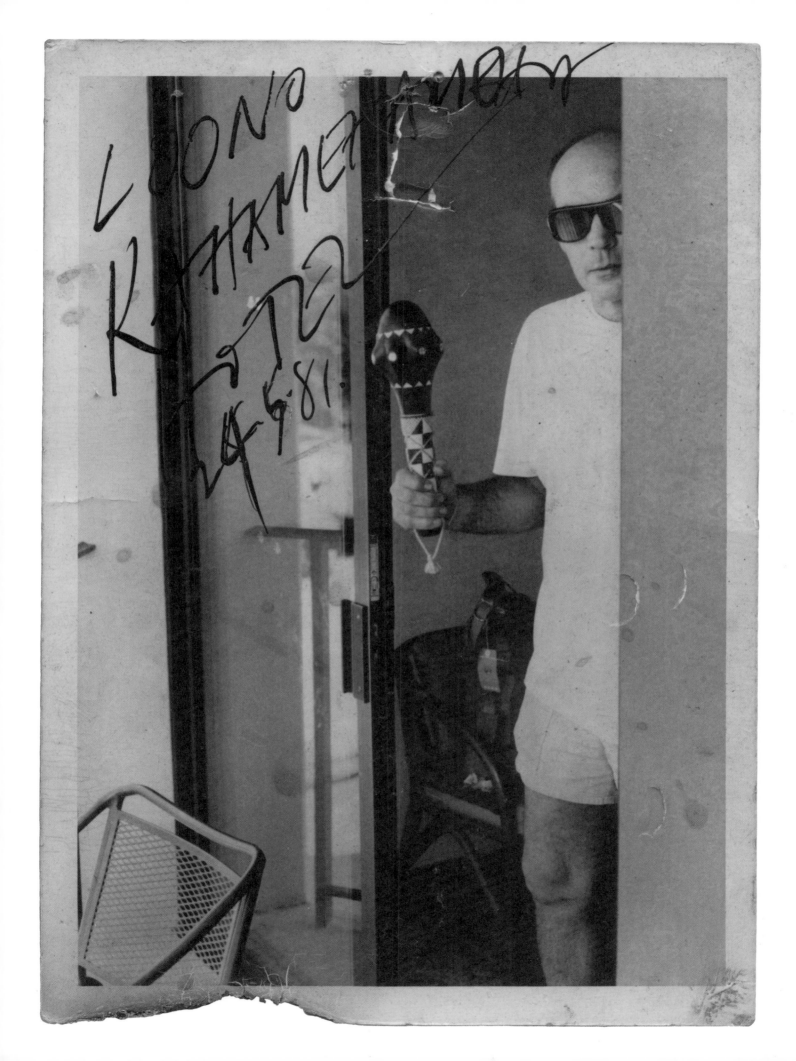

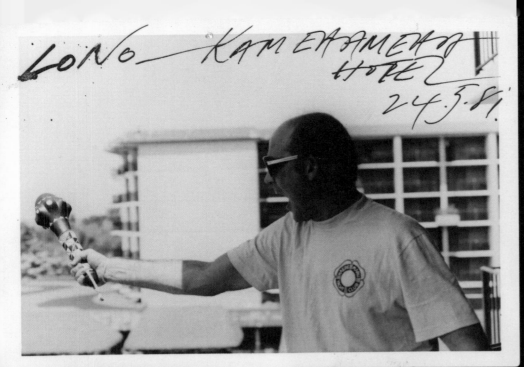

LONO KAMEHAMEHA HOTEL
24.5.81

Eyeball to
Eyeball

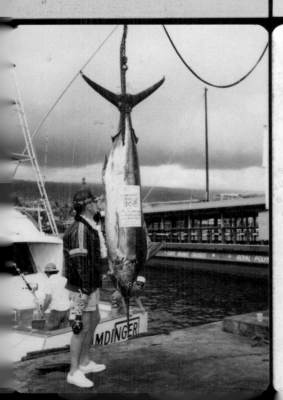

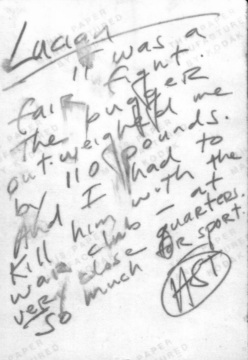

Lucia!
It was a
fair fight
the bugger
out-weighed me
by 110 pounds.
And I had to
kill him with the
war club — at
very close quarters.
So much for sport.
PAST

Ye fucking
Gods!?
I finally
see it now..
that... yes..
I am ZONO
That explains
everything.
Ho. Ho.?

NIGHT MANAGER

Photographs circa 1985

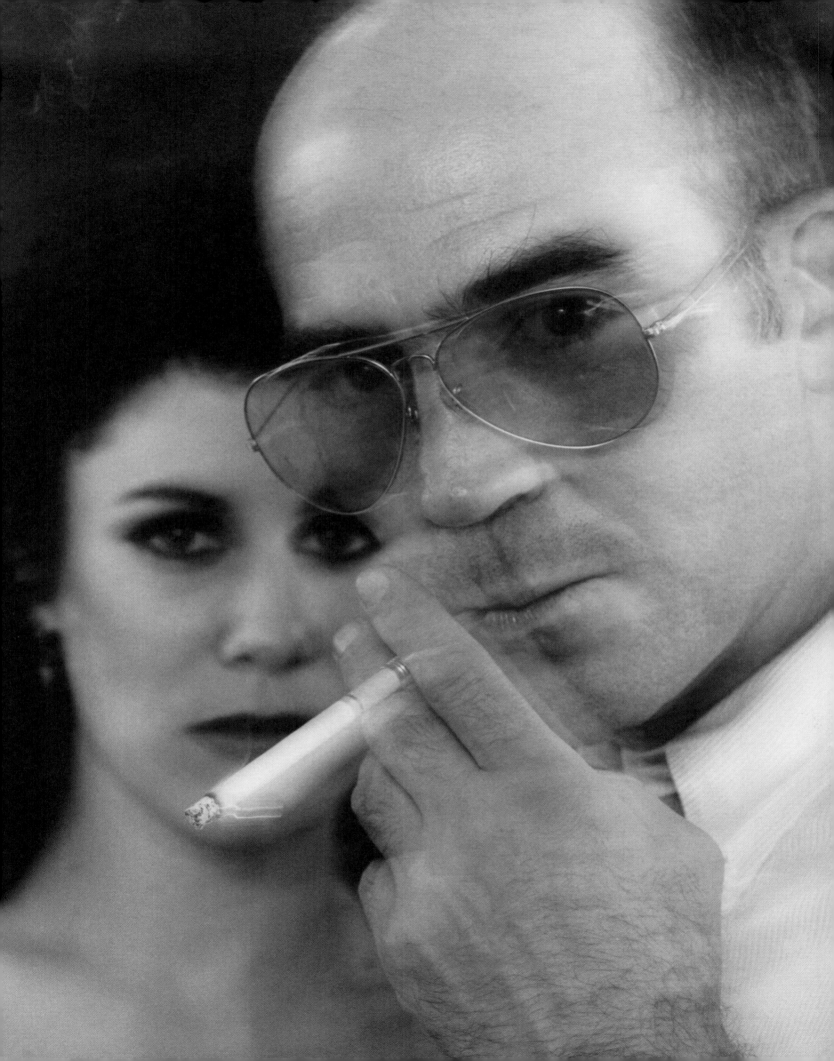

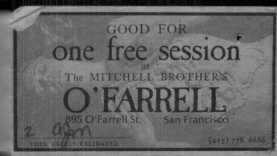

GOOD FOR
one free session
at
The MITCHELL BROTHER'S
O'FARRELL
895 O'Farrell St. San Francisco
2 *apr*

VOID UNLESS VALIDATED (415) 776 6686

Mitchell Brothers Theatre Circuit
895 O'FARRELL STREET, SAN FRANCISCO, CA 94109
(415) 441-1930

HUNTER S. THOMPSON
NIGHT MANAGER

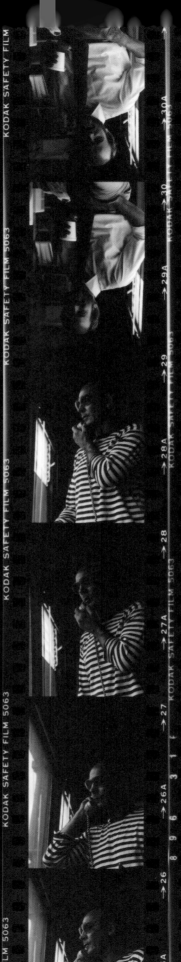

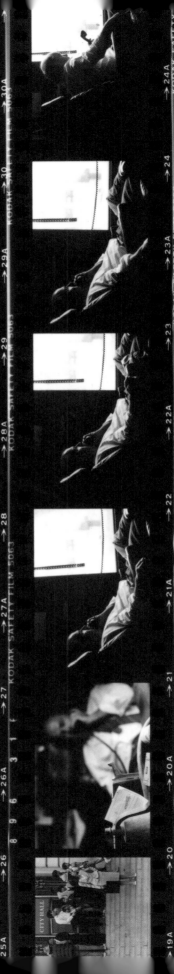

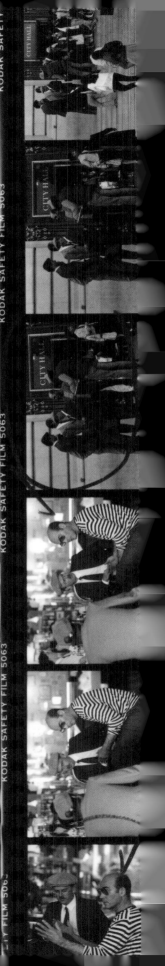

"We are all businessmen these days. I am on my way to SF to market a rare porno film, and I am three hours late for a crucial screening with the Mitchell Brothers at their embattled headquarters on O'Farrell Street. The driver is waiting for me at the airport with an armored car and two fat young sluts from Korea."

from "Kingdom of Fear", "Seize the Night", 2003

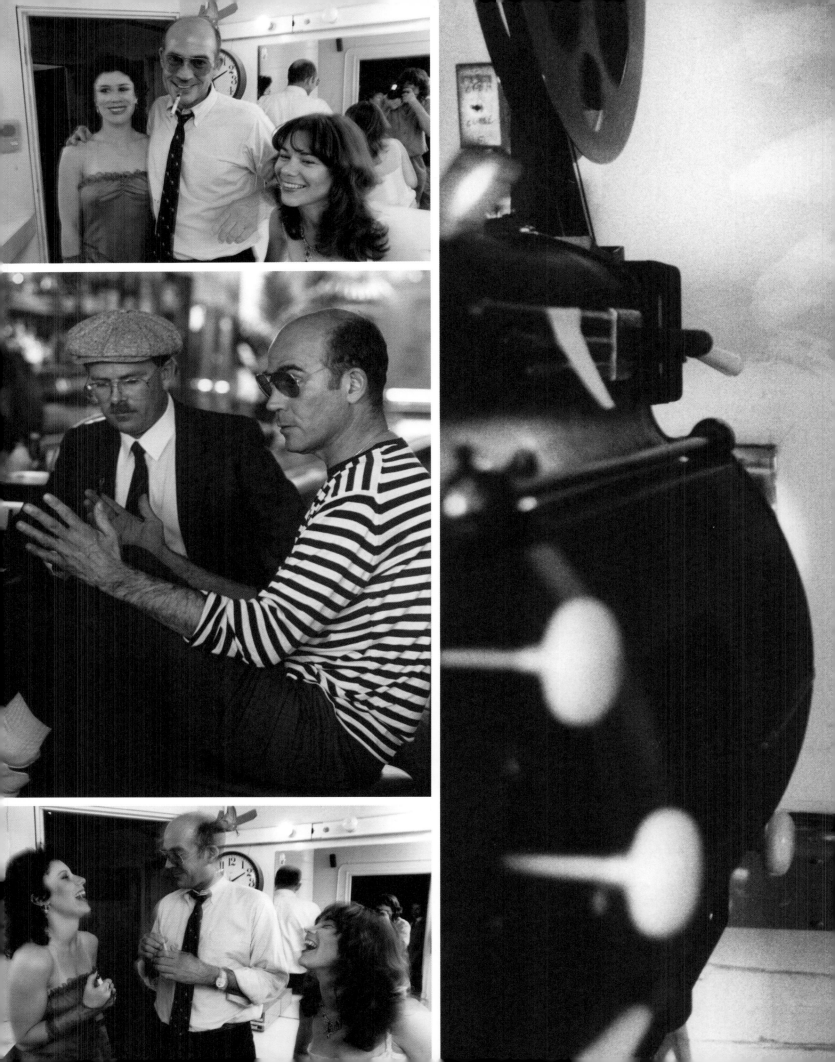

BUY THE TICKET TAKE THE RIDE

Photographs and memorabilia from 1980s–2005

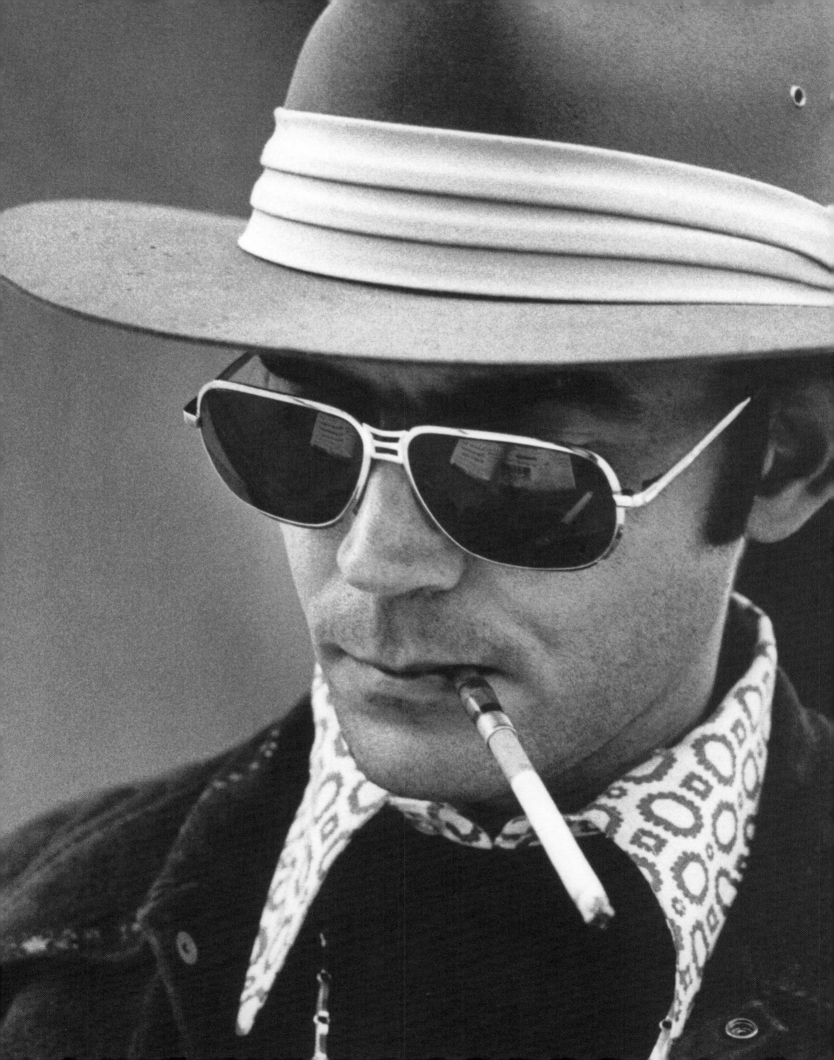

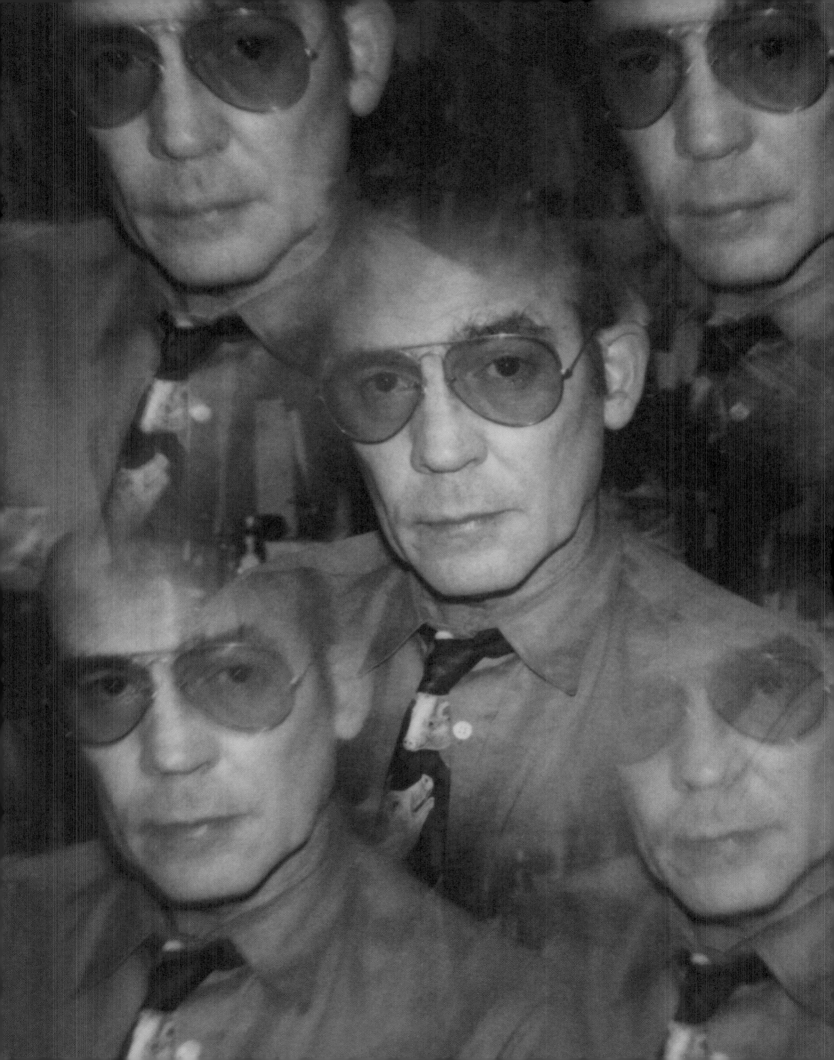

When at the same time your collected works are coming out, a movie's being made about you… and then you're in the comic strips… somewhere along there I became a public figure. Somehow the author has become larger than the writing. And it sucks."

from "Rolling Stone College Papers", interview with David Felton, 1980

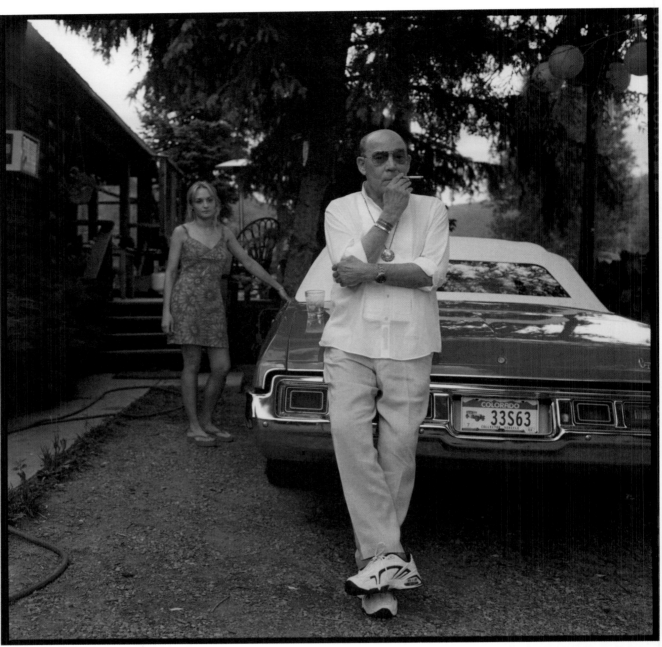

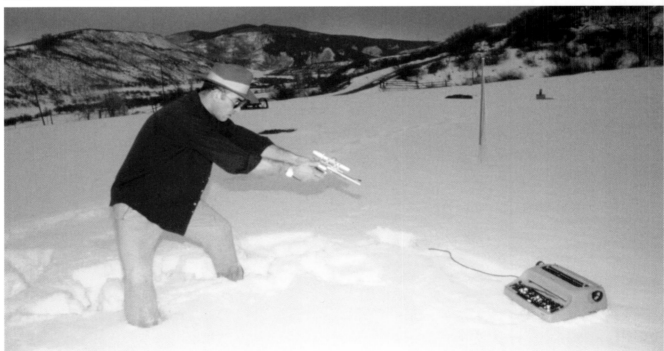

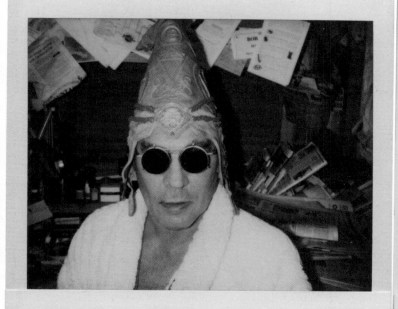

4

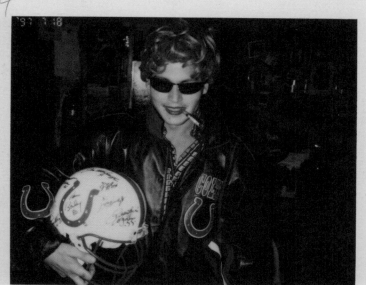

Father Son

Keep Alert

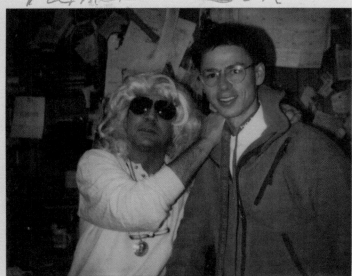

Don't let it happen to you....

Bomb Worshiper

"I hadn't adjusted too well to society—I was in jail for the night of my high school graduation—but I learned at the age of fifteen that to get by you had to find the one thing you can do better than anyone else… at least this was so in my case. I figured that out early. It was writing. It was the rock in my sock. Easier than algebra. It was always work, but it was worthwhile work. I was fascinated early on by seeing my byline in print. It was a rush. Still is."

from "Paris Review", interview with George Plimpton, Fall 2000

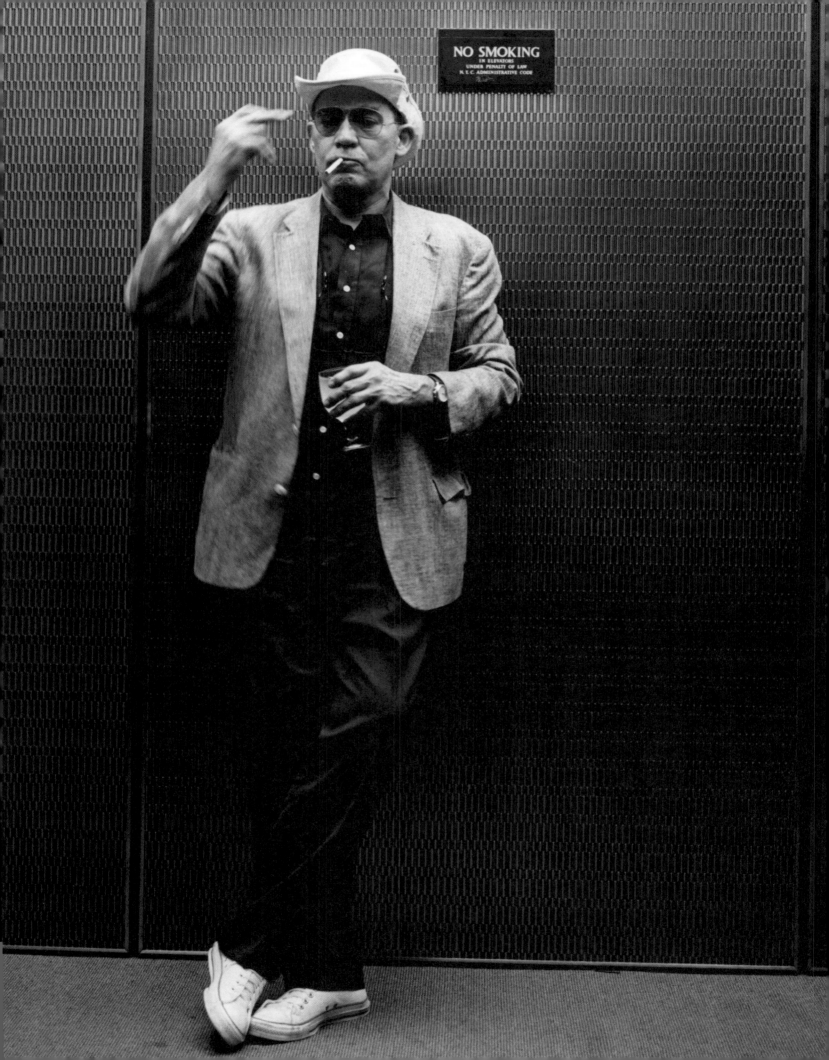

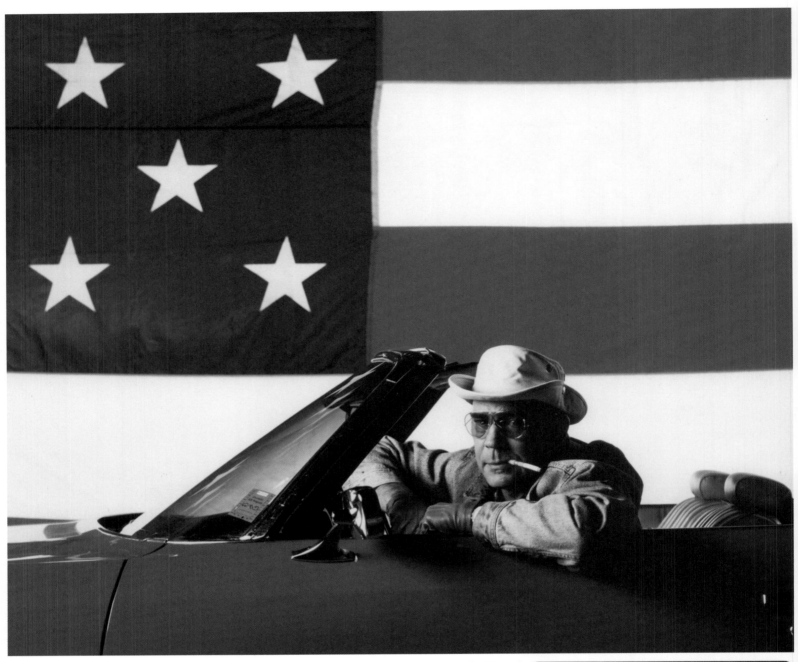

This is going to be a very expensive war, and Victory is not guaranteed—for anyone, and certainly not for anyone as baffled as George W. Bush. All he knows is that his father started the war a long time ago, and that he, the goofy child-President, has been chosen by Fate and the global Oil industry to finish it Now."

from "Kingdom of Fear," written September 12, 2001

"My life has been the polar opposite of safe, but I am proud of it and so is my son, and that is good enough for me. I would do it all over again without changing the beat, although I have never recommended it to others. That would be cruel and irresponsible and wrong, I think, and I am none of those."

from "Kingdom of Fear", "Memo from the Sports Desk", 2003

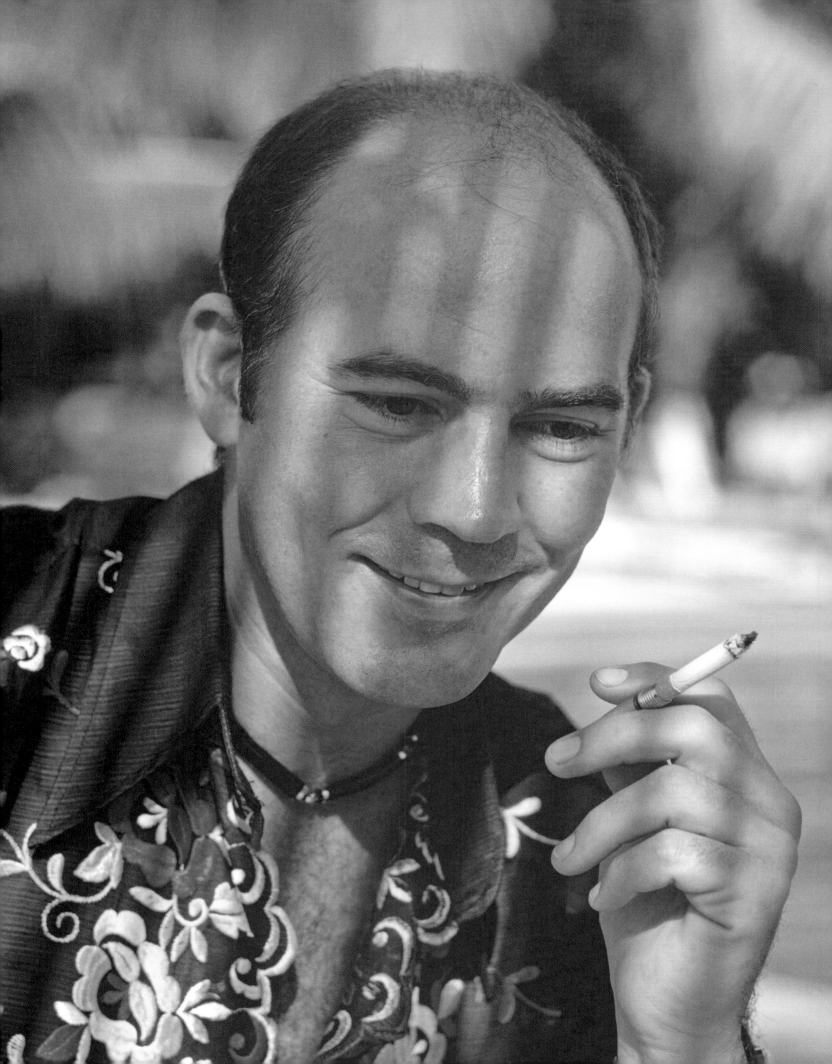

Kick Ass, Die Young

'We were angry and righteous in those days, and there were millions of us. We kicked two chief executives out of the White House because they were stupid warmongers. We conquered Lyndon Johnson and we stomped on Richard Nixon—which wise people said was impossible, but so what? It was fun. We were warriors then, and our tribe was strong like a river. That river is still running. All we have to do is get out and vote, while it's still legal, and we will wash those crooked warmongers out of the White House."

from "Rolling Stone", "Fear and Loathing, Campaign 2004", 2004

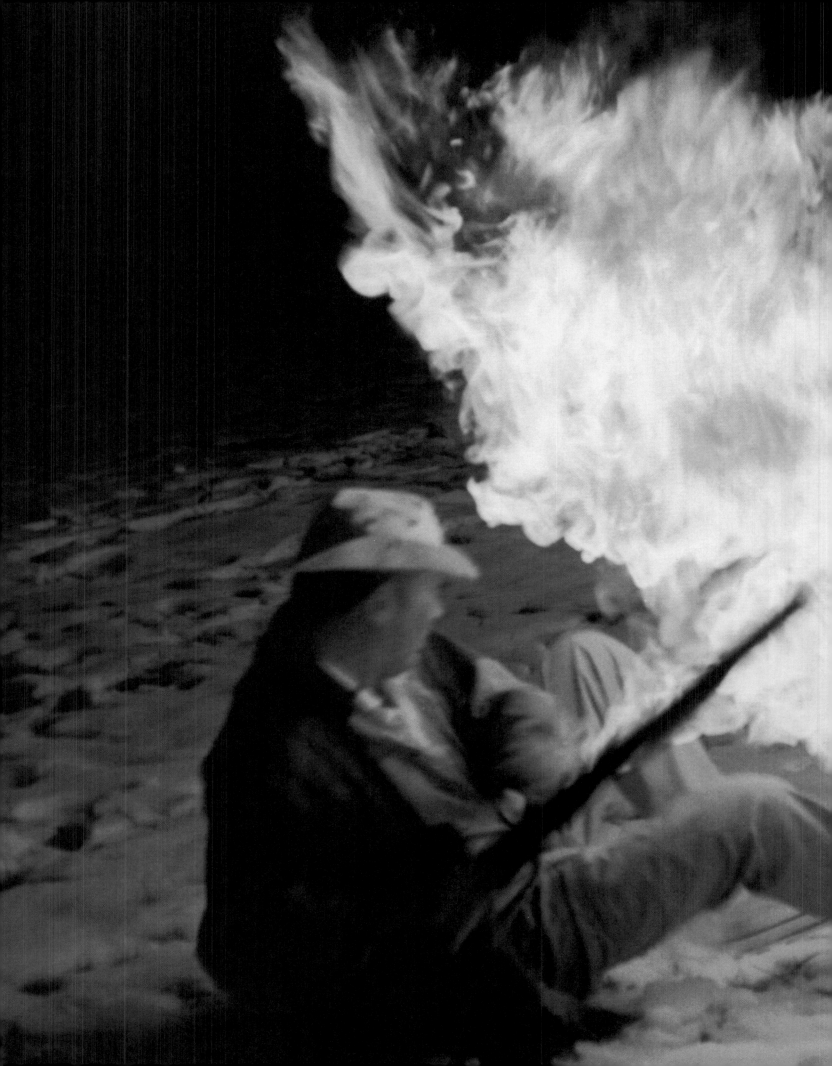

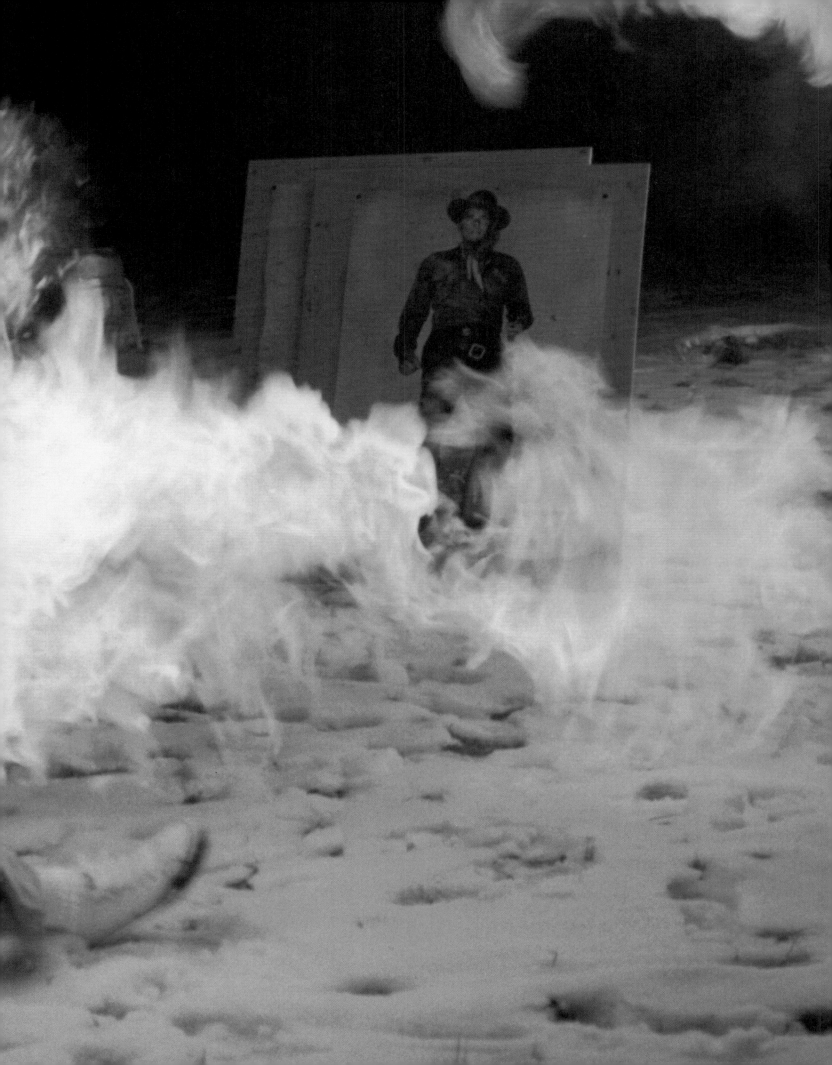

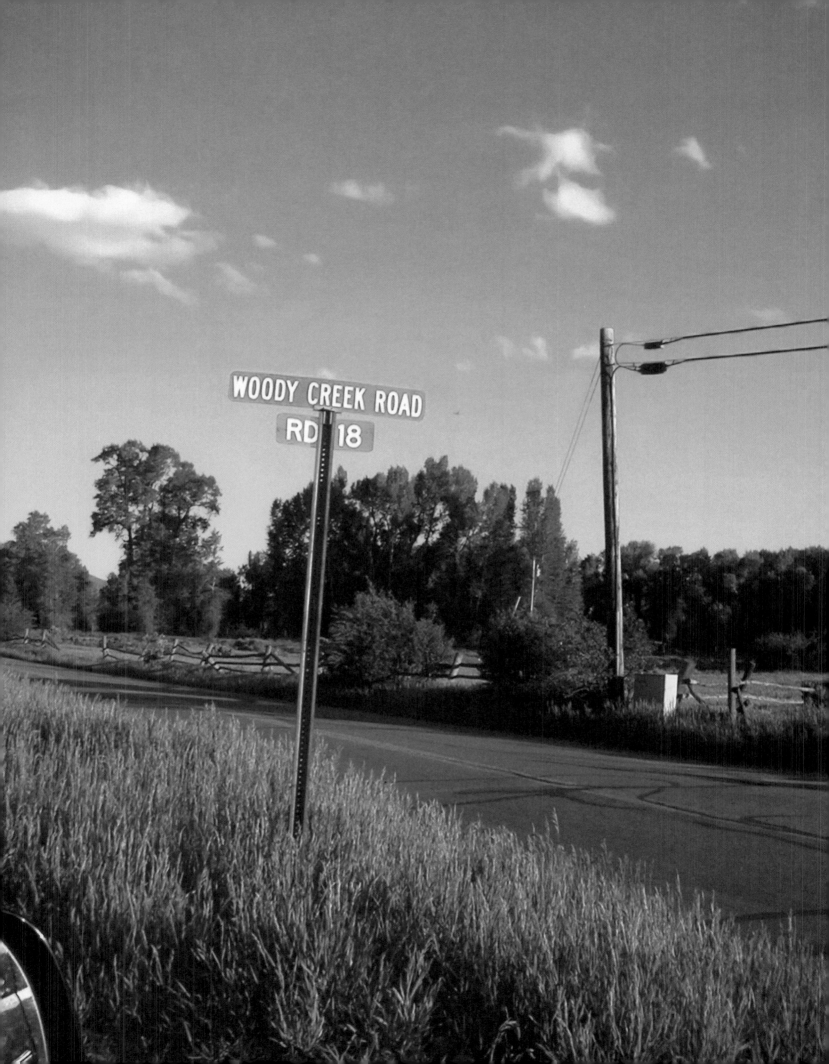

"Maybe there is no Heaven. Or maybe this is all pure gibberish, a product of the demented imagination of a lazy drunken hillbilly with a heart full of hate who has found out a way to live out there where the 'real' wind blows—to sleep late, have fun, get wild, drink whiskey and drive fast on empty streets with nothing in mind except falling in love and not getting arrested....

Res ipsa loquitor.
Let the good times roll."

from "Generation of Swine", author's note, 1998

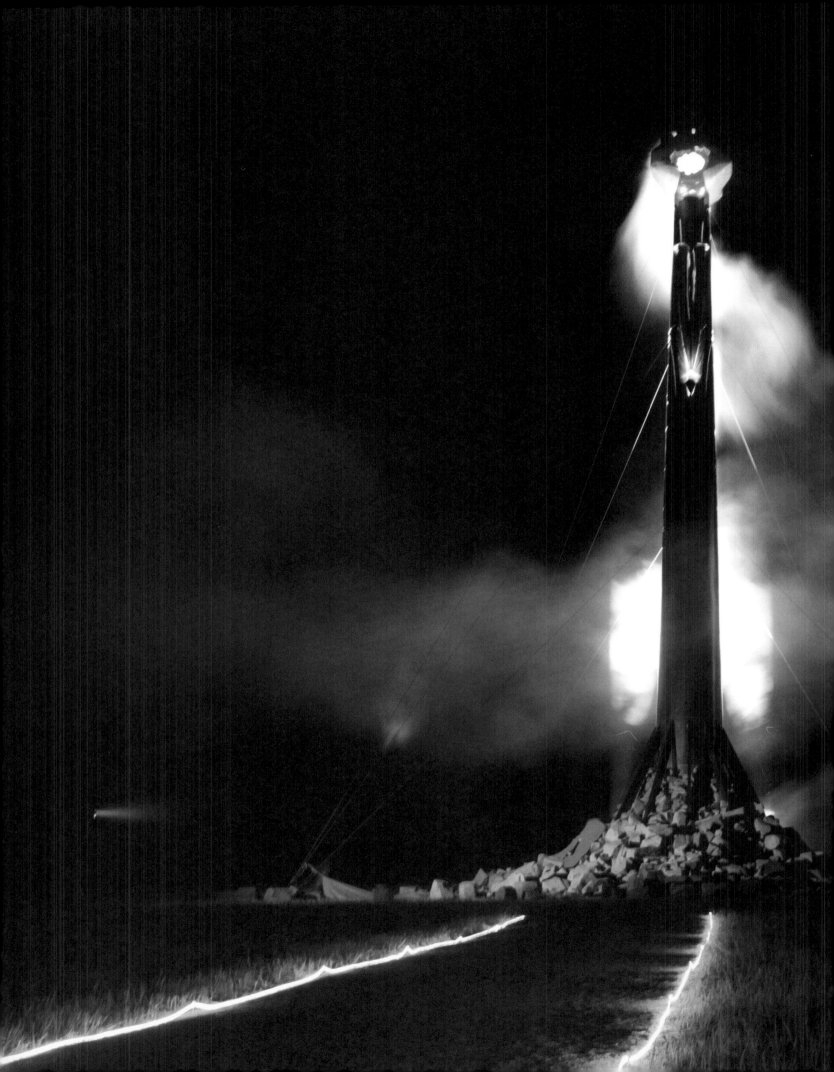

"It never got weird enough for me."

LIST OF PLATES

All original photographs and art used within GONZO were created by Hunter S. Thompson, unless otherwise noted below:

AIR FORCE DAYS

Page 013: News release written by HST, 1957
Page 014–015: HST at hanger party, 1957
Page 017: HST with Fred Fulkerson, Foster Stadium, one week before D-day, Eglin, 1957

ROAD TRIP TO THE WEST COAST

Page 019: HST on road, photo by Paul Semonin, September 1960
Page 023: "Low Octane for the Long Haul" by HST
Page 025: Steve Bragg with gas can, Kansas
Page 026: HST and Paul Semonin

NEW YORK

Page 029: Street portrait, New York City
Page 032–033: Making beer in HST apartment, March 1962
Page 035: Bronx Zoo tiger
Page 036–038: Cuddebackville, New York, photos by Robert W. Bone

RUM DIARY DAYS

Page 041: Unknown woman and HST, Puerto Rico, 1960
Page 042: San Juan, Puerto Rico, photos by Robert W. Bone
Page 043: HST in St. Thomas cemetery, photo by Paul Semonin
Page 045: Sandy Conklin, HST, and Paul Semonin, Bermuda, photo by Bermuda News Bureau
Page 046–047: HST self portrait, Aruba, 1961

BIG SUR

Page 051: Sandy Conklin on rock, Big Sur
Page 054–055: Agar and Sandy, Big Sur
Page 056: HST with telescope, photo by Jo Hudson
Page 059: Sandy Conklin with Agar, on road trip with HST after leaving Big Sur
Page 060: HST self portrait, Big Sur

ROAD TRIP TO TIJUANA

Page 066: HST self portrait, on road to Tijuana
Page 071: Highway 101, Gaviota Pass, California

KENTUCKY

Page 073: HST self portrait, Louisville, 1963
Page 078–079: HST and Don Cooke in pool hall, Louisville, 1962, photos of HST by Don Cooke
Page 080–085: National Folk Festival, Covington, Kentucky, 1963

SOUTH AMERICA

All photographs by HST while on assignment for "The National Observer"

PLUMAS COUNTY FAIR

All photographs by HST while on assignment for "The National Observer", 1963

Page 103: HST self portrait, Plumas County, California, 1963

HELL'S ANGELS

All photographs by HST while riding with the Hell's Angels, circa 1965-1966

Page 117: Terry the Tramp and friend
Page 119: HST after stomping by the Hell's Angels, 1966

WOODY CREEK

Page 123: HST with motorcycle, Woody Creek, photo by Michael Montfort
Page 128: Contact sheet of Juan Thompson
Page 130: Shotgun art with Juan Thompson
Page 131: HST, Woody Creek, photo by Michael Montfort

FREAK POWER TICKET

Page 133: Thompson for Sheriff poster, by Tom Benton, 1970
Page 134: Girl with HST poster, and HST at radio station, photos by David Hiser
Page 134: Oscar Acosta portrait, photo by Bob Krueger
Page 135: Campaign poster, and voting booth detail, photos by David Hiser
Page 135: HST signing card, photo by Bob Krueger
Page 136: Photo by David Hiser
Page 138–139: Photos by Bob Krueger
Page 140–141: Photo by David Hiser
Page 143: Photo by David Hiser

FEAR AND LOATHING IN LAS VEGAS

Page 147: First page of original "Fear and Loathing in Las Vegas" manuscript
Page 154: Original "Rolling Stone" cover, illustration by Ralph Steadman
Page 155: Original "Rolling Stone" cover, illustration by Ralph Steadman

FEAR AND LOATHING: ON THE CAMPAIGN TRAIL '72

Page 164: HST with Democratic presidential candidate George McGovern, 1972, photo by Annie Leibovitz
Page 165: HST on campaign bus, 1972, photo by Annie Leibovitz
Page 167: Original "Rolling Stone" cover, illustration by Ralph Steadman
Page 169: HST sleeping, photo by Annie Leibovitz

THE 1970s

Page 171: HST on beach, Cozumel, Mexico, March 12, 1974, photo by Al Satterwhite
Page 172–173: HST in Arab robes, photos by Laila Nabulsi
Page 173: HST bare chested, sleeping, and wearing towel, photos by Laila Nabulsi
Page 173: Bill Murray and John Belushi
Page 175: HST sobriety test, photos by Annie Leibovitz

Page 176: HST firing gun, photo by Michael Montfort
Page 176: HST in doorway, photo by Annie Leibovitz
Page 176: HST self portrait in mirror, Cozumel
Page 177: HST Polaroid, photo by Laila Nabulsi
Page 178–179: HST and Jann Wenner, New York, 1976, photo by Annie Leibovitz

KEY WEST

All photographs in Key West by Tom Corcoran, except page 183.

Page 183: Still life with typewriter
Page 187: "The Silk Road", unpublished original outline by HST

THE CURSE OF LONO

Page 195–196: HST with Samoan war club, Hawaii. photos by Ralph Steadman

NIGHT MANAGER

Page 199: HST smoking, photo by Michael Nichols
Page 200: Contact sheet by Matthew Naythons
Page 202: HST with girls, photos by Michael Nichols
Page 202: HST with Jim Mitchell, photo by Matthew Naythons
Page 203: Projection booth, photo by Matthew Naythons

BUY THE TICKET, TAKE THE RIDE.

Page 205: "The Great Shark Hunt" cover, photo by Edmund Shea
Page 208: HST with Anita Thompson, photo by Jonathan Becker
Page 208: HST shooting typewriter, photo by Paul Chesley
Page 209: Johnny Depp with football helmet
Page 209: HST in wig with Juan Thompson
Page 211: HST in elevator, photo by Chris Buck
Page 212: HST in car, photo by Louie Psihoyos
Page 215: HST portrait, photo by Al Satterwhite
Page 218–219: HST with fireball, Woody Creek, Colorado, photo by Deborah Fuller
Page 220: Woody Creek Road, photo by Steve Crist
Page 222–223: HST memorial, Owl Farm, August 20, 2005, photo by Peter Mountain

INTRODUCTION

Quand je pense à Hunter, ce qui m'arrive très souvent, je me sens immédiatement envahi par un flux irrépressible de souvenirs. Des souvenirs qui me traversent l'esprit, aussi variés que l'homme lui-même a pu l'être. Voici quelques images de nos aventures les plus privées.

Une expédition à l'aube pour acheter des pistolets magnum…

Un rendez-vous à 3 heures du matin pour un rasage de tête, exécuté avec diligence et délicatesse par le Docteur en personne…

Des cuites soignées tendrement—en sirotant du *Fernet Branca* tout en tirant sur une bouteille d'oxygène (aucune des deux méthodes ne marche)…

La pure satisfaction de le voir saler et poivrer ses mets (ça pouvait lui prendre plus d'une heure, mais jamais moins de vingt minutes)…

Une décision heureusement de courte durée mais qui a failli nous être fatale de nous marier à des péquenaudes—par correspondance…

Nous deux, jacassant comme des fous, à pourchasser dans la maison un mainate échappé de sa cage (Edward—un cadeau de Hunter et Laila Nabulsi)…

Cinq jours et cinq nuits passés enfermés dans une chambre d'hôtel de San Francisco (une longue accumulation de condiments, d'assiettes de fruits, de club sandwiches, de cocktails de crevettes, et oui… de pamplemousses, le tout formant une pile précaire qui touchait le plafond de notre suite)…

Des heures et des heures passées en des tête-à-têtes intensément lyriques—à lire de miraculeux passages dans ses œuvres nombreuses et légendaires…

Et puis ces remarques spontanées et brillantes, qui auraient fait crouler n'importe qui de rire, ces moments intenses de rages hystériques, d'hilarité et de baratin qui me faisaient pleurer de rire et de douleur par terre.

Il avait le coup de main, notre bon docteur. Il avait le don étrange de pouvoir froisser quelqu'un en gardant tout son charme et en étant irrésistiblement persuasif. Et cela en restant cohérent (car il avait toujours de la cohérence). Un œil attentif pour tout ce qui pouvait se passer autour de lui. Observateur infatigable, il ne prenait jamais son talent pour acquis. Sa nature était d'observer et de disséquer toute situation, donc observation et dissection ont été menées avec une ferveur inexorable. Il les vivait, les respirait et les célébrait dans leur totalité. Et si par chance, vous aviez la chance de devenir le compagnon d'une de ses escapades, vous le deveniez dans la plus grande intensité.

Chaque document, chaque bout de papier, chaque serviette de cocktail et chaque photo était sacré pour Hunter. Ce livre reflète la trame essentielle de la tapisserie de sa vie, assemblant les pièces d'un puzzle qui auront été consciencieusement rangées et mises en sécurité pour la postérité. Elles offrent un éclairage important dans sa vie et dans son œuvre. Une flânerie le long de ces pages nous montre que Hunter était non seulement prêt, mais qu'il était même en harmonie parfaite avec ce que le destin avait en réserve pour lui.

Quelques minutes après avoir appris sa décision bouleversante de mettre fin à ses jours, j'étais au téléphone avec Laila, essayant désespérément de comprendre ce qui s'était passé, ce qui était impossible. On était tous les deux en larmes, à se consoler l'un l'autre dans ces circonstances douloureuses. Et tout à coup, la même idée nous a traversé l'esprit, comme si le Docteur lui même nous avait sorti de notre brouillard. Au même moment, on s'est exclamés « ET LE CANON ? », « mon dieu… le monument… ». À cet instant, notre perspective a commencé à changer. On était au courant des exigences de Hunter et elles n'étaient pas minces. « Rien de Minable ! », cela semblait être le mot d'ordre de notre ami disparu. Les sketches et les plans ont été dessinés dès le lendemain et la construction du monstre a démarré dans les semaines qui ont suivi. Il avait demandé un monument/canon de 45,70 mètres pour catapulter ses restes dans le ciel au dessus de sa chère Owl Farm. Simple. Pas si simple. On m'a conseillé d'abandonner toute espoir de voir cette mission s'accomplir. Non seulement impossible, mais complètement dément, m'a-t-on dit. On a persisté. Au cours des recherches conduites pour rendre cet impossible possible, j'ai découvert que la Statue de la Liberté mesurait 46 mètres de haut !!! Merde… Le monument de Hunter prenait des proportions minables en comparaison. Sachant l'importance que chaque détail possédait pour lui, et c'était un détail

qui devait être réglé prompto, on a pris la décision d'augmenter la mise et les plans ont été modifiés pour que le monument atteigne 46,60 mètres. Soixante centimètres de plus. Pourquoi ? Parce que dans la mort comme dans la vie, Hunter aurait dépassé le Rêve Américain de plus d'un centimètre ou deux. Si tout un chacun peut conduire une voiture avec une pression de pneu à 18 kilos, Hunter la conduirait avec une pression à 45 kilos, juste pour être sûr. Sûr de quoi, il était le seul à savoir. C'était un truc à la Hunter. L'équipe de construction du Monument a travaillé d'arrache-pied pour réaliser ses dernières volontés, mettant l'impossible dans le domaine du possible. On a réussi à rester concentrés et motivés, même quand on a été confrontés à un échec potentiel, une éventualité qui nous a accompagnés tout au long du projet. C'est seulement plus tard, quand j'ai été tout complètement absorbés par le projet, que je me suis rendu compte qu'une grande partie de l'intention de Hunter avait été de distraire ses amis les plus proches de leur douleur en leur assignant une tâche aussi pharaonique. Il était fin psychologue, ce Dr. Thompson.

Des morceaux choisis me reviennent constamment en mémoire quand je me souviens du bon docteur. Même aujourd'hui, presque deux ans après sa disparition, je suis toujours aussi transporté quand je pense à lui. Et même si je sais qu'il ne téléphonera pas, que cette canaille ne va pas m'appeler continuellement au milieu de la nuit, j'entends sa voix. Je l'entends hurler chaque fois que le son « One Toke Over the Line » sort de la radio, je l'entends exulter quand « Sympathy for the Devil » résonne. Il se calme et médite sur la gravité de « Mr. Tambourine Man ».

Il apparaît quand j'ai besoin de lui.

Il arrive quand l'absurdité culmine.

J'imagine qu'il le fera toujours.

Col. Depp
Los Angeles, 5 septembre 2006

INTRODUCTION

"Laissons le lecteur s'interroger : quel est l'homme le plus heureux, celui qui a bravé les orages de la vie et a vécu, ou celui qui est resté en sécurité et s'est contenté d'exister ?"
Extrait de "Security" de Hunter S. Thompson
à l'âge de dix-sept ans, 1955

PÉRIODE DE L'ARMÉE DE L'AIR
Base de l'Armée de l'Air à Eglin, 1956–1957

"Devenez clochard sur la plage, soûlard à Paris, maquereau en Italie ou pervers au Danemark, mais ne vous engagez jamais dans les forces Armées."
Extrait de "The Proud Highway", lettre écrite de la base de l'Armée de l'Air à Eglin, 10 mars 1957

VOYAGE EN VOITURE SUR LA CÔTE OUEST
Photographies datant d'environ 1960

"À 22 ans, j'ai créé le record encore imbattu de la distance parcourue à faire du stop en bermuda : 6000 kilomètres en trois semaines."
Extrait de "The National Observer", "The Extinct Hitchhiker", 22 juillet 1963

"Aucun bus, aucun avion ni aucun train ne pourra remplacer le sentiment qu'on peut avoir au bord de la route, avec le soleil du matin dans la figure et l'odeur de l'herbe coupée qui embaume, et pour seul souci de savoir jusqu'où la prochaine voiture nous emmènera."
Extrait de "The National Observer", "The Extinct Hitchhiker", 22 juillet 1963

NEW YORK
Photographies datant d'environ 1957–1962

"Mon appartement, qui était la scène d'une intimité discrète et d'une sexualité paresseuse, s'est métamorphosé dans les deux dernières semaines en un antre de démence soûle et hurlante. Il y a des gens qui dorment partout—dans mon lit, sur le canapé, sur le lit de camp, et même par terre dans des sacs de couchage. Tout a pris une odeur de bière éventée, presque tous mes disques sont cassés, tous mes draps, mes serviettes et mes habits sont sales, la vaisselle n'a pas été faite depuis des semaines, mes voisins sont allés voir mon propriétaire pour me faire expulser, je ne baise plus, je n'ai pas d'argent, pas de nourriture, pas d'intimité, et certainement pas de tranquillité d'esprit."

Extrait de "The Proud Highway", lettre à Larry Callen, appartement de Perry Street, 6 juin 1958

"Au vu de ma situation actuelle, je vais devenir écrivain. Je ne suis pas sûr d'être bon, ni même de pouvoir gagner ma vie avec, mais jusqu'au jour où la main noire du destin m'écrase dans la poussière et me dit « tu n'es rien », je serai écrivain."
Extrait de "The Proud Highway", lettre à Roger Richards écrite de Cuddebackville, 3 juin 1959

LA PÉRIODE DU RUM DIARY
Photographies datant d'environ 1960

"Je vis à 8 kilomètres de la ville, une maison de quatre pièces sur la plage, un scooter, pas de boulot, quelques articles en freelance pour des journaux de Stateside, un peu de fiction, tellement de punaises que j'arrive pas à respirer, ma femme avec la cuisine, pas d'argent, un artiste vagabond de New York avec nous, son voilier, l'un dans l'autre la vie ne vas pas trop mal."
Extrait de "The Proud Highway", lettre écrite de Loiz Aldea, Porto Rico, 25 mai 1960

"Ma vie ressemble à un grand tourbillon, et je commence à avoir l'impression d'être un lièvre géant qui saute d'un coin du monde à l'autre dans une grande frénésie d'avidité et de violence."
Extrait de "The Proud Highway", lettre écrite de Loiz Aldea, Porto Rico, 25 mai 1960

BIG SUR
Photographies datant d'environ 1960–1961

"Voilà comment se passe ma vie à Big Sur : j'attends le courrier, je regarde les lions de mer dans les vagues, ou les cargos à l'horizon, je me plonge dans les baignoires de Hot Springs, de temps en temps je vais boire un verre—et, la plupart du temps, je travaille sur ce qui m'a amené ici, la peinture, l'écriture, le jardinage, ou simplement l'art de vivre sa vie."
Extrait de "Rogue Magazine", "Big Sur: The Garden of Agony", 1961

"Je suis entouré de fous ici, des gens qui hurlent chaque fois que je tire sur la gâchette, qui s'excitent parce que mon tee-shirt est trempé de sang, des meutes d'homos qui attendent de me trucider, tellement de créditeurs que j'en ai perdu le compte, un doberman énorme sur le lit, un revolver près de mon bureau, le temps qui passe, mes cheveux qui tombent, pas d'argent, une grande soif pour le whiskey du monde, mes habits qui pourrissent dans le brouillard, une moto sans phare, une propriétaire qui écrit un roman sur du papier de boucher, des sangliers dans les colline et des homos sur les routes, des cuves de bière fabriquée maison dans le placard, les chats que je buttent pour me relaxer, les jacasseries des bouddhistes dans les arbres, les putes dans les canyons, je me demande combien de temps je vais tenir le coup."
Extrait de "The Proud Highway", lettre écrite de Big Sur, 4 août 1961

VOYAGE EN VOITURE À TIJUANA
Photographies datant d'environ 1960

"Lundi je pars en stop vers le sud—Carmel, Monterey, Big Sur, j'irai peut-être même jusqu'à Los Angeles. Quoi qu'il se passe, ça me convient. J'ai pas de plans et je m'en fous. Tout ce que je veux, c'est d'aller sur la côte et voir la Californie dont tout le monde parle. J'irai aussi loin que m'amènera chaque voiture, je dormirai sur la plage (sac de couchage), et si c'est nécessaire, je mendierai pour de la nourriture."
Extrait de "The Proud Highway", lettre à Sandy Conklin, 28 octobre 1960

KENTUCKY
Photographies datant d'environ 1961–1963

"La voix de Joanie Baez flotte dans la maison vide, un son qui hante mon esprit agité. Je m'attends à regarder par la fenêtre et à voir les collines ou l'océan—mais pas de chance, tout ce que je vois c'est Ransdell Avenue, grise et mouillée, et tellement remplie de fantômes et de souvenirs que l'angoisse me prend quand je sors."
Extrait de "The Proud Highway", lettre écrite de Louisville, 10 novembre 1961

"J'ai toujours compris la musique en terme d'énergie, en terme de Carburant. Quelques sentimentaux l'appellent Inspiration, mais ce qu'ils veulent dire c'est Carburant. J'ai toujours eu besoin d'énergie. Je suis un consommateur assidu. Il m'arrive de croire qu'on peut encore conduire 80 kilomètres avec un réservoir vide si on met la bonne musique à plein volume dans la voiture."
extrait de "Kingdom of Fear, Hey Rube, I Love You", 2003

AMÉRIQUE DU SUD
Photographies datant des années 1960

"Il ne me reste que 10 dollars, mais j'ai développé une théorie qui sera connue sous le nom de Loi de Thompson sur l'économie du voyage. À savoir : en avant toute et au diable le coût, tout s'arrangera d'une manière ou d'une autre."
Extrait de "The Proud Highway", lettre écrite en route vers Bogota, 26 mai 1962

"J'essaye de me tirer d'ici par le train de la jungle, mais l'hôtel n'accepte pas mes chèques, donc je ne peux pas partir. Je reste dans ma chambre et j'appelle pour qu'on m'amène plus de bière. La vie s'est énormément améliorée depuis qu'on m'a forcé à arrêter de la prendre au sérieux."
Extrait de "The Proud Highway", lettre écrite de La Paz, Bolivie, 18 août 1962

FOIRE DU COMTÉ DE PLUMAS
Reportage pour le National Observer, 1963

L'attribution de cette tâche n'est pas disponible.

HELL'S ANGELS
Photographies datant d'environ 1965

"Je n'ai jamais rencontré de gens aussi bizarres. C'était un peu comme de recevoir un roman où les personnages seraient déjà développés."
Extrait de "Songs of the Doomed", "Hell's Angels: Long Nights, Ugly Days, Orgy of the Doomed...", mars 1990

"Ils avaient l'air un peu surpris à l'idée qu'un journalisme à l'air décent, envoyé par un magazine littéraire de New York, soit venu les chercher jusque dans une boutique obscure de boîtes de vitesses des banlieues industrielles du sud de San Francisco. Ils étaient un peu désorientés au début, mais après 50 ou 60 bières on s'est trouvé des choses en commun. Les cinglés se reconnaissent toujours entre eux."
Extrait de "The Playboy Interview", novembre 1974

WOODY CREEK
Photographies datant environ des années 1960s et 1970s

"J'ai été expulsé de tous les logements où j'ai habité à part celui où je vis maintenant. J'ai finalement dû acheter un ranch pour éviter qu'on m'expulse."
Extrait de "Songs of the Doomed", "Wild Sex in Sausalito", 17 mai 1985

"Mon luxe principal pendant ces années—un luxe nécessaire en fait—a été la possibilité de travailler à partir de ma forteresse de Woody Creek. Ça a été un point d'ancrage psychologique important pour moi, un point de chute où je savais qu'on m'aimait, que j'avais quelques amis et de voisins agréables. C'était mon phare personnel, que je pouvais toujours voir de n'importe où dans le monde, où que je sois, et les situations pouvaient devenir bizarres, insensées ou dangereuses, tout rentrerait dans l'ordre si je retournais à la maison. Dès que je passais le dernier lacet de la route qui mène à Woody Creek, je me sentais en sécurité."
Extrait de "Fear and Loathing in America", notes de l'auteur, 20 août 2000

LISTE ÉLECTORALE DU FREAK POWER
Campagne électorale pour le poste de shérif du comté de Pitkin, 1970

"Mais on a provoqué un vote de protestation important. Ils ne pouvaient pas supporter d'avoir un shérif qui avalait de la mescaline, se rasait la tête et qui ressemblait au diable."
Extrait de "Songs of the Doomed", "Chicago 1968: Death to the Weird", mars 1990

"Quand j'ai été candidat pour le poste de sheriff à Aspen, c'était l'idée. Dans le contexte de fascisme pourri des événements de 1969 aux Etats-Unis, c'était honorable d'être un détraqué."
Extrait de "The Playboy Interview", novembre 1974

LAS VEGAS PARANO
Photographies et souvenirs datant environ des années 1970

"En tant que journalisme gonzo authentique, ça ne marche pas du tout—et même si ça marchait, je ne pourrais pas l'admettre. Il faudrait être un sacrément déjanté pour écrire quelque chose comme ça et prétendre que c'est vrai."
Extrait de "Fear and Loathing in Las Vegas", jaquette d'un livre, 1972

"Oscar était un de ces prototypes divin—une espèce de super mutant qui ne devait jamais devenir un produit de masse. Il était trop bizarre pour vivre, et trop sublime pour mourir."
Extrait de "Rolling Stone", "The Great Shark Hunt", 15 décembre 1977

FEAR AND LOATHING: ON THE CAMPAIGN TRAIL '72
Photographies datant d'environ 1970

"Quand je suis parti à Washington pour écrire " Fear and Loathing: On the Campaign Trail '72", j'y suis allé avec mon approche habituelle de journaliste : un marteau et un scalpel, et à la grâce de dieu pour ceux qui sont sur mon chemin."
Extrait de "The Playboy Interview", 1974

"Nixon avait le don unique de donner à ses ennemis un air respectable, et ça nous a aidé à développer un certain sentiment de fraternité. Certains de mes meilleurs amis ont détesté Nixon pendant toute leur vie. Ma mère déteste Nixon, mon fils déteste Nixon, je déteste Nixon, et toute cette haine nous a réunis."
Extrait de "Rolling Stone", "Memo from the National Affairs Desk, Notes on the Passing of an American Monster", 16 juin 1994

LES ANNÉE 1970
Photographies et souvenirs datant environ des années 1970

"Les années 70 étaient déchaînées et folles. C'était le rock 'n roll."
Extrait de "Rocky Mountain News", entretien avec Jeff Kass, 18 décembre 2000

"C'est pour ça que c'est difficile d'écrire quand on a pris de la mescaline. Les pensées vont quatre fois plus vite que les mains, on est désorganisé et on n'arrive pas à garder ses idées en phase avec les doigts. C'est pour ça que je dois acheter des machines à écrire de plus en plus rapides. N'importe quelle machine, si elle est plus rapide que la mienne, je l'achète."
Extrait de "Songs of the Doomed", "LSD-25: Res Ipsa Loquitor", mars 1990

KEY WEST
Photographies datant d'environ 1979–1980

"Mon propre bateau—un Mako de 17 pieds avec un gros moteur Mercury à l'arrière—est ancré à environ 6 mètres de ma machine à écrire, prêt à partir. J'ai fait le plein hier soir vers sept heures, et quand on m'a demandé pourquoi je prenais de l'essence avant une mauvaise nuit sans lune, j'ai répondu que j'aurai peut-être envie d'aller à Cuba. La femme aux poissons a ri, mais pas moi."
Extrait de "Song of the Doomed", "Sugarloaf Key: Tales of the Swine Family", 18 mars 1983

"Je n'ai jamais prétendu être plus qu'un type sympa et un athlète."
Extrait de "Sound Bites from Counter Culture", 1990

LA MALÉDICTION DU LONO
Photographies et souvenirs datant environ des années 1980

"C'est une vie bizarre, c'est sûr, mais pour le moment c'est tout ce que j'ai. La nuit dernière, vers minuit, j'ai entendu quelqu'un qui grattait à la porte, et une voix de femme qui murmurait « Quand les choses deviennent bizarres, les bizarres deviennent des pros ». J'ai crié « c'est vrai, je t'aime ! ». Aucune réponse. Seulement le son de la mer vaste et sans fond qui me parle toutes les nuits et qui me fait sourire dans mon sommeil."
Extrait de "Songs of the Doomed", lettre à Ralph Steadman, 30 juin 1981

MANAGER DE NUIT
Photographies datant d'environ 1985

"Nous sommes tous des hommes d'affaires ces jours. Je suis en route pour San Francisco pour vendre un film porno rare, et j'ai trois heures de retard pour assister à une projection avec les frères Mitchell dans leur bureau de O'Farrell Street. Le chauffeur m'attend à l'aéroport avec une voiture blindée et deux jeunes putes coréennes."
Extrait de "Kingdom of Fear", "Seize the Night", 2003

BILLET EN POCHE, LEVONS L'ANCRE.
Photographies et souvenirs datant des années 1980 à 2005

"On publie mes œuvres complètes, on fait un film sur moi, et je suis un personnage de bande dessinée, ça montre qu'à un moment donné, je suis devenu une célébrité. L'auteur que je suis est devenu plus important que ses écrits. Et c'est nul."
Extrait de "Rolling Stone College Papers", entretien avec David Felton, 1980

"J'étais pas très bien intégré dans la société—j'ai passé la nuit de mon bac en prison—mais j'ai appris à l'âge de quinze ans que pour survivre il faut savoir faire quelque chose mieux que tout le monde... en tout cas c'était comme ça pour moi. J'ai compris ça très tôt. J'écrivais. C'était ma botte secrète. Plus facile que les maths. C'était quand même du travail, mais du travail qui en valait la peine. J'étais fasciné de voir ma signature publiée."
Extrait de "Paris Review", entretien avec George Plimpton, automne 2000

"Ça va être une guerre très coûteuse, et la victoire n'est garantie pour personne, certainement pas pour quelqu'un d'aussi ahuri que George W. Bush. Tout ce qu'il sait c'est que son père a commencé une guerre il y a bien longtemps, et que lui, le président-enfant à l'air niais, a été choisi par le Destin et par l'industrie du Pétrole pour la finir Maintenant."
Extrait de "Kingdom of Fear", écrit le 12 septembre 2001

"Ma vie a été à l'exact opposé de la stabilité, mais j'en suis fier, et mon fils en est fier aussi, ce qui me suffit. Si c'était à refaire, je n'en changerai pas une minute, même si je ne conseillerais à personne de faire la même chose. J'aurais tort, et je serais cruel et irresponsable, ce qui ne me ressemble pas."
Extrait de "Kingdom of Fear", "Memo from the Sports Desk", 2003

"On avait de la colère et un sens de la justice à cette époque, et on se comptait par millions. On a réussi à faire démissionner trois officiels du gouvernement parce que tout ce qu'ils voulaient c'était la guerre. On a conquis Lyndon Johnson et on a écrasé Richard Nixon—alors qu'on nous avait dit que c'était impossible à faire. C'était amusant. On était comme des guerriers, et notre tribu était puissante comme une rivière. Et cette rivière coule toujours. Il suffit d'aller voter, pendant que c'est encore légal, et on arrivera à faire partir ces militaristes pourris de la Maison Blanche."
from "Rolling Stone", "Fear and Loathing, Campaign 2004", 2004

"Le Paradis n'existe peut-être pas. C'est peut-être que du charabia—le fruit de l'imagination démente d'un plouc soûlard et fainéant avec le cœur plein de haine, et qui aurait trouvé le moyen de vivre dans la réalité—dormir tard, s'éclater, perdre la tête, boire du whiskey et conduire à fond dans des rues vides en pensant seulement à tomber amoureux et ne pas se faire arrêter. Res ipsa loquitor. Que la fête commence."
Extrait de "Generation of Swine", note de l'auteur, 1998

"Rien n'était trop bizarre pour moi."

EINLEITUNG

Wenn ich an Hunter denke, was sehr oft der Fall ist, dann öffnen sich die Schleusen und augenblicklich, mühelos und bereitwillig überkommt mich eine Riesenflut von Erinnerungen. Erinnerungen, so vielfältig wie dieser Mann selbst es war, kommen mir in den Sinn. Bilder von einigen unserer weniger bekannten Abenteuer:

Eine Einkaufstour im Morgengrauen, um Magnum-Pistolen aufzutreiben...

Ein Termin zur Kopfrasur um 3 Uhr morgens, vom Doctor pünktlich und sorgsam ausgeführt...

Behutsame Behandlung grässlicher Kater—indem wir einander *Fernet Branca* einflößten, während wir abwechselnd an einem Sauerstofftank hingen (keins von beidem wirkte)...

Die blanke Faszination, wenn man ihn dabei beobachtete, wie er sein Essen salzte und pfefferte (das konnte bis zu einer Stunde dauern, aber nie kürzer als zwanzig Minuten)...

Unser zum Glück nur kurzlebiger und beinah fataler Spontan-Entschluss, uns Hillbilly-Bräute zu nehmen—als Fernbeziehung...

Wir beide, wie verrückt gackernd, während wir einem entfleucht-en Beo (Edward—ein Geschenk von Hunter und Laila Nabulsi) durch mein Haus nachjagten ...

Fünf Tage und Nächte mit ihm eingesperrt in einem Hotelzimmer in San Francisco (eine riesige Haufen Zutaten, Obstteller, Clubsandwiches, Krabbencocktails und ja... sorgfältig aufeinander gestapelte Grapefruits, die in einer Ecke der Suite bis zur Decke reichten)...

Stunden und Stunden intensivster schwärmerischer Tête-à-têtes—beim Lesen wunderbarer Passagen aus seinen vielen geistreichen und legendären Arbeiten...

Es gab schmissige, in Sekundenbruchteilen sich ereignende, punktgenaue, urkomische Begebenheiten, die jeden in die Knie gezwungen hätten, unendliche Augenblicke der hysterischen Raserei, der Ausgelassenheit und des Schwadronierens, die meist damit endeten, dass ich mit Bauchweh vor lauter Lachen wie ein Baby zusammengekrümmt, kraftlos und mit Tränen in den Augen am Boden lag.

Ja, er hatte eine Gabe, unser guter Doctor. Er besaß die geradezu unheimliche Fähigkeit, Leute zu verärgern, während es ihm zugleich gelang, jeden zu allem zu überreden oder von allem abzubringen, was ihm gerade zufällig in den Sinn gekommen war. Und immer schaffte er es währenddessen, bei der Geschichte zu bleiben (denn es gab immer eine Story). Scharfsichtig behielt er alles, was sich um ihn herum zutrug, im Auge. Als ewiger Beobachter betrachtete er das Geschenk seines Genies niemals als Selbstverständlichkeit. Jegliche Situation zu beobachten und zu analysieren, das lag in seiner Natur, also beobachtete und analysierte er mit unerbittlicher Leidenschaft. Er lebte, er atmete und zelebrierte all das. Und wenn man das Glück hatte, bei einer seiner Eskapaden neben ihm herstrolchen zu können, dann tat man das, und zwar bis zum Anschlag.

Jedes Dokument, jeder Fetzen Papier, jeder Zeitungsausschnitt, jede Cocktailserviette und jedes Foto waren Hunter heilig. Was in diesem Buch fortlebt, das sind die roten Fäden im Wandteppich seines Lebens, Puzzleteile, die sorgsam weggepackt worden waren, für die Nachwelt sicher verwahrt. Sie gewähren einen tiefen Einblick in sein Leben und sein Werk. Wenn man durch diese Seiten blättert, dann wird einem klar, dass Hunter wirklich mehr als nur gut vertraut oder sogar ganz im Einklang mit dem war, was das Schicksal für ihn bereithielt.

Schon Minuten nachdem ich die schreckliche Nachricht von Hunters Entscheidung, sein Leben zu beenden, vernommen hatte, telefonierte ich mit Laila. Es war der erbärmliche Versuch, dem Geschehen irgendeinen Sinn abzuringen, was natürlich misslang. Wir weinten und trösteten einander so gut wir es unter so grauenhaften Umständen vermochten. Und dann plötzlich setzte sich eine Erkenntnis durch, ganz so, als habe der Doctor selbst uns in unserem Trauernebel angestupst. Im absolut selben Moment stießen wir hervor: "WAS IST MIT DER KANONE???" "O Gott... Das Denkmal..." Noch in der Sekunde begann sich der Brennpunkt langsam zu ändern. Wir waren mit Hunters Erwartungen sehr gut vertraut, und die waren nicht gerade gering. "Nichts Niedliches!!!" schien die wichtigste Anweisung unseres verstorbenen Freundes zu lauten. Mit den ersten Zeichnungen und Entwürfen wurde am nächsten Morgen begonnen und mit dem

Bau des Biests in den darauf folgenden Wochen. Sein Wunsch war ein 150 Fuß hohes Monument/eine Kanone gewesen, um seine sterblichen Überreste in den Himmel über seiner geliebten Owl Farm zu schießen. Einfach. Nicht einfach. Man hatte mir geraten, mir jegliche Hoffnungen auf die Realisierung dieses Auftrags aus dem Kopf zu schlagen. Das sei nicht nur unmöglich, sondern auch völlig verrückt, sagte man mir. Wir kämpften weiter. Während ich recherchierte, wie sich das Unmögliche ermöglichen ließe, entdeckte ich, dass die Freiheitsstatue 151 FUSS HOCH ist!!! Scheiße... "Niedlich" und Hunters Denkmal schienen sich einander anzunähern. Weil ich wusste, dass Details ihm über alles gingen und dass dieses Detail rasch berücksichtigt werden musste, erging der Beschluss, die Latte noch höher zu legen und die Entwürfe dahingehend zu ändern, dass das Monument 153 Fuß hoch würde. Zwei Fuß höher. Weil Hunter im Tod wie auch im Leben den American Dream (und seine anmutige Verkörperung) um mehr als nur ein oder zwei Inches übertreffen musste. Wenn man ein Auto mit 40 lbs. Luftdruck pro Reifen fahren konnte, fuhr Hunter mit 100 lbs., nur für alle Fälle. Für welche Fälle? Das wusste stets nur er selbst. Das war eben typisch Hunter. Das Denkmalteam und die Crew arbeiteten monatelang ohne Pause, um Hunters letzten Wunsch zu realisieren und das Unmögliche zu ermöglichen. Selbst angesichts des eventuellen totalen Scheiterns, das während des gesamten Vorgangs gefährlich dräute, blieben wir alle konzentriert und motiviert. Erst nach einer ganzen Weile und als wir alle von dem Projekt schon völlig in Anspruch genommen waren, erkannte ich, dass ein Großteil von Hunters Plan darin bestand, jene, die ihm am nächsten gestanden hatten, durch das Erteilen einer so gigantischen Aufgabe abzulenken. Irgendwie wusste er, dass sobald seine liebsten Menschen in den zähen Mist eintauchten, den es bedeutete, die Kanone zu bauen, sie durch ein so monumentales Unterfangen in ihrer Trauer abgelenkt wären. Er war ein ganz schön raffinierter Bursche, dieser Dr. Thompson.

Erinnerungen an den guten Doctor haben immer mehr als nur einige wenige ausgewählte Augenblicke heraufbeschworen, an denen man zu kauen hatte. Selbst heute, fast zwei Jahre nach seinem Abgang, verspüre ich noch die gleiche Anspannung, wenn ich an ihn denke, wie immer. Und obwohl ich weiß, dass er nicht anrufen und dass dieses Dreckstelefon nicht mitten in der Nacht wie verrückt losklingeln wird, kann ich seine Stimme deutlich hören. Ich höre sein WHOOP!!! jedes Mal wenn "One Toke Over the Line" im Radio kommt, ich spüre, wie er sich aufplustert wenn "Sympathy for the Devil" anläuft. Die Schwermütigkeit von "Mr. Tambourine Man" macht ihn ruhig und nachdenklich.

Er taucht auf, wenn er gebraucht wird.

Er erscheint auf dem Gipfel der Absurdität.

Ich glaube, das wird er immer tun.

Col. Depp
Los Angeles, 5. September 2006

EINLEITUNG

"Also sollten wir den Leser diese Frage selbst beantworten lassen: Welcher Mensch ist glücklicher, derjenige, der den Stürmen des Lebens getrotzt und wirklich gelebt hat, oder derjenige, der am sicheren Ufer geblieben ist und nur vor sich hin vegetiert hat?"
aus "Security" von Hunter S. Thompson, im Alter von 17 Jahren, 1955

DIE ZEIT BEI DER AIR FORCE
Luftwaffenstützpunkt Eglin, 1956–1957

"Sei ein Strandguträuber, ein Pariser Absinth-Säufer, ein italienisches Luder oder ein dänischer Perverser—aber halte dich vom Militär fern."
Aus "The Proud Highway", Brief vom Luftwaffenstützpunkt Eglin, 10. März 1957

AUSFLUG AN DIE WESTKÜSTE
Fotografien ca. 1960

"Im Alter von 22 stellte ich einen meiner Ansicht nach ewig gültigen Langstreckenrekord im Trampen mit Bermudashorts auf: 3700 Meilen in drei Wochen."
aus "The National Observer", "The Extinct Hitchhiker", 22. Juli 1963

"Kann irgendein Bus, Flugzeug oder Zug das Gefühl erzeugen, dass man hat, wenn man morgens mit der Sonne im Gesicht und dem Geruch nach frisch gemähtem Gras rundherum an einer Straße steht und alles, was einen kümmert, die Frage ist, wie weit einen der nächste Lift bringen wird?"

aus "The National Observer", "The Extinct Hitchhiker", 22. Juli 1963

NEW YORK
Fotografien ca. 1957–1962

"Meine Wohnung, einst Schauplatz von trägem Sex und stiller Intimität, ist im Laufe der letzten zwei Wochen zu einer echten Höhle des grölenden, besoffenen Wahnsinns verkommen. Überall schlafen Leute—in meinem Bett, auf der Couch, auf dem Feldbett, ja sogar auf Schlafsäcken am Boden. Schlichtweg alles ist von schalem Bier getränkt, die meisten meiner Platten sind kaputt, jedes Stück Bettzeug, jedes Handtuch oder Kleidungsstück in der Wohnung ist dreckig, der Abwasch seit Wochen nicht gemacht, die Nachbarn beknien den Hauswirt, mich rauszuschmeißen, mein Sexualleben ist ein Desaster, ich habe kein Geld, nichts zu essen, keine Privatsphäre und definitiv keinen Seelenfrieden mehr."
aus "The Proud Highway", Brief an Larry Callen, Perry Street Apartment, 6. Juni 1958

"So wie es jetzt aussieht, werde ich Schriftsteller. Keine Ahnung, ob ein guter oder auch nur einer, der sich selbst ernähren kann, aber bis der schwarze Daumen des Schicksals mich in den Staub drückt und sagt 'du bist nichts', werde ich ein Schriftsteller sein."
aus "The Proud Highway", Brief an Roger Richards aus Cuddebackville, 3. Juni 1959

DIE ZEIT DER RUM-TAGEBÜCHER
Fotografien ca. 1960er

"Ich lebe 5 Meilen außerhalb der Stadt am Strand, 4-Zimmer-Haus, Motorboot, kein Job, schreibe als freier Mitarbeiter Sachen für Zeitungen in den Staaten, auch Prosa, so viel Ungeziefer, dass ich kaum atmen kann, Ehefrau hier, die kocht, kein Geld, umherziehender Künstler aus New York lebt auch hier, besitzt ein Segelboot, alles in allem kein schlechtes Leben."
aus "The Proud Highway", Brief von Loiz Aldea, Puerto Rico, 25. Mai 1960

"Mein Leben ist ein wildes Karussell und ich fange an, mich wie ein großer hungriger Hase zu fühlen, der in einem Rausch aus Gier und Gewalt von einem Teil der Welt zum nächsten springt."
aus "The Proud Highway", Brief von Loiz Aldea, Puerto Rico, 25. Mai 1960

BIG SUR
Fotografien ca. 1960–1961

"So lebt man in Big Sur: Man wartet auf die Post, beobachtet die Seelöwen in der Brandung oder die Frachter am Horizont, sitzt in den Wannen von Hot Springs, hin und wieder ein Drink—und die meiste Zeit verbringt man mit der Arbeit, um derentwillen man hergekommen ist, Malen, Schreiben, Gärtnern oder einfach die Kunst, sein eigenes Leben zu leben."
aus "Rogue Magazine", "Big Sur: The Garden of Agony" 1961

"Ich bin hier von Verrückten umgeben, von Leuten, die jedes Mal kreischen, wenn ich einen Abzug drücke, die wegen ihrer blutgetränkten Hemden schreien, haufenweise Schwule, die darauf warten, mir den Garaus zu machen, so viele Gläubiger, dass ich den Überblick verloren habe, ein riesiger Dobermann auf dem Bett, eine Pistole neben dem Schreibtisch, verrinnende Zeit, kahler werden, kein Geld, ein großer Durst nach allem Whiskey der Welt, meine Kleider, die im Nebel verrotten, ein Motorrad ohne Licht, eine Hauswirtin, die auf Fettpapier vom Metzger einen Roman schreibt, Wildschweine in den Hügeln und Verrückte auf den Straßen, Fässer mit selbst gemachtem Bier im Schrank, auf Katzen schießen, um Druck abzulassen, das Gequassel von Buddhisten in den Bäumen, Huren in den Schluchten, Gott allein weiß, ob ich das noch lange aushalten kann."
aus "The Proud Highway", Brief aus Big Sur, 4. August 1961

AUSFLUG NACH TIJUANA
Fotografien ca. 1960

"Am Montag werde ich meinen Daumen in Richtung Süden ausstrecken—Carmel, Monterey, Big Sur und vielleicht sogar die ganze Strecke bis Los Angeles. Was auch immer passiert, es wird in Ordnung sein. Es macht mir nichts aus und ich habe keinen Plan. Alles, was ich möchte, ist an die Küste kommen und das Kalifornien sehen, von dem alle reden. Ich werde so weit fahren, wie ich komme, am Strand schlafen (Schlafsack) und falls nötig um Essen betteln."
aus "The Proud Highway", Brief an Sandy Conklin, 28. Okt. 1960

KENTUCKY
Fotografien ca. 1961–1963

"Die Stimme von Joanie Baez schwebt durch das leere Haus, ein unheimlicher Klang für meine rastlosen Ohren. Ich erwarte, aus dem Fenster zu blicken und die Hügel oder das Meer zu sehen—aber das ist nicht drin, nur die Ransdell Avenue, grau und nass und bevölkert von so vielen Geistern und Erinnerungen, dass mich jedes Mal, wenn ich rausgehe, die ANGST packt."
aus "The Proud Highway", Brief aus Louisville, 10. November 1961

"Musik hatte für mich immer mit Energie zu tun, war eine Frage des TREIBSTOFFS. Sentimentale Leute nennen es INSPIRATION, aber eigentlich meinen sie TREIBSTOFF. Ich habe immer Treibstoff gebraucht. Ich bin ein guter Abnehmer. In manchen Nächten glaube ich immer noch, dass ein Auto mit der Tankanzeige auf Null noch an die fünfzig Meilen weiter fährt, wenn im Radio sehr laut die richtige Musik läuft."
aus "Kingdom of Fear, Hey Rube, I Love You", 2003

SÜDAMERIKA
Fotografien ca. 1960er

"Ich bin bis auf 10 US-Dollar abgebrannt, habe aber eine Theorie entwickelt, die als Thompsons Gesetz der Reiseökonomie in die Geschichte eingehen wird. Und zwar: Volle Kraft voraus und scheiß auf die Kosten—am Ende geht sowieso alles den Bach runter."
aus "The Proud Highway", Brief auf dem Weg nach Bogota, 26. Mai 1962

"Ich versuche mit dem Dschungelzug hier raus zu kommen, aber das Hotel akzeptiert meinen Scheck nicht, also kann ich nicht weg. Ich sitze einfach auf dem Zimmer und läute nach mehr Bier. Das Leben hat sich unendlich verbessert, seit ich gezwungen bin, es nicht mehr ernst zu nehmen."
aus "The Proud Highway", Brief aus La Paz, Bolivien, 18. August 1962

PLUMAS COUNTY FAIR
Auftrag für den National Observer, 1963

Über diesen Auftrag war keinerlei Information verfügbar.

HELL'S ANGELS
Fotografien ca. 1965

"Ich hatte noch nie derart seltsame Leute gesehen. In gewisser Weise war es so, als bekäme man einen Roman mit bereits ausgearbeiteten Charakteren überreicht."
aus "Songs of the Doomed", "Hells Angels: Long Nights, Ugly Days, Orgy of the Doomed..." März 1990

"Sie schienen ein wenig erstaunt von der Vorstellung, dass irgendein normal aussehender Autor einer New Yorker Literaturzeitschrift sie tatsächlich bis in einen zwielichtigen Ersatzteilladen in den Industrie-Slums im südlichen San Francisco verfolgen würde. Zunächst brachte sie das etwas aus der Fassung, aber nach 50 oder 60 Bieren entdeckten wir Gemeinsamkeiten, als da wären... Verrückte erkennen einander immer."
aus "The Playboy Interview", November 1974

WOODY CREEK
Fotografien ca. 1960er und 1970er

"Ich bin bisher aus jeder Behausung, die ich bewohnte, vertrieben worden, außer von dort, wo ich jetzt lebe. Ich musste mir schließlich etwas kaufen, um nicht mehr verjagt zu werden."
aus "Songs of the Doomed", "Wild Sex in Sausalito", 17. Mai 1985

"Mein größter Luxus in jenen Jahren—genau genommen ein notwendiger Luxus—war die Möglichkeit, innerhalb und außerhalb meiner heimischen Festung in Woody Creek zu arbeiten. Das war ein sehr wichtiger psychologischer Anker für mich, eine überaus wichtige Erdung, denn ich wusste, dort habe ich Liebe, Freunde & gute Nachbarn. Das war wie mein privater Leuchtturm, den ich von überall auf der Welt sehen konnte—egal, wo ich mich befand oder wie seltsam & verrückt & gefährlich es zuging, alles würde gut werden, wenn ich es nur bis nach Hause schaffte. Nachdem ich die Haarnadelkurve den Hügel hinauf auf die Woody Creek Road hinter mir gelassen hatte, wusste ich, dass ich in Sicherheit war."
aus "Fear and Loathing in America", Anmerkung des Autors, 20. August 2000

FREAK POWER TICKET
Wahlkampf zum Sheriff von Pitkin County, 1970

"Allerdings sorgten wir bei der Wahl für eine massive Gegenreaktion. Die konnten einen Meskalin konsumierenden Sheriff, der sich den Kopf rasierte und aussah wie der Teufel, einfach nicht einordnen."
aus "Songs of the Doomed", "Chicago 1968: Death to the Weird", März 1990

"Als ich mit der Masche Freak Power für das Amt des Sheriffs von Aspen kandidierte, ging es genau darum. In dem verrotteten faschistischen Kontext der Ereignisse im Amerika des Jahres 1969, war die Entscheidung, sich als Freak auszugeben, ein ehrenwerter Weg"
aus "The Playboy Interview", November 1974

FEAR AND LOATHING IN LAS VEGAS
Fotografien und Memorabilia ca. 1970er

"Als echter Gonzo-Journalismus funktioniert das absolut nicht—und selbst wenn es das täte, könnte ich es unmöglich zugeben. Nur ein gottverdammter Irrer würde etwas wie das hier schreiben und dann behaupten, es wäre wahr."
aus "Fear and Loathing in Las Vegas", Umschlagkopie, 1972

"Oscar war einer dieser göttlichen Prototypen—ein hochgezüchteter Mutant von der Sorte, die für die Massenproduktion niemals auch nur in Betracht kommt. Er war zu seltsam um zu leben und zu selten um zu sterben."
aus "Rolling Stone", "The Great Shark Hunt", 15. Dezember 1977

FEAR AND LOATHING: ON THE CAMPAIGN TRAIL '72
Fotografien ca. 1970er

"Als ich nach Washington ging, um "Fear and Loathing: On the Campaign Trail '72" zu schreiben, brach ich mit derselben Einstellung auf, die ich als Journalist überall annehme: Hammer und Zange—und jedem, der mir im Weg steht, gnade Gott."
aus "The Playboy Interview", 1974

"Nixon besaß die einzigartige Fähigkeit, seine Feinde, ehrenwert erscheinen zu lassen, und so entwickelten wir ein ausgeprägtes Gefühl von Bruderschaft. Einige meiner besten Freunde haben Nixon ihr Leben lang gehasst. Meine Mutter hasst Nixon, mein Sohn hasst Nixon. Ich hasse Nixon, und dieser Hass hat uns einander näher gebracht."
aus "Rolling Stone", "Memo from the National Affairs Desk, Notes on the Passing of an American Monster", 16. Juni 1994

DIE 1970er
Fotografien und Memorabilia ca. 1970er

"Die 70er waren unglaublich und wild. Das war Rock n Roll."
aus "Rocky Mountain News", Interview mit Jeff Kass, 18. Dezember 2000

"Es ist deshalb schwer, auf Meskalin zu schreiben, weil dein Hirn viermal schneller funktioniert als deine Hände es können, und dann kommt man total aus dem Tritt und kann Verstand und Finger nicht synchronisieren. Darum brauche ich immer schnellere Schreibmaschinen. Was immer die produzieren, wenn's schneller ist, kaufe ich es"
aus "Songs of the Doomed", "LSD-25: Res Ipsa Loquitor", März 1990

KEY WEST
Fotografien ca. 1979–1980

"Mein eigenes Boot—ein 17-Fuß-Mako mit einem großen schwarzen Mercury-Motor im Heck—liegt etwa 20 Fuß von meiner Schreibmaschine entfernt festgemacht, und ich weiß, der Benzintank ist voll, und als sie mich fragten, warum ich mein Boot am Beginn einer schlechten, mondlosen Nacht auftankte, sagte ich, vielleicht möchte ich nach Kuba fahren. Die Fischkopffrau lachte, ich nicht."
aus "Song of the Doomed", "Sugarloaf Key: Tales of the Swine Family", 18. März 1983

"Ich habe nie behauptet, etwas anderes zu sein als ein netter Kerl und ein Sportler."
aus "Sound Bites from Counter Culture", 1990

LONOS FLUCH
Fotografien und Memorabilia ca. 1980er

"Es ist ein seltsames Leben, keine Frage, aber im Moment ist das alles, was ich habe. Gestern Abend, gegen Mitternacht, hörte ich jemand am Strohdach kratzen und dann flüsterte eine Frauenstimme: "When the going gets weird, the Weird turn pro." "Stimmt!" brüllte ich. "Ich liebe dich!" Aber es kam keine Antwort. Nur die Geräusche dieses riesigen und grundlosen Ozeans, der jede Nacht zu mir spricht und mich im Schlaf lächeln lässt."
aus "Songs of the Doomed", Brief an Ralph Steadman, 30. Juni 1981

NACHTMANAGER
Fotografien ca. 1985

"Heutzutage sind wir alle Geschäftsleute. Bin auf dem Weg nach SF, um einen seltenen Pornofilm zu verkaufen. Ich bin drei Stunden zu spät für eine entscheidende Vorführung mit den Mitchell Brothers in deren bewährtem Hauptquartier an der O'Farrell Street. Der Fahrer wartet mit einem gepanzerten Wagen und zwei fetten jungen Nutten aus Korea am Flughafen auf mich."
aus "Kingdom of Fear", "Seize the Night", 2003

KAUF DAS TICKET, DANN FAHR LOS.
Fotografien und Memorabilia von den 1980ern bis 2005

"Wenn gleichzeitig deine gesammelten Werke erscheinen, ein Kinofilm über dich gedreht wird... und du dann noch in Comics auftauchst... irgendwann um diese Zeit bin ich eine Person des öffentlichen Interesses geworden. Dann ist plötzlich der Autor irgendwie wichtiger als das, was er schreibt. Und das kotzt mich an."
aus "Rolling Stone College Papers", Interview mit David Felton, 1980

"Ich hatte mich nicht sehr gut an die Gesellschaft angepasst—die Nacht meiner Abschlussfeier an der Highschool verbrachte ich im Knast—aber ich lernte mit 15 Jahren, dass man, um durchzukommen, eine Sache finden muss, die man besser kann als jeder andere... zumindest in meinem Fall war das so. Ich habe das früh herausgefunden. Es war das Schreiben. Das war der Stein in meinem Schuh. Leichter als Algebra. Es bedeutete immer Arbeit, aber eine lohnenswerte Arbeit. Von Anfang an faszinierte es mich, meine Verfasserzeile gedruckt zu sehen. Es war ein Rausch. Ist es bis heute."
aus "Paris Review", Interview mit George Plimpton, Herbst 2000

"Das wird ein teurer Krieg werden, und der SIEG ist nicht garantiert—für niemanden, und ganz sicher nicht für einen Wirrkopf wie George W. Bush. Alles, was er weiß, ist, dass sein Vater den Krieg vor langer Zeit begonnen hat und dass er, der alberne Kind-PRÄSIDENT, vom SCHICKSAL und der globalen ÖL-Industrie auserkoren wurde, ihn JETZT zu Ende zu führen."
aus "Kingdom of Fear", geschrieben am 12. September 2001

"Mein Leben war das absolute Gegenteil von gefahrlos, aber ich bin stolz darauf und mein Sohn auch, und das genügt mir. Ich würde alles noch einmal so machen, ohne einen Deut daran zu ändern, obwohl ich es anderen nie empfohlen habe. Das wäre grausam und unverantwortlich und falsch, denke ich, und so bin ich nicht."
aus "Kingdom of Fear", "Memo from the Sports Desk", 2003

"Wir waren damals wütend und rechthaberisch, und es gab Millionen von unserer Sorte. Wir kickten zwei Generaldirektoren aus dem Weißen Haus, weil sie dumme Kriegstreiber waren. Wir besiegten Lyndon Johnson und machten Richard Nixon nieder—was kluge Leute für unmöglich hielten, aber warum nicht. Es hat Spaß gemacht. Wir waren damals Krieger, und unser Stamm so stark wie ein Fluss. Dieser Fluss fließt immer noch. Alles, was wir zu tun haben, ist rausgehen und wählen, solange es noch gesetzlich erlaubt ist, und dann werden wir diese verlogenen Kriegstreiber aus dem Weißen Hause schwemmen."
aus "Rolling Stone", "Fear and Loathing, Campaign 2004", 2004

"Vielleicht gibt es keinen Himmel. Oder vielleicht ist das alles nur Geschwafel—ein Produkt der kranken Fantasie eines faulen betrunkenen Hinterwäldlers mit hasserfülltem Herzen, der herausgefunden hat, wie man das wirklich harte Leben da draußen in den Griff kriegt—lange schlafen, Spaß haben, sich komplett gehen lassen, Whiskey trinken und auf freien Straßen rasen, während man nichts anderes im Kopf hat als sich zu verlieben und nicht in den Knast zu kommen... Res ipsa loquitor. Let the good times roll."
aus "Generation of Swine", Anmerkung des Autors, 1998

"Für mich war es nie seltsam genug."

INTRODUCCIÓN

Cuando pienso en Hunter, lo que hago a menudo, se abren las compuertas del pasado y me siento instantánea, fácil y voluntariamente inundado por un diluvio de recuerdos. Recuerdos tan variados como el hombre en sí cruzan mi mente. Imágenes de algunas de nuestras aventuras menos conocidas:

Un expedición al amanecer para comprar pistolas magnum...

Un cita a las 3:00 de la mañana para afeitarme la cabeza, debida y meticulosamente ejecutada por el Doctor...

Cuidando con mimo espantosas resacas, sirviéndonos mutuamente *Fernet Branca* y turnándonos para aspirar de un tanque de oxígeno (todo ello inútil)...

La fascinación absoluta de verle salpimentar su comida (podía tardar hasta una hora, pero no menos de veinte minutos)...

Nuestra impulsiva decisión, afortunadamente fugaz y casi fatal, de echarnos novias de pueblo, a larga distancia...

Los dos, riéndonos como locos, persiguiendo por mi casa un ave minah que se había escapado (Edward, un regalo de Hunter y Laila Nabulsi)...

Encerrado con él en una habitación de hotel en San Francisco durante cincos días y sus noches (una vasta acumulación de condimentos, platos de fruta, sándwiches, cócteles de gambas, y sí... pomelos, amontonados en una tambaleante pila en la esquina de la suite casi rozando el techo)...

Horas y horas de tête-à-têtes intensamente líricos, leyendo pasajes milagrosos de sus geniales y legendarias obras...

Hacía observaciones hilarantes, acertadas, concisas, rápidas, para partirse de risa, momentos interminables de arrebatos histéricos, hilaridad y diatribas que la mayoría de las veces me dejaban tirado por el suelo, sin fuerzas, llorando de risa.

Sí, tenía un talento, nuestro buen doctor. Tenía la misteriosa habilidad de incordiar al mismo tiempo que podía convencer a cualquiera para hacer o dejar de hacer lo que sea en que se hubiera empeñado. Al tiempo que, siempre, mantenía la historia (porque siempre había una historia). Sin perder de vista ni por un momento todo lo que ocurría a su alrededor. Siempre ojo avizor, sin dar por hecho el don de su genio. Su naturaleza era observar y diseccionar todo tipo de situaciones, y observaba y diseccionaba con un fervor inexorable. Lo vivía, lo respiraba y lo celebraba, todo a la vez. Y si tenías la suerte de rondar con él en una de sus escapadas, también lo hacías tú, a tope.

Cada documento, pedazo de papel, recorte de periódico, servilleta y fotografía eran sagrados para Hunter. Lo que subsiste en este libro, son hebras esenciales del tapiz de su vida, piezas del rompecabezas que se han conservado, sanas y salvas, para la posteridad. Ofrecen una importante perspectiva de su vida y trabajo. Deambulando por estas páginas, parece claro que Hunter estaba mucho más que familiarizado, incluso de acuerdo, con lo que le deparaba el destino.

A los pocos minutos de oír la desoladora noticia de la decisión de Hunter de poner punto final a su vida, estaba hablando por teléfono con Laila en un patético intento de darle sentido a lo que había ocurrido, lo que, por supuesto, era imposible. Lloramos y nos consolamos como pudimos en esas circunstancia tan terribles. Y, de repente, nos damos cuenta de algo, como si el mismo Doctor nos hubiera dado un codazo para sacarnos de esa bruma trágica. En el mismo momento los dos soltamos: "¿QUÉ PASA CON EL CAÑÓN?" "Dios... el Monumento..." En ese segundo el enfoque empezó a cambiar lentamente. Sabíamos de sobra cuales eran las expectativas de Hunter, y no eran poca cosa. "¡Nada pequeño!" parecía ser la orden predominante de nuestro difunto amigo. Los primeros planos y diseños empezaron a la mañana siguiente y la construcción de la bestia se inició a las pocas semanas. Su petición había sido un monumento/cañón de 45,5 metros para disparar sus cenizas al cielo sobre su querido Owl Farm. Fácil. No tan fácil. Me aconsejaron que abandonara toda esperanza de completar con éxito esta misión. No sólo era imposible, era una completa locura, me dijeron. Seguimos adelante. Investigando cómo hacer posible esta imposibilidad, descubrí qué tipo de la Estatua de la Libertad ¡mide 46 metros de altura! Mierda... "pequeño" y el monumento de Hunter parecían confluir. Sabiendo que los detalles lo eran todo para él y que éste era un detalle que había que solucionar "pronto", se tomó la decisión de ir a por todas y el diseño del monumento se aumentó a 46,5 metros de altura. Medio metro más alto. ¿Por qué? Porque en su muerte, como en su vida, Hunter tenía que superar el sueño americano (y su gentil representante) en algo más de una cen-

tímetro o dos. Si es posible conducir un coche con 2,5 bares de presión de aire en cada rueda, Hunter lo conduciría con 7 bares, sólo para estar seguro. Seguro de qué, sólo él lo sabe. Era una de sus cosas. El equipo y la cuadrilla del monumento trabajó sin descanso durante meses para hacer realidad el deseo final de Hunter, hacer posible lo imposible. Todos permanecimos concentrados y motivados incluso de cara a la posibilidad de un fracaso total, que se vislumbraba peligrosamente cerca a lo largo de todo el proceso. No fue sino mucho más tarde, una vez que todos estábamos totalmente absortos en el proyecto, que comprendí que una importante parte del plan de Hunter era distraer a sus amigos e íntimos mediante tamaño encargo. De alguna manera, sabía que una vez que sus seres queridos se enfangarán en el cometido de construir el cañón, el período de luto se vería alterado por la descomunal empresa. Era sutil ese Dr. Thompson.

Evocar al buen doctor siempre suscita más de un momento especial que contemplar. Incluso ahora, casi dos años después de su partida, me sigue emocionado tanto como siempre pensar en él. Y aunque sé que no me va a llamar y que el maldito teléfono no va a sonar y sonar en mitad de la noche, oigo claramente su voz. Le oigo "¡CARAY!" cada vez que "One Toke Over the Line" suena en la radio, le siento resoplar cuando escucho "Sympathy for the Devil". Se tranquiliza y considera la gravedad de "Mr. Tambourine Man".

Aparece cuando hace falta.

Llega cuando el absurdo alcanza el límite.

Imagino que siempre será así.

Col. Depp
Los Ángeles, 5 de septiembre de 2006

INTRODUCCIÓN

"Así que dejemos que el lector responda por sí mismo a esta pregunta: ¿quién es más feliz, el que se ha enfrentado a la tormenta de la vida y ha vivido o el que ha permanecido seguro en la costa y se ha limitado a existir?"
de "Security" por Hunter S. Thompson, 17 años, 1955

DÍAS EN LA FUERZA AÉREA
Base de la Fuerza Aérea de Eglin, 1956–1957

"Puedes ser un vago de playa, un borracho parisino, un chulo italiano o un pervertido danés; pero mantente alejado de las Fuerzas Armadas."
de "The Proud Highway", carta desde la Base de la Fuerza Aérea de Eglin, 10 de marzo de 1957

VIAJE POR CARRETERA A LA COSTA OESTE
Fotografías de alrededor de 1960

"A los 22 años, establecí lo que, insisto, es un récord sin precedentes de autoestopismo de larga distancia en bermudas: 3,700 millas en tres semanas."
de "The National Observer", "The Extinct Hitchhiker", 22 de julio de 1963

"¿Puede un autobús, un avión o un tren igualar el sentimiento que produce estar de pie en la carretera por la mañana con el sol en la cara y el olor de la hierba recién cortada a tu alrededor, sin ninguna preocupación en el mundo excepto lo lejos que llegarás con el siguiente viaje?"
de "The National Observer", "The Extinct Hitchhiker", 22 de julio de 1963

NUEVA YORK
Fotografías de alrededor de 1957–1962

"Mi apartamento, antaño el escenario de sexo perezoso e intimidad tranquila, se ha convertido en las últimas dos semanas en una caverna virtual de vociferante demencia alcohólica. Hay gente durmiendo por todas partes, uno en mi cama, en el sofá, en la cuna, e incluso en sacos de dormir en el suelo. Todo está cubierto de cerveza rancia, la mayoría de mis discos se han arruinado, toda la ropa, las sábanas y las toallas están mugrientas, los platos no se han lavado en semanas, los vecinos han pedido al casero que me eche, mi vida sexual se ha destrozado, no tengo dinero, ni comida, ni intimidad y, ciertamente, no tengo tranquilidad mental."
de "The Proud Highway", carta a Larry Callen, apartamento en Perry Street, 6 de junio de 1958
"Tal y como están las cosas, voy a ser escritor. No estoy seguro de que vaya a ser un buen escritor ni siquiera de que pueda manten-

erme a mí mismo, pero hasta que el tenebroso dedo del destino me haga morder el polvo y diga, "no eres nada", seré un escritor."
de "The Proud Highway", carta a Roger Richards desde Cuddebackville, 3 de junio de 1959

DÍAS DE EL DIARIO DEL RON
Fotografías de alrededor de 1960

"Vivo a 5 millas de la ciudad, en la playa, en una casa de 4 habitaciones, tengo una motocicleta, no tengo trabajo, escribo como freelance para periódicos norteamericanos, también ficción, hay tantos bichos que apenas puedo respirar, mi mujer está aquí, cocinando, no tengo dinero, un artista trotamundos de Nueva York también vive aquí, tiene un barco de vela, en resumen, no es mala vida."
de "The Proud Highway", carta desde Loíza Aldea, Puerto Rico, 25 de mayo de 1960

"Mi vida es un tiovivo y estoy empezando a sentirme como un gran liebre hambrienta brincando de una parte del mundo a otra en un frenesí de avaricia y violencia."
de "The Proud Highway", carta desde Loíza Aldea, Puerto Rico, 25 de mayo de 1960

BIG SUR
Fotografías de 1960–1961

"Así es la vida en Big Sur: esperar por el correo, observar las focas en las olas o los cargueros en el horizonte, sentarse en los estanques de las aguas termales, una copa de vez en cuando y ,la mayor parte del tiempo, trabajar en lo que sea que viniste hacer aquí, tanto si es pintar, escribir, cuidar el jardín o el simple arte de vivir tu propia vida."
de "Rogue Magazine", "Big Sur: The Garden of Agony", 1961

"Estoy rodeado de lunáticos, gente chillando cada vez que aprieto el gatillo, gritando acerca de mi camisa empapada de sangre, grupos de maricas esperando a darme una paliza, tantos acreedores que he perdido la cuenta, un enorme doberman en la cama, una pistola en el escritorio, el tiempo que pasa, perdiendo más pelo, sin dinero, sediento por todo el whiskey del mundo, mi ropa pudriéndose en la niebla, una motocicleta sin luces, una casera que se dedica a escribir una novela en papel de carnicería, jabalíes en las colinas y maricas en las carreteras, cubas de cerveza casera en el armario, disparando a los gatos para aliviar la presión, la charlatanería de los budistas en los árboles, putas en los cañones, sabe Dios si puedo aguantarlo."
de "The Proud Highway", carta desde Big Sur, 4 de agosto de 1961

VIAJE POR CARRETERA A TIJUANA
Fotografías de alrededor de 1960

"El lunes pondré el pulgar rumbo al sur, Carmel, Monterey, Big Sur y quizá llegue hasta Los Ángeles. Pase lo que pase estará bien. No me importa y no tengo planes. Todo lo que quiero es ir a la costa y ver la California de la que todo el mundo habla. Llegaré hasta donde me lleve el viaje, dormiré en la playa (saco de dormir) y, si hace falta, mendigaré comida."
de "The Proud Highway", carta a Sandy Conklin, 28 de octubre de 1960

KENTUCKY
Fotografías de 1961–1963

"Por la casa vacía flota la voz de Joanie Baez, un sonido sobrecogedor para mis inquietos oídos. Espero mirar por la ventana y ver las colinas o el océano, pero no hay manera, sólo Ransdell Avenue, gris y mojada y llena de tantos fantasmas y recuerdos que me entrael Miedo siempre que pongo el pie en la calle."
de "The Proud Highway", carta desde Louisville, 10 de noviembre de 1961

"La música ha sido siempre un asunto de energía para mí, una cuestión de combustible. Los sentimentales lo llaman Inspiración, pero lo que quieren decir es Combustible. Siempre he necesitado combustible. Soy un consumidor constante. Algunas noches aún creo que un automóvil con la aguja del indicador de gasolina marcando vacío puede recorrer 80 kilómetros más si tienes en la radio la música adecuada a todo volumen."
de "Kingdom of Fear, Hey Rube, I Love You", 2003

SUDAMÉRICA
Fotografías de alrededor de 1960

"Solo me quedan 10 dólares pero he elaborado una teoría que pasará a la historia como la Ley de la Economía del Viaje de Thompson. A saber: a toda máquina y maldito el precio, lo que tenga que pasar pasará."
de "The Proud Highway", carta de camino a Bogotá,
26 de mayo de 1962

"Estoy intentando largarme de aquí en el tren de la jungla, pero el hotel no acepta mi cheque así que no puedo irme. Me siento en la habitación y pido más cerveza. La vida ha mejorado inmensamente desde que me he visto forzado a dejar de tomármela en serio."
de "The Proud Highway", carta desde La Paz, Bolivia,
18 de agosto de 1962

FERIA DE PLUMAS COUNTY
Encargo del National Observer, 1963

No hay información disponible en relación a este encargo.

LOS ÁNGELES DEL INFIERNO
Fotografías de alrededor de 1965

"Nunca he visto gente tan extraña. En cierto sentido, es como recibir una novela con los personajes ya desarrollados."
de "Songs of the Doomed", "Hell's Angels: Long Nights, Ugly Days, Orgy of the Doomed...", marzo de 1990

"Parecían un poco sorprendidos con la idea de que un escritor de aspecto convencional de una revista literaria de Nueva York los hubiera seguido la pista hasta una recóndita tienda de transmisiones en un tugurio al sur de San Francisco. Al principio, estaban un poco desconcertados pero después de 50 o 60 cervezas, encontramos afinidades, por decirlo así... los locos siempre se reconocen los unos a los otros."
de la entrevista en "Playboy", noviembre de 1974

WOODY CREEK
Fotografías de alrededor de 1960 y 1970

"Me han echado de todos los sitios en los que he vivido excepto de donde vivo ahora. Al final, he tenido que comprarlo para que no me desahuciaran."
de "Songs of the Doomed", "Wild Sex in Sausalito",
17 de mayo de 1985

"Mi lujo principal en eso años—un lujo necesario, en realidad—era la capacidad de trabajar desde mi fortaleza base en Woody Creek. Era un ancla psicológica muy importante para mí, un punto de conexión donde siempre sabía que tenía amor, amigos y buenos vecinos. Era como mi faro personal que podía ver desde cualquier punto del mundo, no importaba donde estuviera o lo extrañas o raras o peligrosas que se tornaran las cosas, todo estaría bien si lograba volver a casa. Cuando tomaba esa curva cerrada subiendo la colina a Woody Creek sabía que estaba a salvo."
de "Fear and Loathing in America", nota del autor,
20 de agosto de 2000

CANDIDATO POR FREAK POWER
Campaña a sheriff del condado de Pitkin, 1970

"Pero conseguimos una reacción masiva de los votantes. No podían soportar un sheriff consumidor de mescalina que se afeitaba la cabeza y parecía el mismo diablo."
de "Songs of the Doomed", "Chicago 1968: Death to the Weird",
marzo de 1990

"De eso se trataba cuando me presenté a sheriff de Aspen como candidato de Freak Power. En el podrido contexto fascista de lo que estaba ocurriendo en América en 1969, ser un friki era una forma honrosa de existencia."
de la entrevista para "Playboy", noviembre de 1974

MIEDO Y ASCO EN LAS VEGAS
Fotografías y recuerdos de alrededor de 1970

"Como auténtico periodismo Gonzo, esto no funciona, e incluso si lo hiciera, no podría admitirlo. Sólo un condenado lunático escribiría algo así y luego pretender que todo era cierto."
de "Miedo y asco en Las Vegas", sobrecubierta, 1972

"Oscar era uno de los prototipos del mismo Dios, un mutante poderoso de algún tipo que nunca se consideró para producción en serie. Era demasiado raro para vivir, y demasiado raro para morir."
de "Rolling Stone", "La gran caza del tiburón",
15 de diciembre de 1977

FEAR AND LOATHING: ON THE CAMPAIGN TRAIL '72
Fotografías de alrededor de 1970

"Cuando fui a Washington a escribir "Miedo y asco en la campaña del 72", fui con la misma actitud que tomo en todas partes como periodista: con todas mis fuerzas, y que Dios perdone a quien se cruce en mi camino."
de la entrevista para "Playboy", 1974

"Nixon tenía el talento singular de hacer que sus enemigos parecieran honrados, y desarrollamos un agudo sentido de fraternidad. Algunos de mis mejores amigos han odiado a Nixon toda la vida. Mi madre odia a Nixon, mi hijo odia a Nixon, yo odio a Nixon, y este odio nos hermana."
de "Rolling Stone", "Memo from the National Affairs Desk, Notes on the Passing of an American Monster", 16 de junio de 1994

LOS AÑOS 70
Fotografías y recuerdos de alrededor de 1970

"Los 70 fueron increíbles y salvajes. Eso era rock and roll."
de "Rocky Mountain News", entrevista con Jeff Kass,
18 de diciembre de 2000

"Por eso es difícil escribir en mescalina, porque la mente va cuatro veces más rápido que la mano y uno se desorganiza y no puede mantener la mente al ritmo de las manos. Por eso tengo que conseguir máquinas de escribir cada vez más rápidas. Cualquier cosa que fabriquen, si es más rápida, la compro."
de "Songs of the Doomed", "LSD-25: Res Ipsa Loquitor",
marzo de 1990

KEY WEST
Fotografías de 1979–1980

"Mi propio barco, un Mako de 17 pies con un enorme motor Mercury negro en la parte trasera, está atracado a unos 20 pies delante de mi máquina de escribir, y sé que el depósito de gasolina está lleno. Lo llené anoche alrededor de las siete de la tarde, y cuando me preguntaron por qué estaba repostando el barco al inicio de una mala noche sin luna, les dije que a lo mejor me apetecía ir a Cuba. La mujer con cabeza de pez se rió pero yo no."
de "Song of the Doomed", "Sugarloaf Key: Tales of the Swine Family", 18 de marzo de 1983

"Nunca he afirmado ser nada más que un chico simpático y un atleta".
de "Sound Bites from Counter Culture", 1990

LA MALDICIÓN DE LONO
Fotografías y recuerdos de alrededor de 1970

"Es una vida extraña, seguro, pero por ahora es todo lo que tengo. Anoche, alrededor de medianoche, oí a alguien arañando el techo de paja y una voz de mujer susurrando: "Cuando las cosas se ponen raras, los raros entran en acción". "Eso es", grité, "Te quiero". No hubo respuesta. Sólo el sonido de este inmenso e insondable mar, que me habla cada noche y me hace sonreír mientras duermo."
de "Songs of the Doomed", carta a Ralph Steadman,
30 de junio de 1981

GERENTE DE NOCHE
Fotografías de alrededor de 1985

"Hoy día, todos somos hombres de negocio. Voy de camino a San Francisco para vender una curiosa película porno, y llevo tres horas de retraso a un pase crucial con los hermanos Mitchell en su controvertida sede en O'Farrell Street. El chofer me está esperando en el aeropuerto con un coche blindado y dos jóvenes putas gordas de Corea."
de "Kingdom of Fear", "Seize the Night", 2003

HACIENDO FRENTE A LAS CONSECUENCIAS
Fotografías y recuerdos de alrededor de 1980 a 2005

"Cuando al mismo tiempo que se publican tus obras completas, se está filmando una película acerca de ti... y cuando apareces en tiras cómicas... en algún momento me convertí en una figura

pública. De alguna manera el autor se ha hecho más famoso que sus escritos. Y es una mierda."
de "Rolling Stone College Papers", entrevista con David Felton, 1980

"No me había adaptado muy bien a la sociedad, pasé en la cárcel la noche de la fiesta de graduación de la escuela secundaria, pero aprendí a la edad de 15 años que para salir adelante tienes que encontrar algo que hagas mejor que nadie... al menos ese era mi caso. Lo resolví muy pronto. Era escribir. Me ponía a cien. Más fácil que el álgebra. Era trabajo constante, pero merecía la pena. Me sentí fascinado desde muy temprano al ver mi nombre impreso. Era un subidón. Lo sigue siendo."
de "Paris Review", entrevista con George Plimpton, otoño de 2000

"Va a ser una guerra muy cara y la victoria no está garantizada, para nadie y, desde luego, para nadie tan confundido como George W. Bush. Todo lo que sabe es que su padre empezó la guerra hace mucho tiempo y que él, el niño bobo Presidente ha sido elegido por el Destino y la Industria petrolera global para acabarla. Ahora."
de "Kingdom of Fear", escrito el 12 de septiembre de 2001

"Mi vida ha sido el polo opuesto de seguridad, pero estoy orgulloso de ella y mi hijo también lo está, y eso es bastante para mí. Volvería a hacer lo mismo sin cambiar ni un ápice, aunque nunca se la he recomendado a otros. Sería cruel e irresponsable y dañino, creo, y no soy nada de lo anterior."
de "Kingdom of Fear", "Memo from the Sports Desk", 2003

"En esos tiempos, estábamos furiosos y cargados de razón y había millones como nosotros. Echamos a dos presidentes de la Casa Blanca porque eran unos belicistas estúpidos. Sometimos a Lyndon Johnson y pisoteamos a Richard Nixon, lo que los sabiondos decían que era imposible, ¿y qué? Fue divertido. Éramos guerreros y nuestra tribu era fuerte como un río. Ese río sigue fluyendo. Todo lo que tenemos que hacer es ir a votar, mientras siga siendo legal, y erradicaremos a esos belicistas tramposos de la Casa Blanca."
de "Rolling Stone", "Fear and Loathing, Campaign 2004", 2004

"Quizá no exista el Cielo. O quizá todo esto sean monsergas, un producto de la imaginación demente de un paleto borracho y perezoso con un corazón lleno de odio que ha encontrado una forma de vivir a tope, durmiendo hasta tarde, divirtiéndose sin control, bebiendo whiskey y conduciendo rápido por calles vacías con nada en la mente excepto enamorarse y que no le arresten... Res ipsa loquitor. Que empiece la fiesta."
de "Generation of Swine", nota del autor, 1998

"Nunca ha sido bastante raro para mí."

BOOKS BY HUNTER S. THOMPSON

"Hell's Angels: A Strange and Terrible Saga". New York: Random House, 1967.

"Fear and Loathing in Las Vegas: A Savage Journey to the Heart of the American Dream".
 New York: Warner Books, 1971.

"Fear and Loathing: On the Campaign Trail '72". San Francisco: Straight Arrow Books, 1973.

"The Great Shark Hunt: Strange Tales from a Strange Time". New York: Summit Books, 1979.

"The Curse of Lono". New York: Bantam Books, 1983.

"Generation of Swine: Tales of Shame and Degradation in the '80s". New York: Summit Books, 1988.

"Songs of the Doomed: More Notes on the Death of the American Dream: Gonzo Papers, Vol. 3".
 New York: Summit Books, 1990.

"Screwjack". Santa Barbara: Neville Press, 1991.

"Better than Sex: Confessions of a Political Junkie". New York: Random House, 1994.

"The Proud Highway: Saga of a Desperate Southern Gentleman, 1955–1967". New York: Villard, 1997.

"The Rum Diary: The Long Lost Novel". New York: Simon & Schuster, 1998.

"Fear and Loathing in America: The Brutal Odyssey of an Outlaw Journalist, 1968–1976".
 New York: Simon & Schuster, 2000.

"Kingdom of Fear: Loathsome Secrets of a Star-Crossed Child in the Final Days of the American Century".
 New York: Simon & Schuster, 2003.

"Hey Rube: Blood Sport, the Bush Doctrine, and the Downward Spiral of Dumbness:
 Modern History from the Sports Desk". New York: Simon & Schuster, 2004.

GONZO HONOR ROLL

Pierre Adeli
Jorge Arciniega
Barney
Cristina Bartolucci
Tom Benton
Douglas Brinkley
Tom Cabbell
Graydon Carter
William Claxton
Tom Corcoran
Ryan Corey
Clarence E. Crist
Donna Crist
Gloria Fowler Crist
Lola Crist
Miles Crist
Lulu de Kwiatkowski
Benicio del Toro
Christi Dembrowski
Johnny Depp
Stephen Deuters
Martha Dewell
Chitta Dey
Purabi Dey
Dan Dibble
Bob Dylan
Bette Einbinder
Kendra Finn
Jason Foreman
Deborah Fuller

Brian Gant
Lynn Geller
Terry Gilliam
Mitch Glazer
Gayle Golding
Hal Haddon
Carole Harrington
Bill Heiden
Jeri Heiden
John Heiden
Robert Heiden
Jamie Jo Hoang
Laura Howard
Stephanie Howard
Jo Hudson
Anjelica Huston
Austin Jordan
Keith Kinsella
Florence Kircher
Angela Lipparoni
Enrico Lipparoni
Semmes Luckett
Dan Marfisi
Steve Martinez
William McKeen
Dr. Hikmat Nabulsi
Laura Norton
Paul Norton
Rose Norton
Tinti Dey Norton

Sarah Conley Odenkirk
Todd Oldham
Kevin Ostrowski
Melissa Padilla
Angela Crist Ruffing
Eric Ruffing
Paul Semonin
Lihi Shadmi
Peter Shurkin
Kate Soto
Ralph Steadman
Patti Stranahan
Bob Thiele
Anita Thompson
Davison Thompson
Jennifer Thompson
Juan Thompson
Will Thompson
George Tobia
Norman Todd
Benjamin Trigano
Camilla Trigano
Sondi Thompson Wakefield
Don Weinstein
Jann Wenner
David Wexler
David Wilder

GONZO
by Hunter S. Thompson

Introduction by Johnny Depp
Produced by Steve Crist and Paul Norton for AMMO Books, LLC
Edited by Steve Crist and Laila Nabulsi
Design: John Heiden and Ryan Corey for SMOG Design, Inc., Los Angeles
www.smogdesign.com
French Translation: Florence Kircher, New York
German Translation: Henriette Zeltner, Munich
Spanish Translation: Marian Getino, Barcelona
Typefaces: from the Fedra family by Peter Bil'ak

Distributed in the USA and CANADA by Ingram Publisher Services
Distributed in the UK by Orca Book Services

Library of Congress Control Number: 2006933049
EIN: 9780978607661
ISBN: 0-9786076-6-X

PRINTED IN CHINA

To purchase additional copies of GONZO, or for more information on
AMMO Books, please visit our web site at www.ammobooks.com

AMMO
AMERICAN MODERN BOOKS